Drawing Mentor

Volume 14
Fantasy Drawing

Volume 15
Fantasy Drawing II

Volume 16
Fantasy Drawing III

By Sarah Bowles

Copyright © 2016 Sarah Bowles

All rights reserved. No part of this book, text, photographs or illustrations may be reproduced or transmitted in any form or by any means by print, photoprint, microfilm, microfiche, photocopier, internet or in any way known or as yet unknown, without written permission.

ISBN-13: 978-1539011576

ISBN-10: 1539011577

Preface

The *Drawing Mentor* series of books is intended to help beginning to intermediate drawers learn and improve their drawing skills. Each book is written as a stand-alone lesson which can be used on its own, this gives the reader the ability to pick and choose the lessons and skills they would like to learn to the exclusion of all else.

The earlier lessons in the series are very foundational, designed to improve the reader's technical ability and understanding before going on to later lessons which are more project-based and written assuming technical skills have already been developed. If you're an absolute beginner it's recommended that you proceed from Volume 1 as that will ensure your understanding of how to use the techniques employed in later lessons as occasionally these lessons will refer to principles and skills taught in previous volumes.

This book includes Volumes 14, 15 and 16 which are all advanced lessons that use the skills developed in previous volumes to complete fantasy drawings. Each lesson takes you through the thought process of brainstorming and planning and then leads a step by step example to help you complete your own drawing. Each step is explained and detailed pictures are provided. Volume 14 is a simple overview of fantasy and includes a lesson on drawing simple dragons; Volume 15 and 16 continue the fantasy genre with a project drawing werewolves and a project drawing ogres and dwarfs. (These lessons assume you've already developed fundamental drawing skills. Before attempting it is recommended that you first learn and understand sketching, layout, and how to apply tone, shading and highlights. If you have not developed these skills please refer to previous volumes.)

The intent of the Drawing Mentor series is to periodically add new lessons over time to help you continue to improve your skills. If there is a particular skill or lesson you would like covered please feel free to send an email to drawingmentor@gmail.com. Your feedback suggestions and reviews are very much appreciated and will be used to help create lessons that will benefit you the most.

Thanks for choosing *Drawing Mentor*. Here's to your success.

Sincerely,

Sarah Bowles

Help support someone in need.
10% of all profits are donated to organizations
giving humanitarian assistance.

Contents

Fantasy Drawing 1

What is a Fantasy Drawing? 1

What Do You Include in a Fantasy Drawing? 2

Step by Step Exercise 2

- Step 1 3
- Step 2 5
- Step 3 6
- Step 4 7
- Step 5 8
- Step 6 9
- Step 7 10
- Step 8 11
- Step 9 12
- Step 10 13
- Step 11 14
- Step 12 15
- Step 13 16
- Step 14 17
- Step 15 18
- Step 16 19
- Step 17 20
- Step 18 21

Results 22

Conclusion 23

Fantasy Drawing II 25

The Werewolf 25

Doing the Research 26

Foreshortening 43

Step by Step Exercise 45

- Step 1 46
- Step 2 47
- Step 3 48
- Step 4 49
- Step 5 50

Step 6	52
Step 7	53
Step 8	54
Step 9	55
Step 10	56
Step 11	58
Step 12	59
Step 13	60
Step 14	61
Step 15	62
Step 16	63
Step 17	64
Step 18	65

Conclusion 67

Fantasy Drawing III 69

The Subject 69

Doing the Research 70

Inking 111

Step by Step Exercise 115

Brainstorming	115
Step 1	117
Step 2	118
Step 3	119
Step 4	120
Step 5	121
Step 6	122
Step 7	123
Step 8	124
Step 9	125
Step 10	126
Step 11	127
Step 12	128
Step 13	129
Step 14	133
Step 15	134
Step 16	135
Step 17	136
Step 18	137

Conclusion 139

Fantasy Drawing

Welcome to Volume 14. This lesson is an introductory lesson to fantasy drawing. Many people find fantasy drawing to be a fun genre because it's possible to draw just about anything, plus there's a lot of freedom to develop your own style.

What Is a Fantasy Drawing?

The fantasy genre includes anything that doesn't exist in real life. That being said, even though these drawings go outside the boundaries of what is real, there are still many elements of reality which are usually included. The reason this lesson is being presented in Volume 14 is so that, if you've completed the previous volumes, you will have had time to develop your drawing skills. The strategy here is to become competent in drawing reality before moving on to something imaginary.

You can do anything you want with fantasy art but the most successful pieces include characteristics of reality.

This of course doesn't mean everything is real. It means the rules of drawing like perspective, shading and tone, still apply. Studying the world around you and being able to draw what you see gives you a good foundation to draw the things you can only imagine.

Basing a fantasy drawing on reality doesn't stop with the drawing rules. One of the best things about fantasy is the wonderful creatures you find. Many of these creatures are combinations of things we have on earth. For example, centaurs have a horse body and a human torso, arms and head. The Minotaur is half man, half bull. A vampire can be a man, a bat, a demon or a combination of all three. You can come up with new creatures, however you may find that you want to include certain characteristics of animals we have on earth. Because so many creatures are based on animals in our world, it's helpful to know how to draw animals if you're going to use them as a starting point for fantasy creatures.

Some things in a fantasy drawing might be exactly like our world. For example, a rock could still be a rock and a tree could still be a tree, however, you also have the freedom to give your rock or tree a face, maybe arms or legs, and the ability to interact with its environment the same way people do. This once again combines two things from our world to create one fantastic thing in a fantasy world.

Although drawing rules still apply, the laws of physics don't have to. For example, creatures and objects can defy gravity and fly around with no logical explanation. An elephant can be as light as a feather and a mouse can weigh a thousand pounds. Fire, ice, electricity or anything else for that matter can appear out of nowhere and move around however you want it to.

A fantasy drawing can be set in any time period, past, present or future; the point is, the better you get at drawing reality, the easier it'll be to combine your skills with your imagination and be successful.

What Do You Include in a Fantasy Drawing?

What you draw in your fantasy world is entirely up to you. It could be a drawing of the future with flying houses, spaceships and aliens, a drawing of the past with knights in shining armor, dragons, and wizards, or you could even mix these together. You may also want to try adding a touch of fantasy to a drawing of your own neighborhood.

Adding familiar fantasy creatures will help give your drawing more appeal. People generally like what they're familiar with, some familiar fantasy creatures include:

Witches	Wizards
Goblins	Dwarves
Gnomes	Elves
Ogres	Griffins
Dragons	Fairies
Vampires	Robots
Werewolves	Aliens

This list could be much longer; there are hundreds of popular fantasy creatures.

Most cultures have myths which often include imaginary creatures and/or people of some sort. Every person and every artist has their own idea of what these creatures look like and what they do. Your art will appeal most to people who agree with your interpretation.

Remember that you as an artist are only limited by your imagination. You don't have to draw a creature that everyone is familiar with; you can create something totally new. There aren't any rules for how things are supposed to look so don't let anyone tell you that you messed up, you can't mess up fantasy! Creatures, plants, landscapes and buildings can all be changed into a more fantastic state. You don't have to change any of these if you don't want to but don't be afraid to try.

One thing to remember about fantasy drawing is that exaggeration can be very helpful. Mountains are taller and sharper, buildings are larger, monsters and heroes are bigger and stronger. Exaggerating things larger adds energy and intensity to your drawing, exaggerating things smaller adds intrigue and mystery.

Step by Step Exercise

It's time to start a fantasy drawing! Feel free to follow the example, or just follow the steps as you develop your own drawing. This lesson takes you step by step through the process of drawing a dragon.

Step 1.

Study.

The first thing to do is get an understanding of the creature you're going to draw. There is a lot of lore written on the numerous fantasy creatures, and dragons in particular. It doesn't take long to find an abundance of material to help you understand dragons.

Various cultures have differing views on what a dragon is, what it looks like, and its powers and abilities. To quickly give an example of the contrasting views one must look no further than the difference between the Asian dragon and that of the western Europeans.

The Asian dragon is described as a serpent-like creature. It had a long body like a snake, with four powerful legs and strong claws. Depending on the particular Asian culture the dragon would have between three and five toes per foot. The head of these dragons was large, at least as wide as, if not wider than the neck, with great horns, a mane, large teeth and flaring nostrils. These dragons were powerful, benevolent and wise. Strongly associated with the ruling powers, they were not necessarily feared but reverenced and respected.

The Western European dragon was of a different sort entirely. They were typically cruel and vicious, savage monsters that would wreak havoc across the land. To kill a dragon was a heroic feat. Some are depicted as intelligent and very cunning, others as mindless animals, but either way they were an animal to be feared. These dragons were stouter than the Asian dragons, with large bodies shaped more like a lion's. Their legs were also longer but still powerfully built. They're typically depicted with a long tail and neck, and a smaller, narrower head with two or more horns. These dragons, unlike the Asian dragons, had massive wings most often described as being similar to bat wings.

As you can see, there is a wide array of characteristics that can be attributed to dragons and today, thanks to the explosion of movies, TV, books and games, you can find descriptions of dragons that cover every shape, size and color, and an even larger array of personalities and abilities. Ask ten different people what a dragon is and you'll get ten different answers. Everyone has their own opinion, but there are some characteristics that are definitely

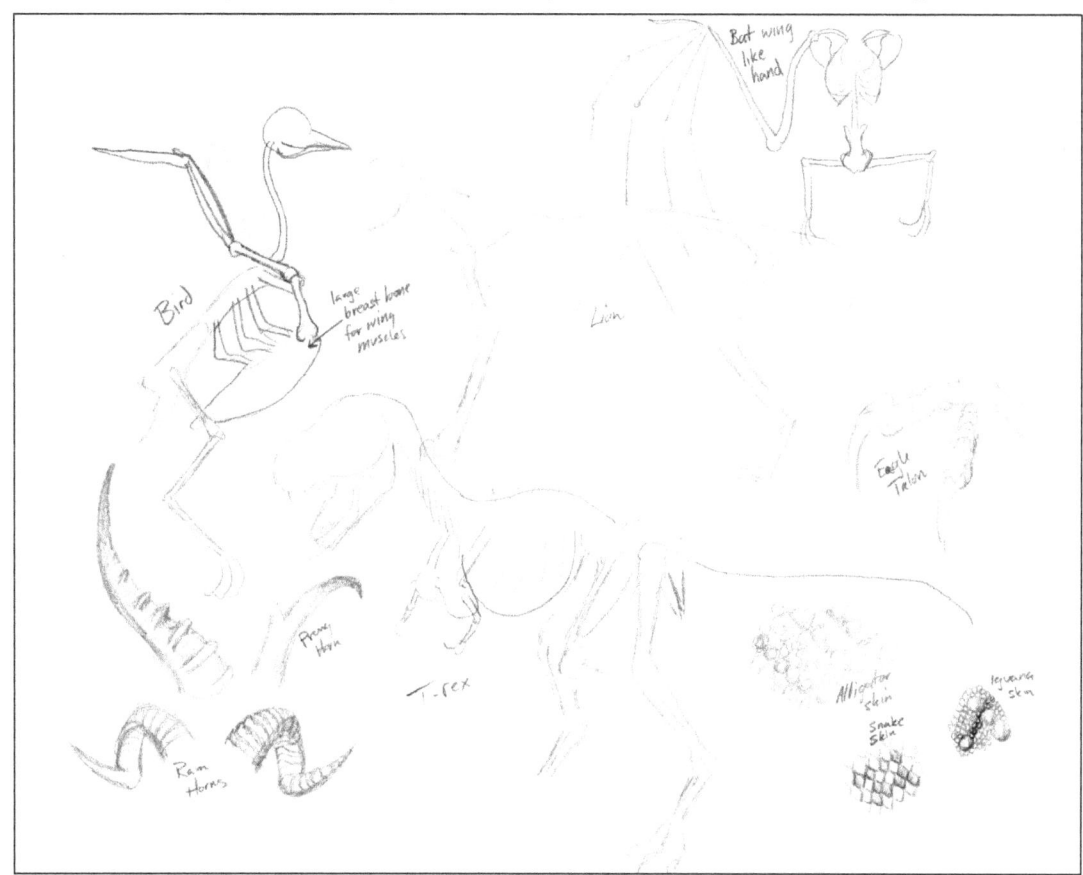

Figure 14-1. Animal bone structures and body parts

mentioned more than others. Most all dragons are said to have some sort of magical abilities, though some descriptions don't mention this, and many of them can project something from their mouth, typically fire but also things like lightning and poison. One thing that typically does not change is people's use of different animal parts when describing a dragon's body. Most dragons are described as scaly though slime, hair and feathers have also been noted. Most dragons are described as having horns which can range from horns like a ram to those of an antelope. Other animal features attributed to dragons are teeth like a lion, claws like an eagle (or again like a lion), and wings like a bat.

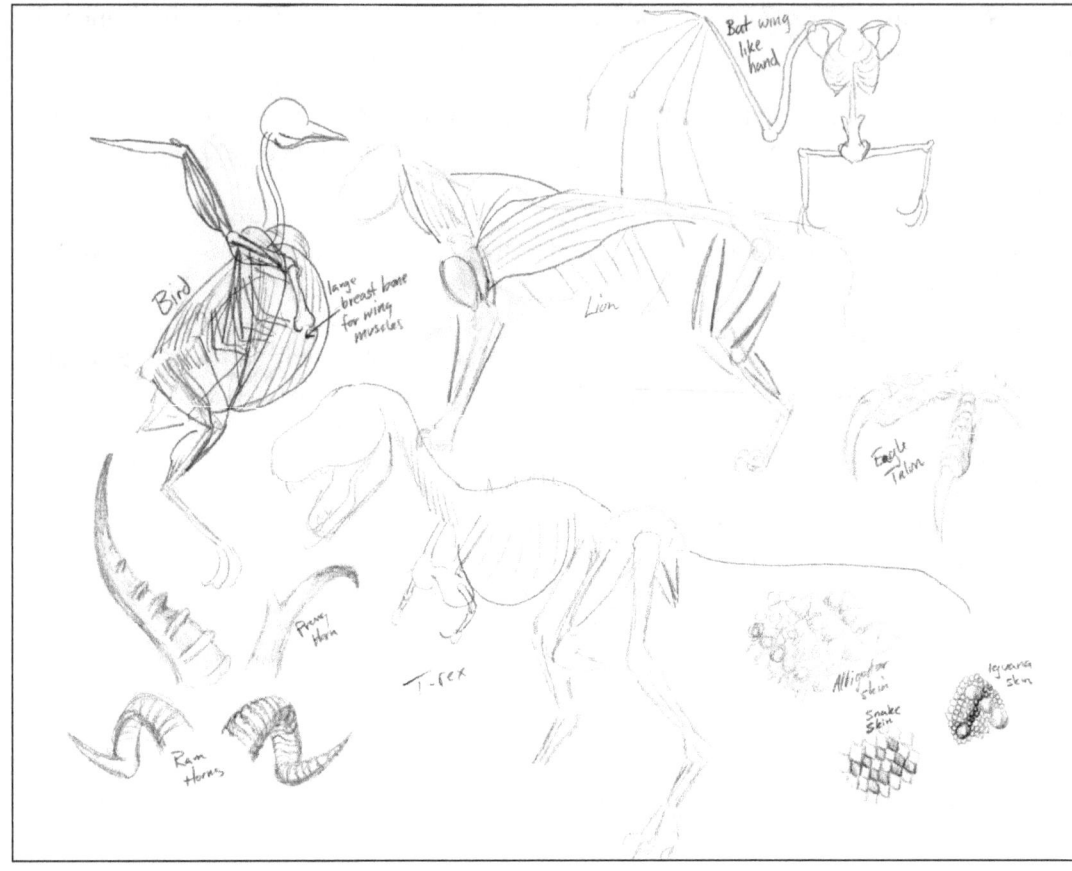

Figure 14-2. Muscles added to bones

As you study, begin to piece together in your mind the type of creature you want to draw and the physical characteristics you think it should have. Once you have a good idea of the features you're going to include, it then becomes helpful to sketch animals that have similar features. (As you become more familiar with your topic you won't have to do this as frequently).

The dragon in this example is based more on the Western European version as far as body type goes. Its mannerisms and expressions are relatively neutral, leaving the interpretation of the personality up to the viewer.

Figure 14-1 is a compilation of basic skeleton sketches, skin textures, and other animal parts. The sketches were used to learn about body parts and other animal features that could be used while drawing the dragon. In Figure 14-2, muscles were added to some of the skeletons to get an idea of how thick the limbs of the dragon might be.

The lion is a good general body shape; it's well balanced and enough muscle can be added to it to make the dragon look powerful. The hips and legs of the tyrannosaurus can be used in the same way, plus they show how a long thick tail attaches to the hips. Bat-like wings will be added to the dragon so the sketch of the bat skeleton was added. The bird skeleton was drawn to study the breastbone. It will take a lot of muscle to move the dragon's wings, the bird's skeleton shows how a large breastbone attaches to the ribs. Sketches of various types of horns, different lizard skins and finally some eagle talons were also sketched.

Skeletons and features can be combined however you want. Find the pieces you like best and mix them all together

Step 2.

Visualize and sketch poses.

Studying nature and determining the creature's disposition can help you know what you want your creature to look like. The next step is to decide what the creature will be doing. There are three general categories to pick from, asleep, awake but motionless, or in motion. Make a few sketches for at least one if not all of the categories, keep them simple by using as few lines as possible to show the body and each limb. Each sketch should only take a few seconds.

Visualizing can take a long time; it's possible to sketch for hours before finding a pose you want to draw. However, the more you sketch and hone the poses you like best, the easier the final drawing will be.

Whatever you decide you want your creature to be doing, find a picture or two of a person or animal doing a comparable action. If you want the creature to be in motion, find a picture of another animal in a similar motion. Use these as references in addition to your sketches.

Figure 14-3 is a collection of different sketched poses; each has the potential to make an interesting drawing. The circled pose in the middle was chosen as the basis for this example because it's fairly simple but still interesting.

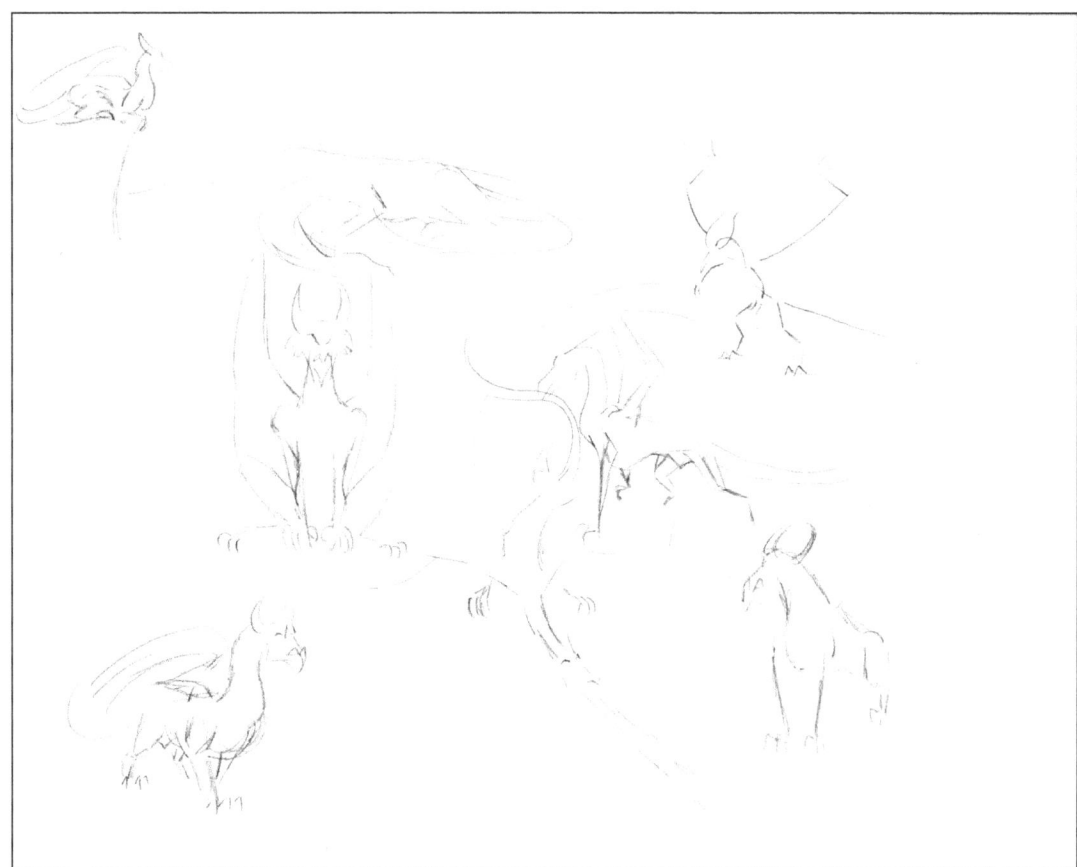

Figure 14-3. Layout sketches

Step 3.

With research and sketches done you're prepared to start drawing. Copy this example or just implement each step as you draw your own creature.

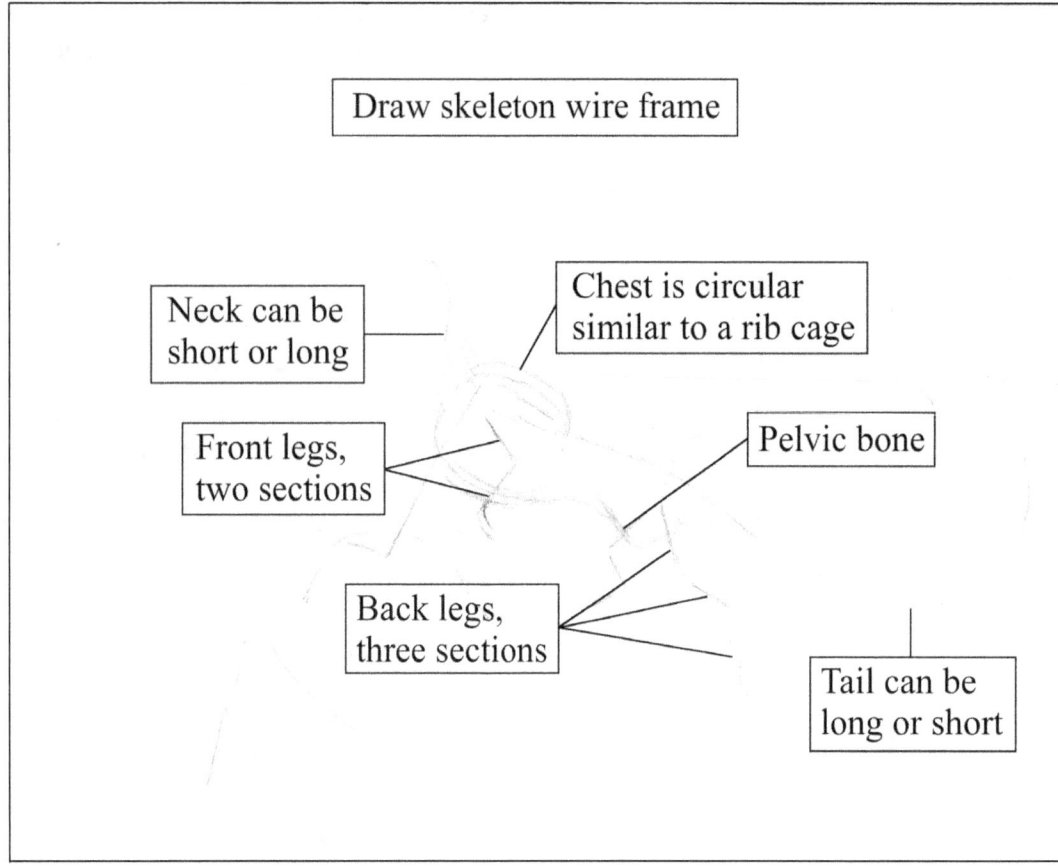

Figure 14-4. Initial wire frame sketch of body position

First, lay out the general shape and size of the dragon with a wire frame. The majority of the wire frame of this dragon is based on the skeletons of the lion and the tyrannosaurus which were studied in Step 1. This wire frame will be used as the foundation for everything else. Keep it simple for now, eventually muscles, skin, hair and horns will be added. If your creature requires clothes you can start to add them at any point after the skin is done.

Be aware that even at this point exaggeration can work to your advantage. Exaggerating the characteristics will give your creature personality and interest.

Step 4.

Draw shapes over the wire frame to add mass to the body. The shapes should match the muscle structures studied in Step 1. This is another point where exaggeration can be used to your advantage. Making muscles very big, very small, or combining some very large muscles and limbs with some very small muscles and limbs will completely change the feel and personality of the creature.

Notice that most of the muscles are combinations of triangles and ellipses, especially in the legs and neck. The muscles of this dragon are large, round at one end, and taper to a rounded point on the other. The chest is circular. The head follows the general shape of the tyrannosaurus skull with a long wide nose that leads to a bit of a circular bulb at the back.

A simple way to start the feet of clawed animals is to draw only the top of the largest joint of each finger. This will show the number of fingers and the spacing between them.

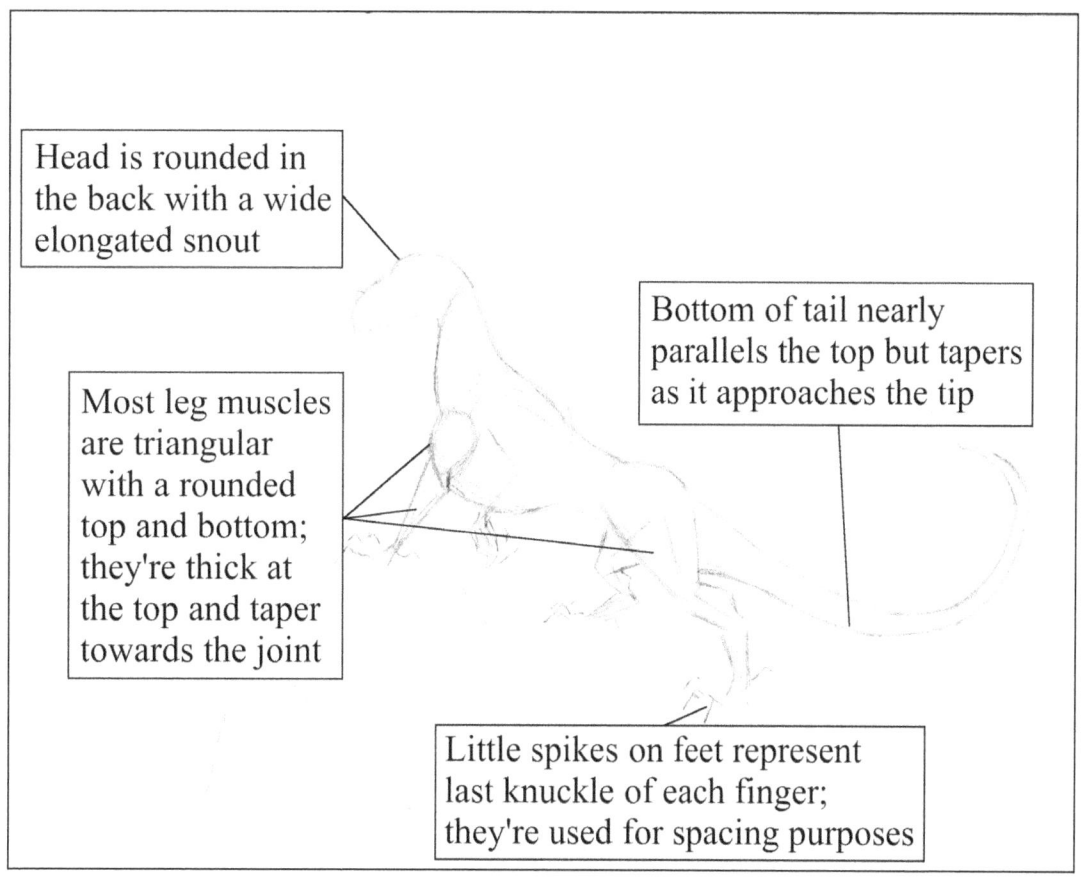

Figure 14-5. Adding shapes to give the body mass

Step 5.

After completing the main shapes of each body part, finalize the outline of the body and erase any internal guidelines that are no longer needed.

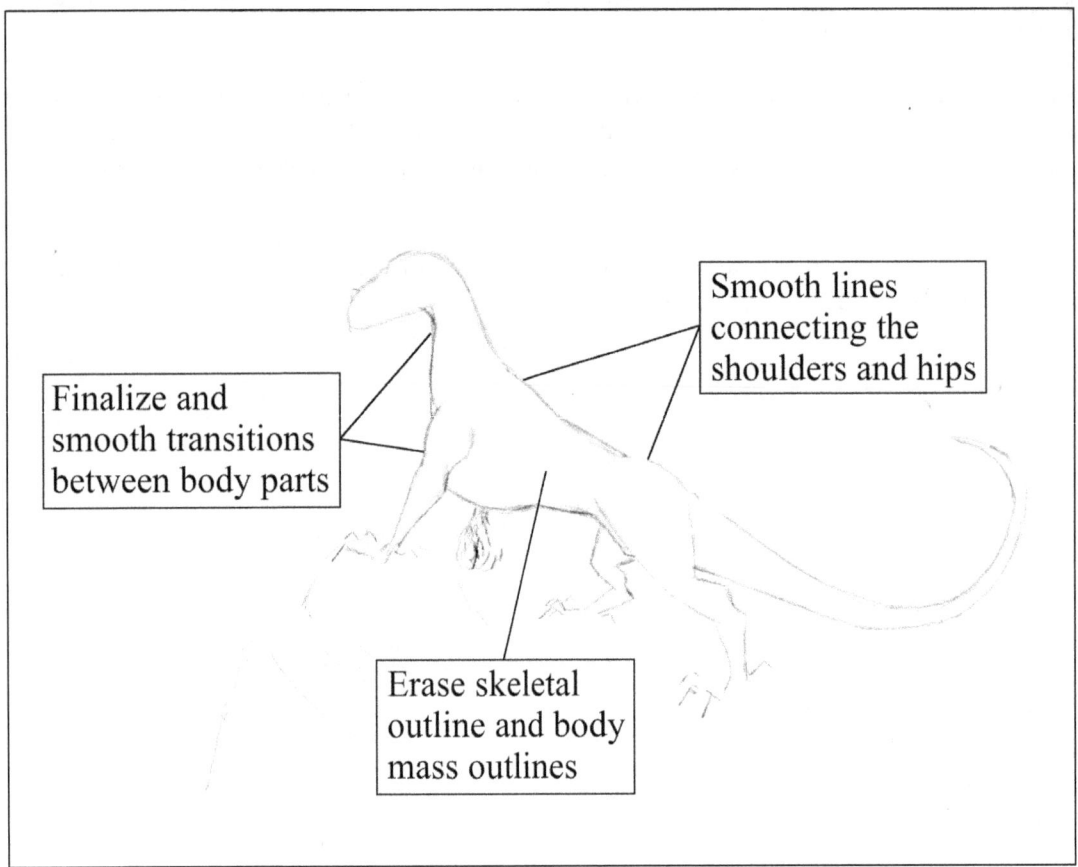

Figure 14-6. Final body outline

Step 6.

Add wings to complete the outline of the body. This is relatively complicated because the wings stretch from the body both away from, and towards the viewer. To add these wings correctly you have to use foreshortening. This means that as the wing gets closer to the viewer's eye it will appear bigger, as it gets farther away it will appear smaller; it also means you won't be able to see the entire wing because some parts of the wing which are closer to the viewer will block other parts from view.

The wing on the left in Figure 14-7 has been drawn as if looking down from above and was added to help explain the wing's structure. A number was given to each bone in the top view; corresponding numbers are on the wings drawn on the dragon. This is to help you see how a wing viewed from the top looks when viewed from the side. You should be able to see that the wing is similar to an arm. It has a shoulder, an elbow, a wrist and fingers (see the bat skeleton in Figure 14-1). A thin leathery membrane stretches from fingertip to fingertip and from the innermost finger to the elbow-spike and body.

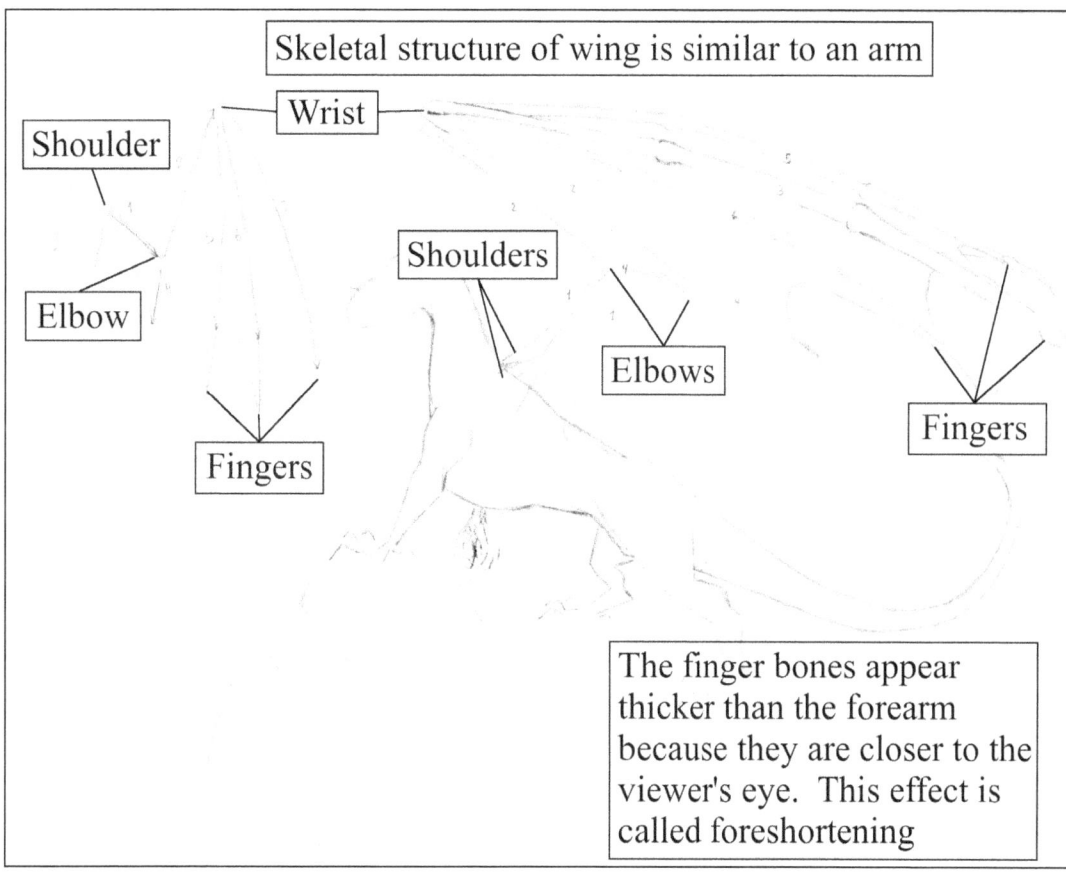

Figure 14-7. Wing layout

Step 7.

After the body has been outlined, detailing can begin.

Start by detailing the major muscles. This should be easy if the limbs and muscles were based on sketches you made previously while studying muscle structures.

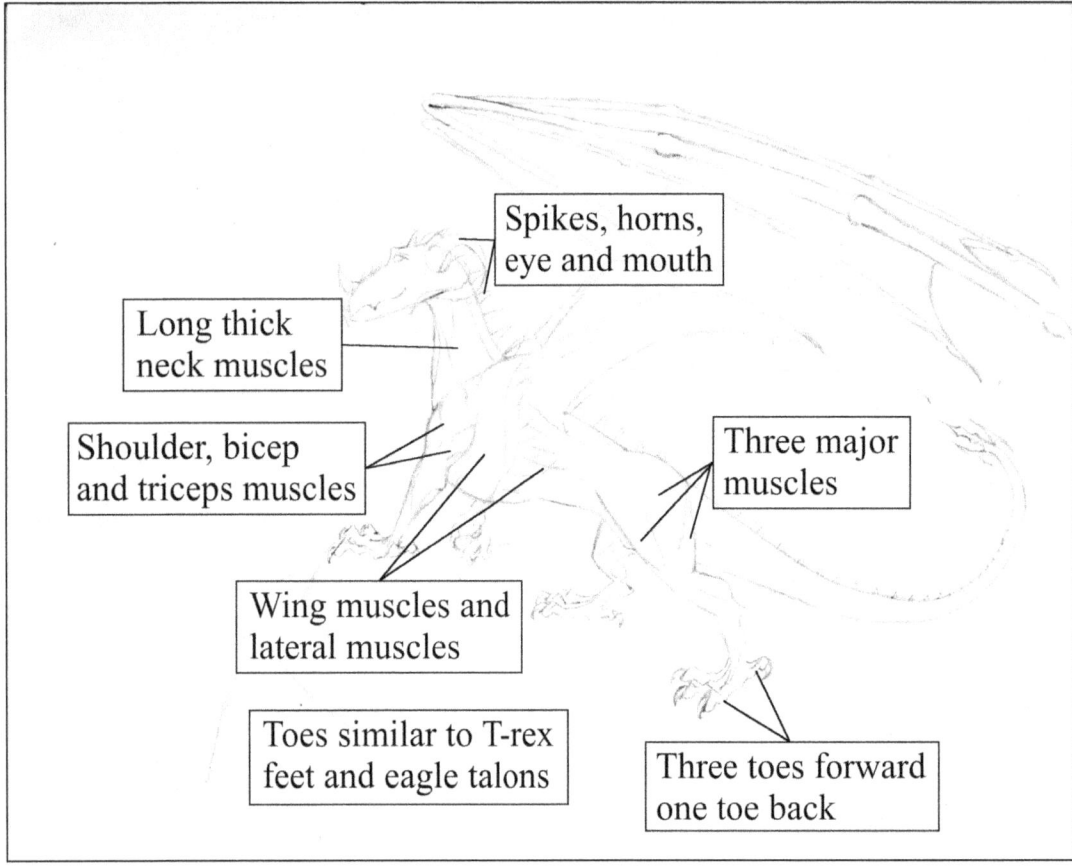

Figure 14-8. Muscle layout and initial details

Depending on the number of limbs your creature has and where you put them, you may have to be creative with muscle placement.

For example, on earth, there aren't any vertebrates with the combination of front arms and wings. To add muscles that fit properly to the extra limbs takes some imagination. Then again, because it's fantasy, it's okay to say "It works because it works." and not worry about which muscles move the extra limbs.

In this example, long muscles have been drawn from the shoulder of the wings down to the chest behind the front arms. Other than that, the leg, arm, neck and tail muscles should be straight forward as they're similar to the muscles of the animals studied in Step 1.

The toes were also added in this step. Each one is knobby and has a sharp claw at its end similar to the eagle talons studied before. Spikes down the spine, horns on the head, a beak and eyes complete the initial layout of details.

The horns can be done many different ways; they don't have to curl around the head. Also, the spikes down the spine don't have to be straight and smooth. You can get as creative and exaggerated as you want with all these details.

Step 8.

Now that the body has been outlined it's time to start adding tone. If you haven't already determined the location of light sources now is the time to choose them. This will make adding tone easier because you'll know where the highlights and shading should go.

Lightly begin adding tone to each muscle. The way to do this is similar to the way you would shade a sphere or cylinder. Most muscles have some roundness to them so the peak closest to the light source will be highlighted. As the muscle moves away from the highlight the shading gets darker and darker.

As you add shading to the muscles you can also add tone and details to the skin. Notice the large plate-like scales added to the belly, chest and front of the neck. These scales are similar to the underside of a snake. Viewing them from the front they would appear to be long rectangles, but because they wrap around the dragon's body, only a small portion of each scale is visible.

If you're going to add clothes to your creature this is a good time to start. If you don't add clothes at this point but plan to later, be careful not to add too much tone or shading to the body where you know the clothes will be. It's easier to add clothes and then the tone and shading, rather than erasing tone to add clothes.

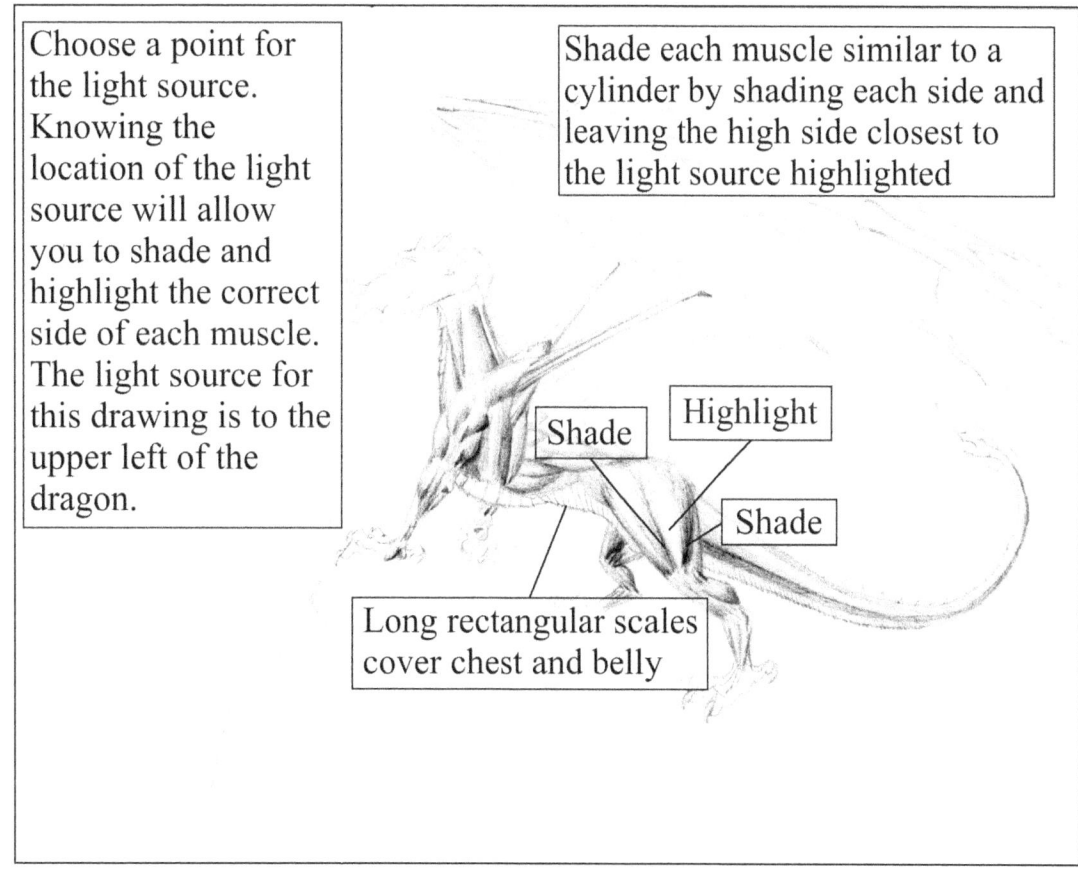

Figure 14-9. Initial layer of tone defines the shape of the muscles

Step 9.

After a light initial layer of tone is added to the body, begin adding details as well.

If you're going to add clothes to your creature and didn't do it before, this is definitely the time to start. As far as this dragon is concerned, there are a number of ways to make an acceptable skin.

The skin could be left smooth and shiny, even to the point of looking wet and slimy. Another option is a complex pattern of hard scales. Hair and/or feathers are also acceptable. Another alternative is to have skin that doesn't cover the entire body but exposes interior features like muscle, bones and organs.

Often the details are where you can use your imagination the most.

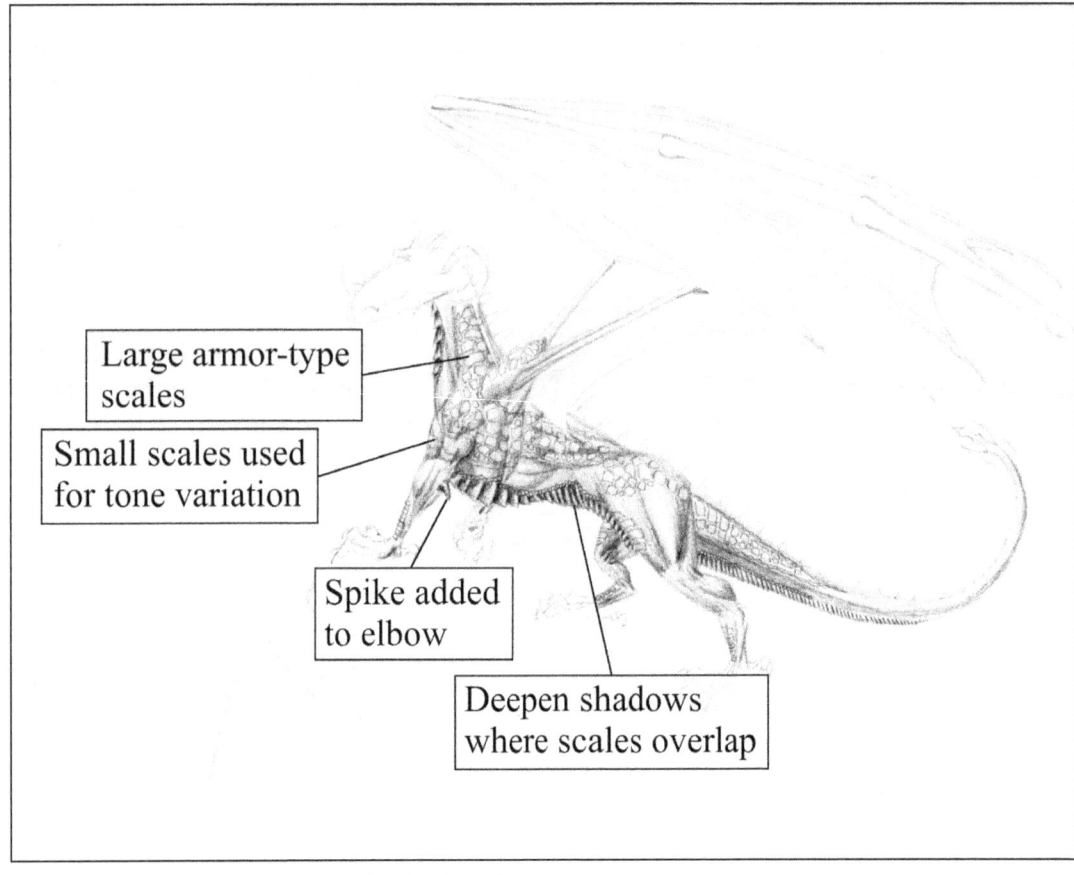

Figure 14-10. Initial body details

Be creative and add the things that are most acceptable and fun for you. In this example, a large portion of the dragon's upper back and sides have been armored using a fairly random arrangement of large scales. The front of each shin was also detailed with large scales. Using little scales which are basically just dots, thin stripes have been added down the sides and on the arms.

The belly scales have been detailed using deep shadows where the scales overlap. This creates a highlighted effect along the rim of each scale and can help show the texture. A smooth shadow lets you know the scales are smooth while a rough or broken shadow will indicate rough scales.

Step 10.

Continue adding details to the body. Add depth to the large scales by shading around the edges, especially on the side away from the light source. Darken the stripes on the arms and along the side of the body. Add new sets of stripes diagonally from the belly to the large scales.

To increase the rough scaled look, add texture in the areas where the muscles are shaded most. Use small hatching lines in the direction of the scales or actually draw small individual scales. The simplest scale is a small "u" or "v" shape. The curve of the "u" or tip of the "v" will generally point in the direction of the wrists or ankles if the scales are on the legs, or in the direction of the tail if on the body. You don't have to draw every scale, small groups of scales here and there is usually enough.

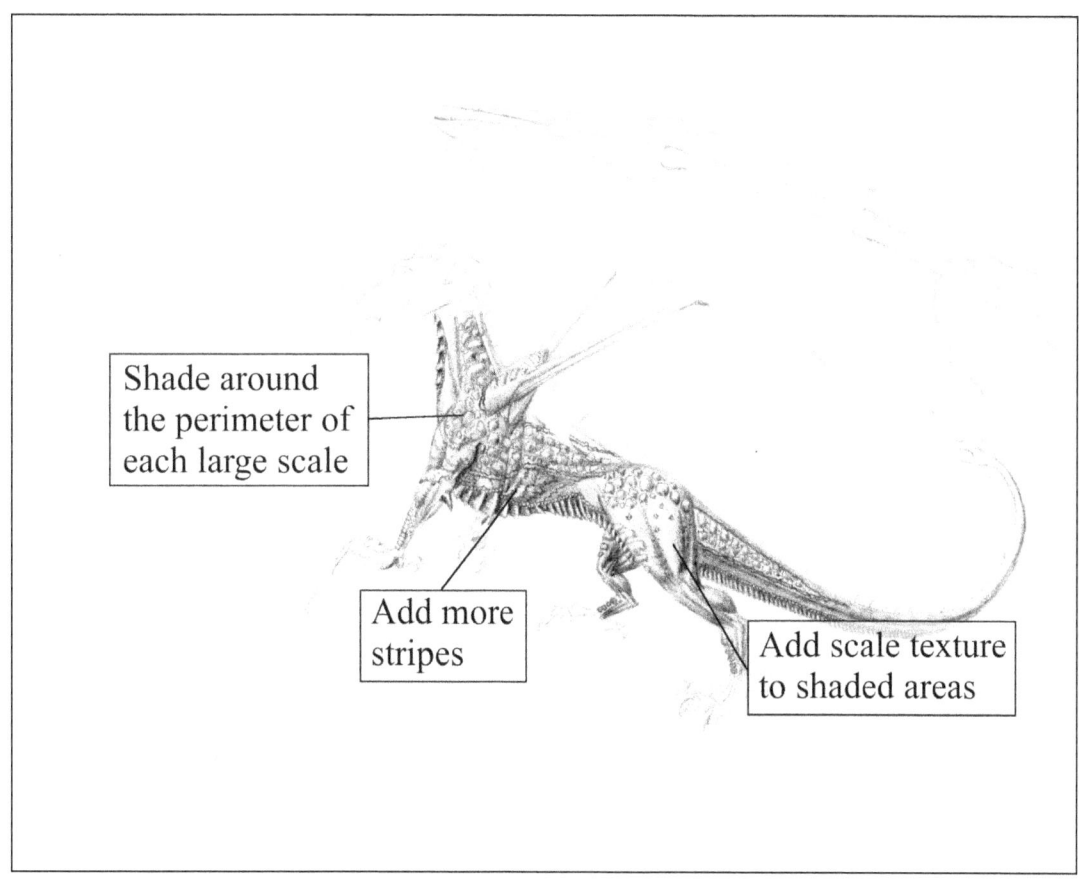

Figure 14-11. Finish initial body details

Step 11.

When you've completed detailing the body of your creature, touch up the tones using your pencil to darken shadows and an eraser to create highlights. In this example, all the large scales have been cleaned up, all the stripes were made thicker and darker, and the shadows around the contours of the muscles were darkened and slightly blended.

Now that the body and limbs are done, finish the hands and feet. Notice in Figure 14-12 that there is a large bulb at the end of each toe on the bottom, and a pointy knuckle in the middle of each toe on the top. Use dark shading to describe the bulbs of the toes. Coming out of the bulb at the end of each toe is a claw which curves down towards the ground and comes to a sharp point. The claws are highlighted on top because they're smooth and shiny.

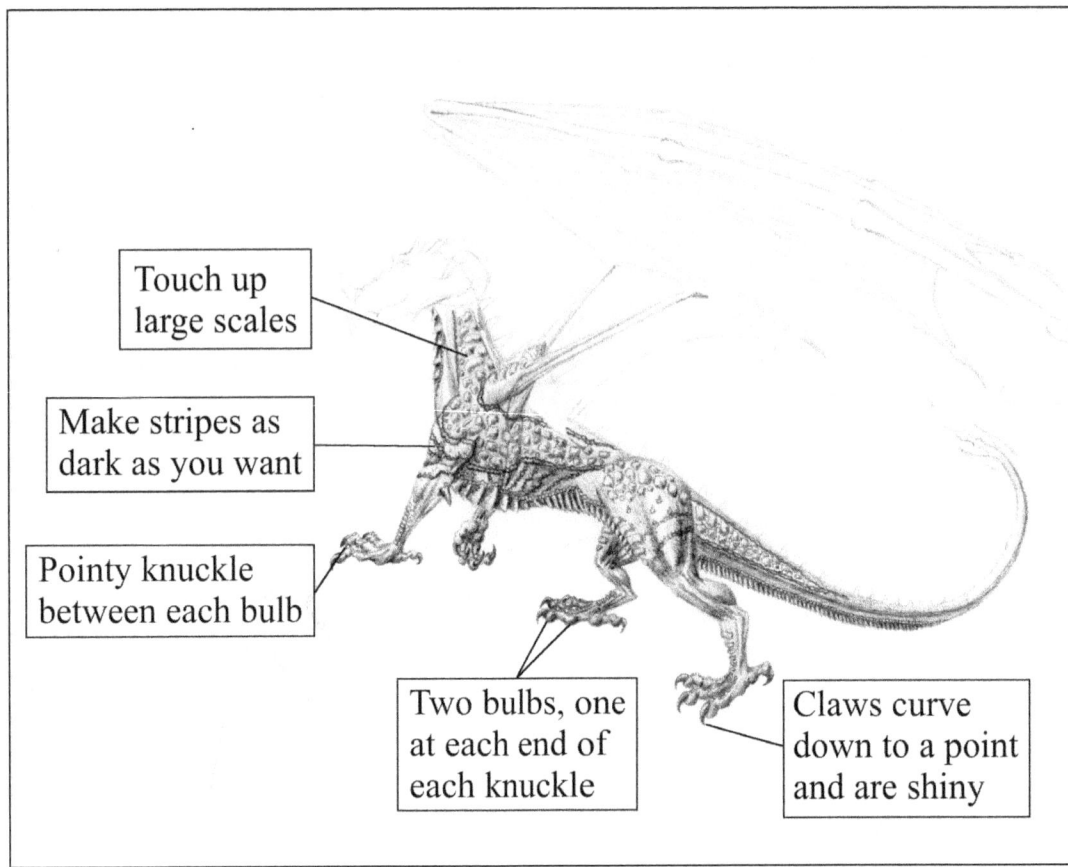

Figure 14-12. Skin adjustments, hands and feet finished

Step 12.

The head is very important. You can portray a lot of the personality of a creature by its facial expression, especially from the eyes and mouth. The eyes of this dragon are in profile view and, similar to a person's eyes, they'll be more or less wedge shaped, similar to a slice of pie. Draw an arc in the direction the eye is looking and then two lines extending back from the top and bottom of the arc which taper to a point. The colored part of an eye in profile view will be elliptical, not round.

The horns were detailed as ring-layers and shaded like the belly scales. The lips are like a bird's beak, smooth and shiny, and taper to a sharp point. The mouth extends back to below the eyes. The nostrils flare up a little using two half circles, the smaller half circle being below the larger one and more heavily shaded to indicate that there is a hole there. These features and the contours of the face are then shaded. Spikes can be added as extra details and to make the face unique.

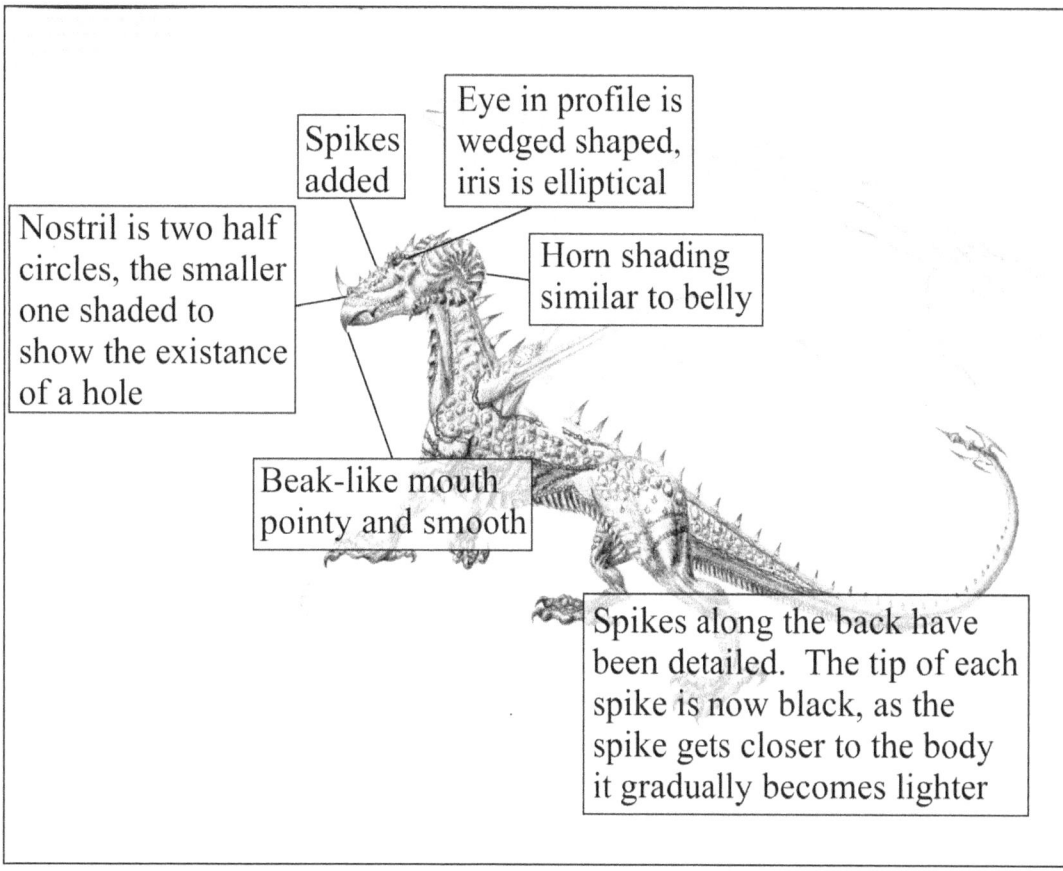

Figure 14-13. Head and spike details

Step 13.

Finish the dragon by adding tone to the wings. The support structures are shaded similar to cylinders, that is, the sides are darker than the highlighted peaks closest to the light source. Muscles are added at the shoulder, and the joints of the "fingers" closest to the viewer are detailed.

The membrane of the wing can be done a couple different ways. It can either block all light, in which case it'll be a solid tone or possibly patterned, or it can be translucent which means some light will be able to pass through. You can show the wing is translucent with careful shading and highlighting, and by adding veins in the highlighted areas using thin jagged lines. In this example, the undersides of the dragon's wings are darker than the tops. This makes it look like the wing is blocking light, however, the shadow gets lighter towards the edge of the wing which indicates the skin gets thinner and blocks less light closer to the edges.

Figure 14-14. Add tone to wings

The focus of this example is the dragon, which is now done. At this point, if the dragon was all you wanted to draw, you would be finished. However, you can enhance the drawing more by adding a background.

Step 14.

The background in this example is going to be fairly simple. First, a distant jagged mountain range is outlined. The Sun is going to be just above the mountains which will silhouette them against the sky. Go ahead and shade the mountains heavily making sure to leave a white highlight line separating the different groups of mountains. A few layers of rolling hills are added in front of the mountains which aren't shaded as dark because the sunlight hits them more directly. Lastly, the outline of a cliff face is drawn where the dragon is standing.

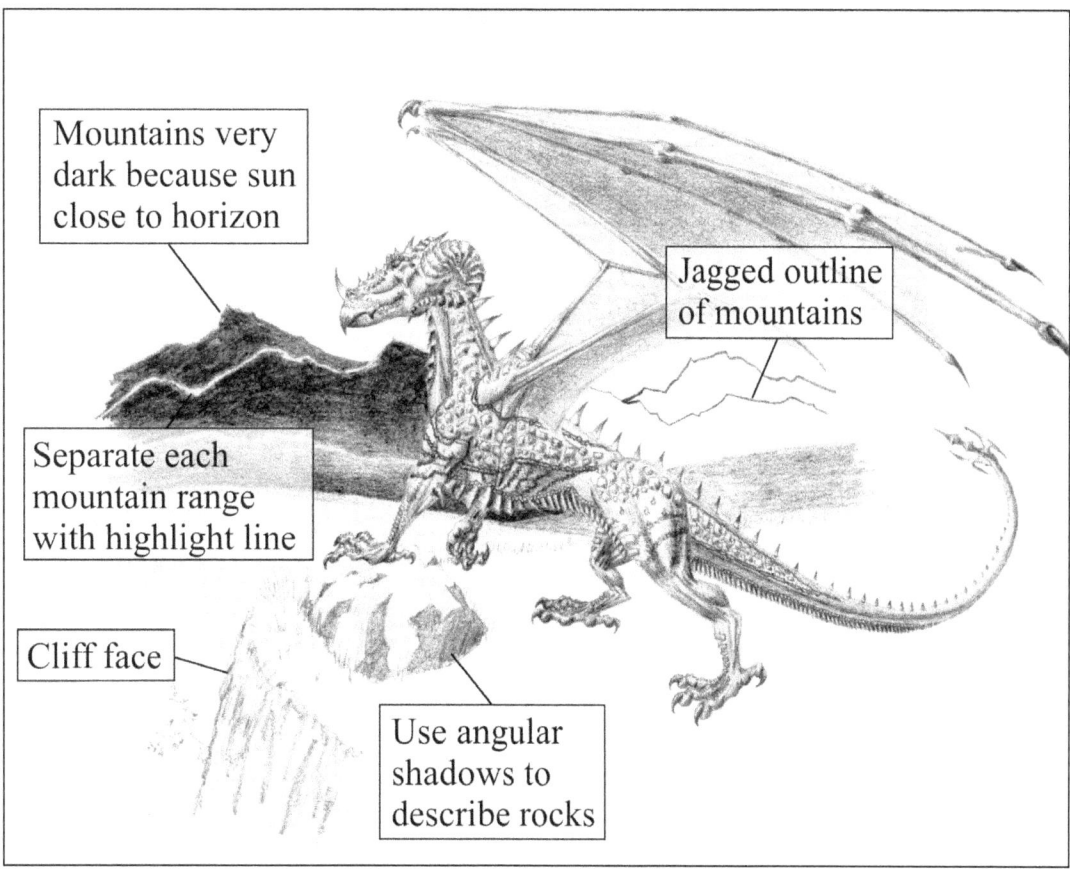

Figure 14-15. Add background and foreground objects

Step 15.

Finish shading the two distant mountain ranges leaving the white highlight line to separate them.

Imagine the sun just to the right of the highest mountain peak. Shadows will project from this area and highlights will be facing it, show contours in the mountains accordingly.

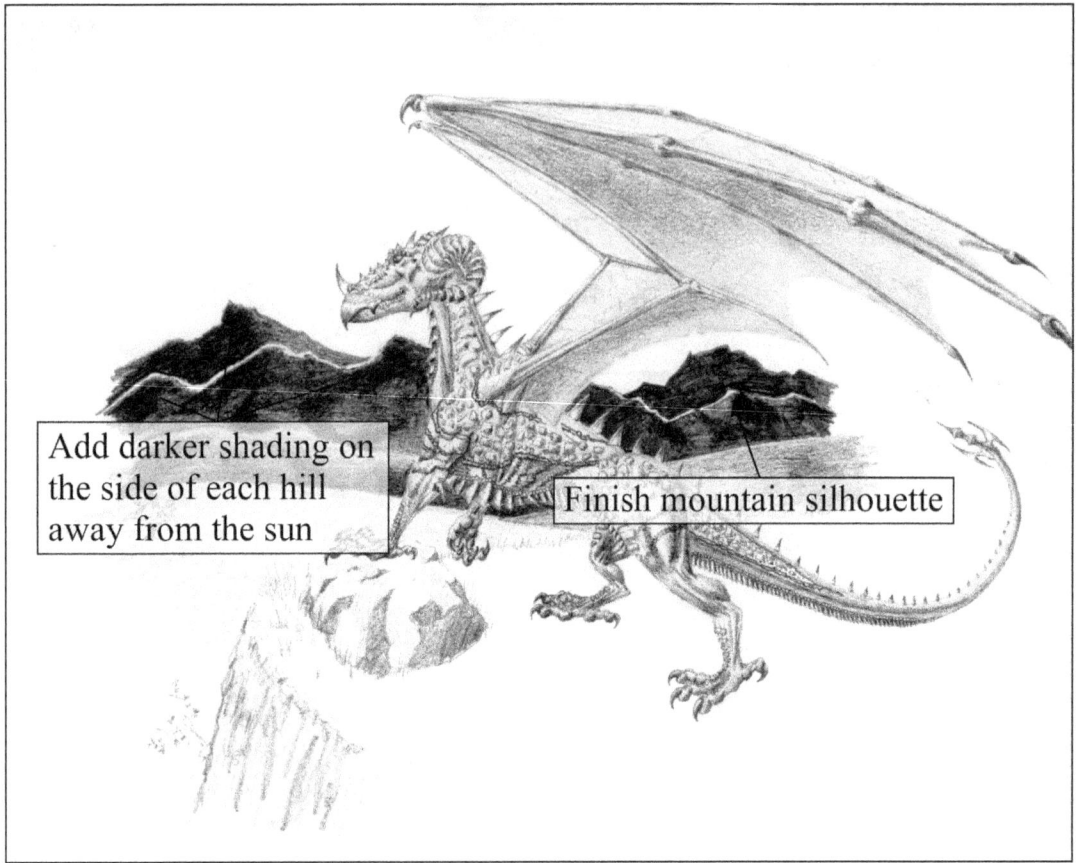

Figure 14-16. Finish the background mountains

Step 16.

The sun is now added and the highlights and shadows of the mountains have been adjusted once more.

A medium tone was added to the hill below the cliff and it was detailed with some basic trees and rocks. The trees and rocks could have been left out and the results would have been fine, these details are about preference.

Hatching is used to draw the shadow extending from the rock on which the dragon is standing. Using hatching makes the shadow look as if it is being cast over grass.

The tone and shadows on the face of the cliff were also darkened.

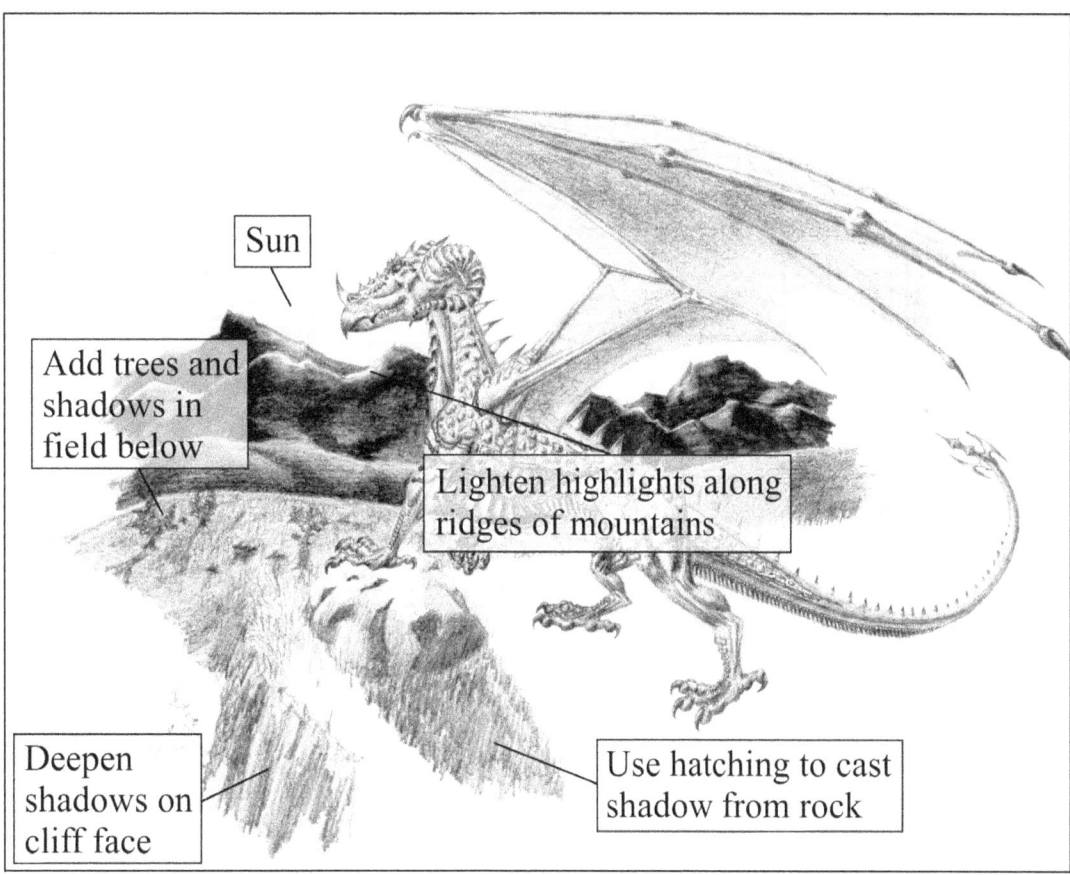

Figure 14-17. Mountain highlights and foreground development

Step 17.

The dragon's shadow is now outlined as it would project onto the ground. (For more information on projecting shadows see Volume 3.)

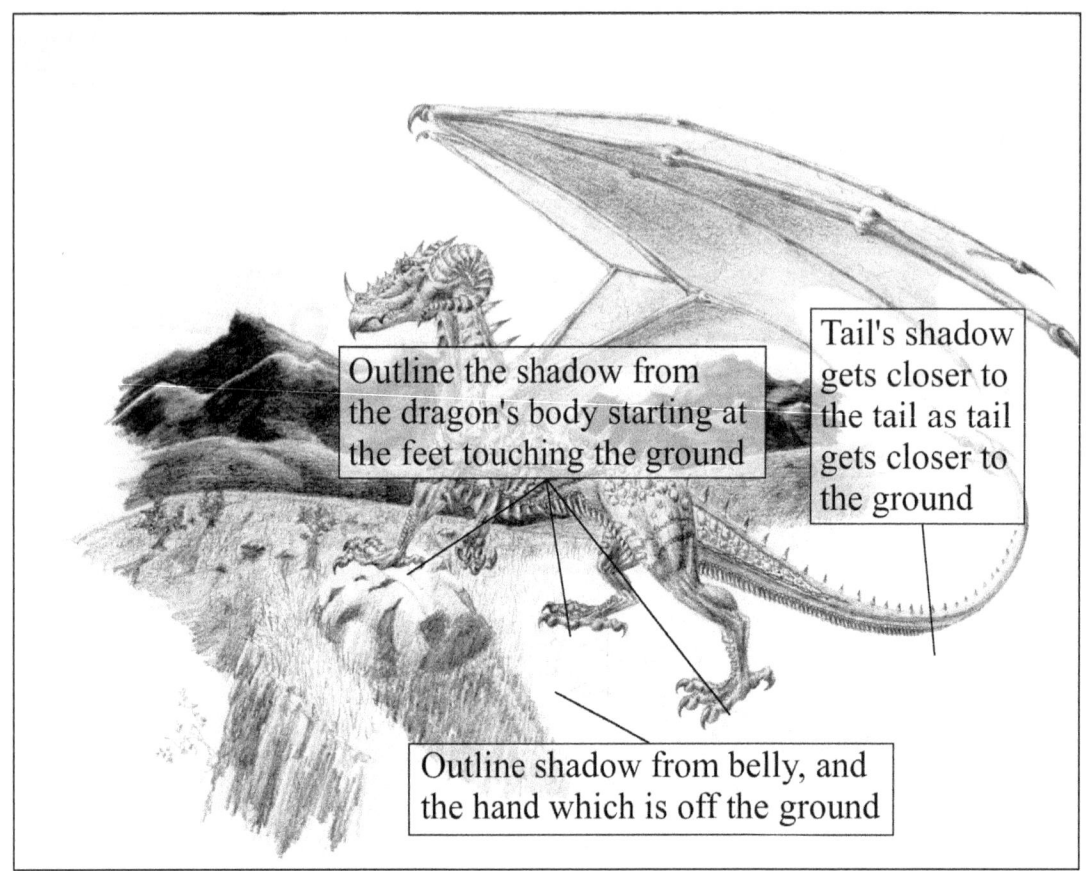

Figure 14-18. Layout for the dragon's shadow

Remember, shadows don't have to be exact; they should have the same general shape as the object but what's more important is that it's projected in the right direction away from the light source.

If you need help visualizing the direction the light rays travel, get a straightedge and place one end in the middle of the light source. Move the other end of the straightedge to different points around the object and extend very faint lines away from the light source, from the object, to the ground. If the object is touching the ground then the shadow will be projected from that point, immediately extend across the ground and be influenced by the contours of the surface. If the object is not touching the ground then you must follow the straightedge to the point where the shadow would project onto the surface. This technique will locate the points on the ground where the shadow will be projected and give you a rough idea of what the shadow should look like.

In this example, there will be a shadow projecting from each foot touching the ground. There will also be a shadow from the hand which is lifted off the ground, but that shadow won't connect to the body, neither will the shadow from the tail, which is also lifted off the ground.

Step 18.

Complete the finishing touches.

Fill in the dragon's shadow using the same hatching technique used in Step 16 to draw the shadow projecting from the rock.

Add random clumps of grass, more rocks, and more trees on the hill below the cliff. Shade each of these as needed.

The dragon's skin and horns were touched up to reflect the sunlight better. Notice that the spikes now have highlights on the sun side and shadows on the opposite side. The spikes are also casting shadows across the dragon's back and tail. The belly scales have been given highlights and the shadows around the tail, legs, chest, and face have been darkened.

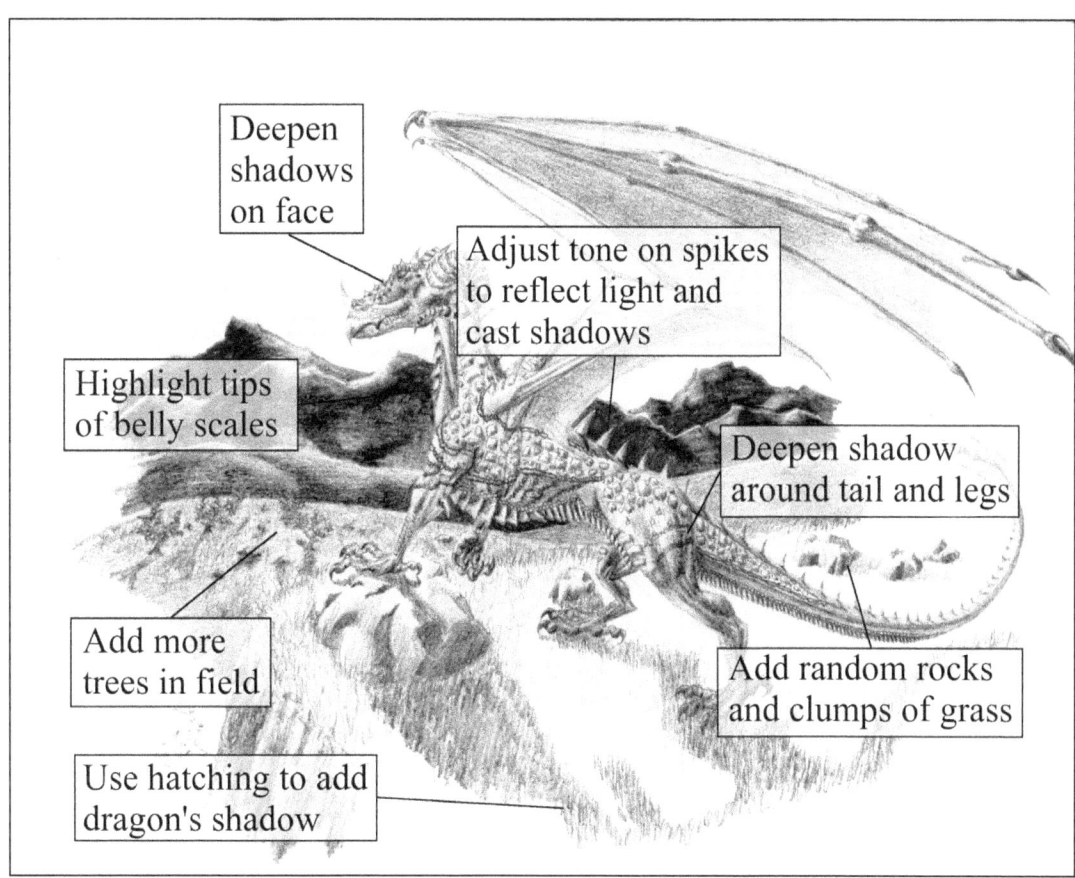

Figure 14-19. Final shading and highlights

Results

Here is the completed drawing of the dragon. There's nothing to compare it to because it's a fictional creature. If you like the results of your drawing that's great; if not, you can always try again. Each time you draw a fantasy drawing you'll get better at it, it'll become easier, and your personal style as an artist will start to show. Remember, there's no right or wrong in fantasy, there's just different.

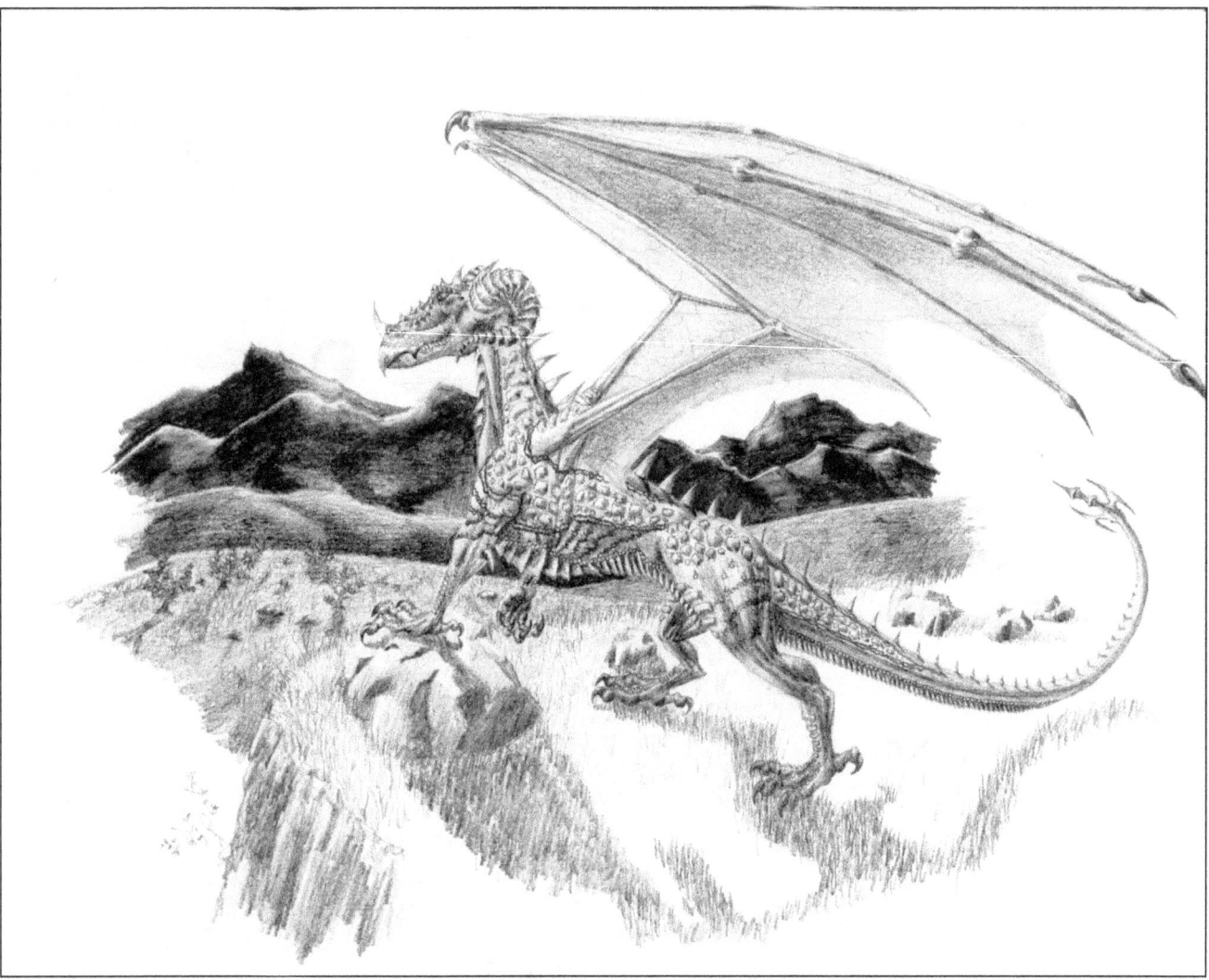

Figure 14-20. Finished drawing of a dragon

Conclusion

You've now completed Volume 14 which is an introduction to fantasy drawing. Please don't consider this the end-all lesson on the subject, there's so much more that can be said and so many more styles to explore. This lesson only scratches the surface of possibilities.

Hopefully you learned something and had fun doing it. If you've completed all the other volumes so far I hope you're happy with how your skills are developing. When you're pleased with your ability and can apply it to things you enjoy drawing, it really makes the pastime enjoyable and, fantasy drawing in particular, a lot of fun.

Fantasy Drawing II

Welcome to Volume 15. This lesson is a continuation of the fantasy genre introduced in Volume 14. Volume 15, while covering its fantasy topic, will also introduce a new skill you can use in other types of drawing. The subject of this lesson is a werewolf and the new skill is the technique of foreshortening. Foreshortening will be utilized while drawing the werewolf so you will have an opportunity to practice this skill.

The Werewolf

As discussed in Volume 14, fantasy drawings include at least one thing which doesn't exist in real life. This lesson will take you step by step through drawing a werewolf.

The werewolf is a mythical creature which has its beginnings several hundred years ago. The varying legends describe werewolves as either a very large wolf or a mixed half-human half-wolf whose dominant traits vary with each story. According to the legends and depending on the culture's local mythology there are several ways to become a werewolf including magic clothing, potions, curses, or infections. Most versions of werewolves with very few exceptions are fierce killers and have little to no conscious control as animal instinct takes over. Some legends say they can change between the human and werewolf form, others say they are permanently transformed. Either way, the werewolf is a fascinating, ferocious, and feared creature in the monster mythology of our time.

A werewolf was chosen for this lesson for a few reasons. One reason was that it's a familiar and popular mythical monster; another is that it's a dynamic beast, fast, agile, and strong, which opens up many possibilities for exciting drawings. The main reason it was chosen was because it's a hybrid of just two things, a human, and a wolf, which means the research for this drawing can be extremely focused. In Volume 14 a dragon is the subject. There are literally hundreds of variations and animals that can be used in researching dragons. With the focus of the research for this drawing down to two things, it gives the artist less to sort through and more time to determine how the two creatures can combine together.

Everyone has their own style and ideas regarding mythical creatures and werewolves are no exception. Some like the idea of a monstrous wolf, others like a more human look, and some like it somewhere in between. Personally I prefer a fairly even mix, maybe leaning a little more towards a wolf. I also like the idea of the two creatures adding to each other's stature and mass as if two actual creatures were added together to make one. This means bones are bigger and thicker, and muscles are enhanced and enlarged. This makes for a large, strong, fierce creature that any normal person would be scared of. Of course you are welcome to your own interpretation.

Doing the Research

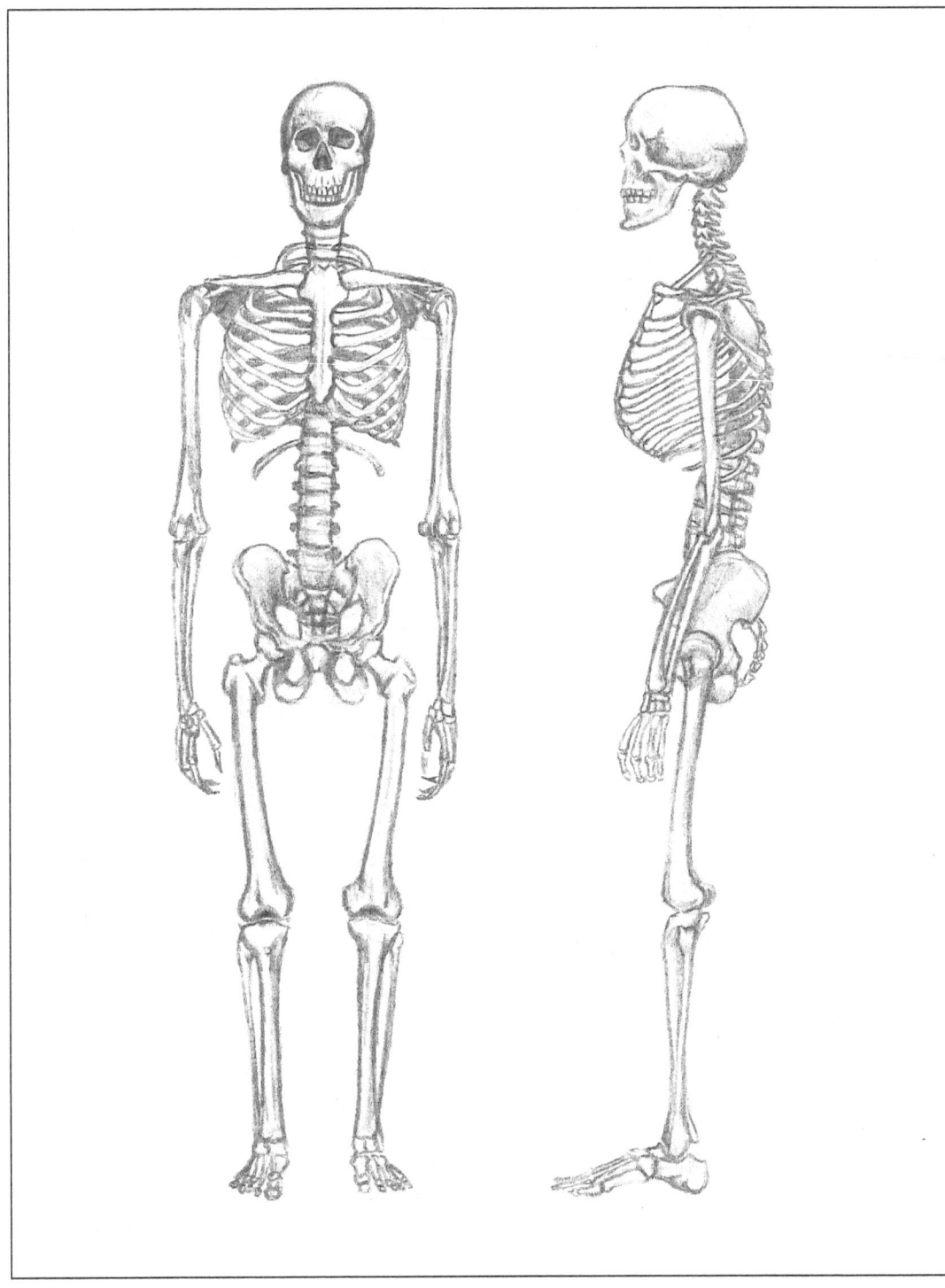

Figure 15-1. Human skeleton, front and profile views

To combine a human and a wolf as seamlessly as possible it's important to have at least a basic understanding of their anatomy, especially the bone and muscle structures.

There are many sources where you can find pictures of the human skeleton. It's well worth your time to sketch the human skeleton several times and from many different angles.

As you sketch skeletons, pay particular attention to the joints. The hips and shoulders are ball and socket joints. These joints have a large range of motion. The bones coming out of these joints can be manipulated into thousands of different angles and they can also rotate, giving them even greater flexibility. The knee and elbow joints are hinge joints. They can only bend in one direction. The ankle and wrist joints are gliding joints which also have a lot of mobility similar to the hips and shoulders.

Other things that are important to note about the human skeleton are the hips, scapula, and clavicle or collarbone. Humans walk upright unlike most other animals; our hips are specifically designed to do that and

therefore function differently and are shaped differently than the hips of most other animals. Another difference that comes from being bipedal is our shoulders. Our arms hang down to the side as opposed to four-legged animals whose front limbs are held out in front of their chests. This affects the shape, function, and placement of our collarbone and scapula.

Understanding the foundational structure of the human body is especially helpful while sketching. Wireframe sketches (as discussed in Volume 5) are a quick and easy way to begin drawing any human or animal. However, in order to draw the final shape of each limb you need to be familiar with the muscles that cover the skeleton.

Just as it's easy to find source pictures for human skeletons, it's also easy to find source pictures of the skeletal muscles. Studying muscles is a bit more complicated than studying bones. There are many more muscles than there are bones and each muscle connects to at least two different bones. Everyone basically has the exact same muscles but personal traits will change the muscle's shape, length, and fullness. Muscles also change shape as they move the bones through a full range of motion. For these reasons it takes more time to learn the muscle structure of the body, and how it functions.

Figures 15-1 and 15-2 are final sketches of the human skeleton and basic human musculature.

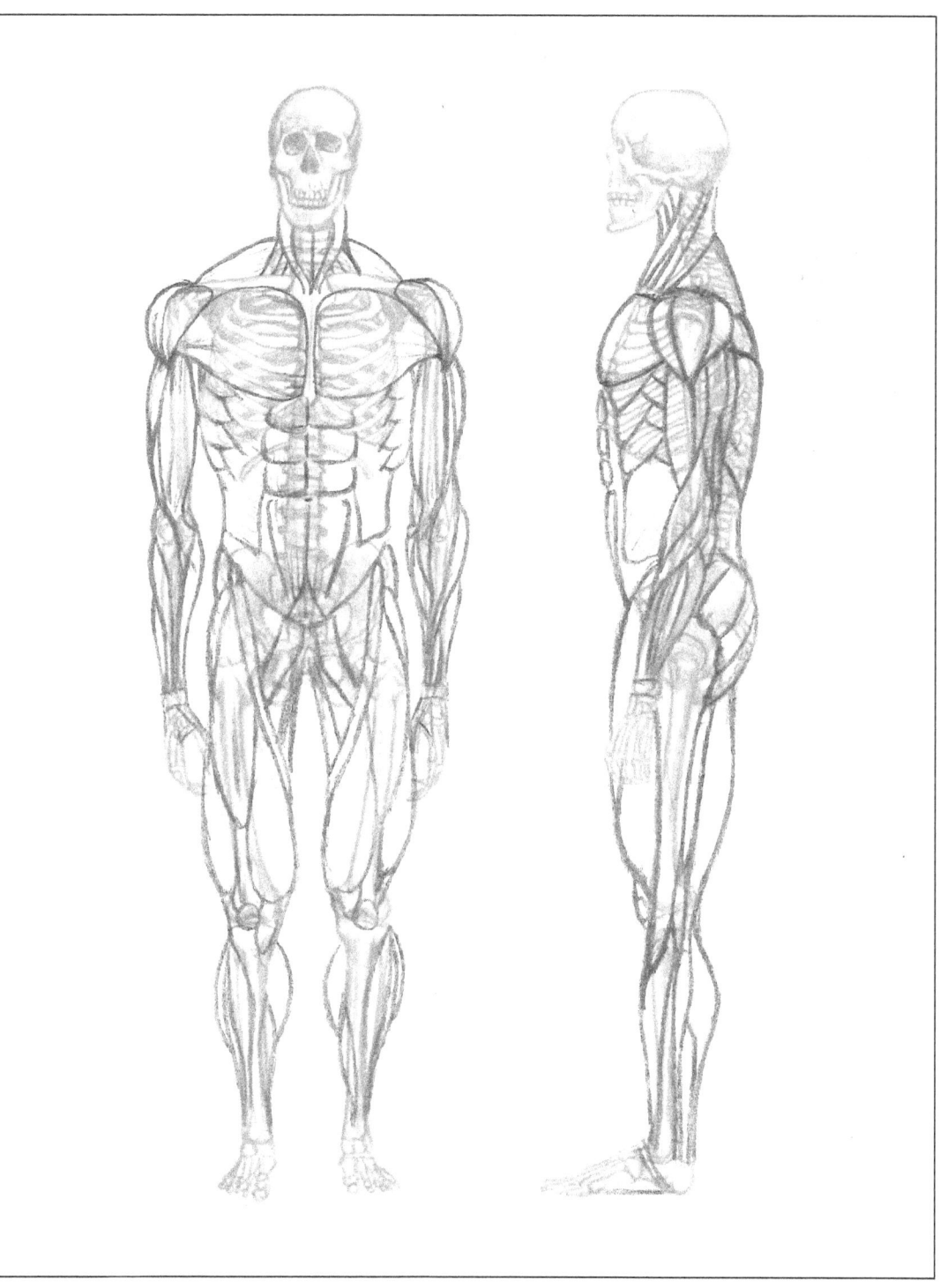

Figure 15-2. Human skeleton with major muscle groups overlaid

Once you're comfortable with the skeletal structure and muscles of humans, turn your research to the wolf.

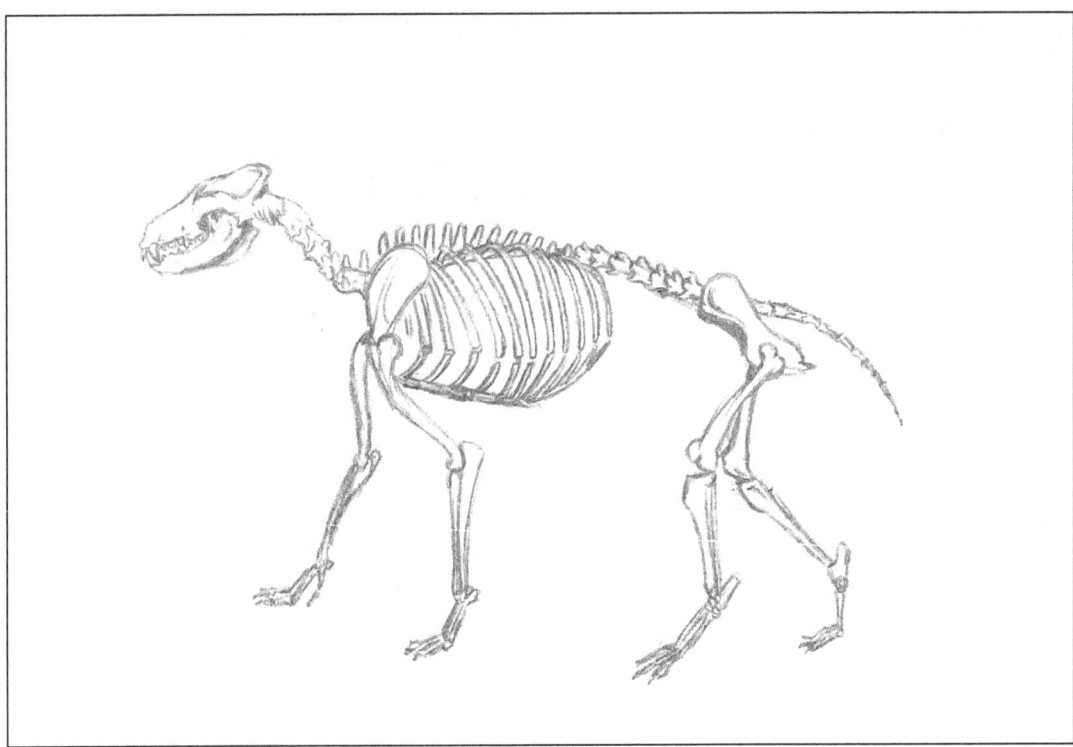

Figure 15-3. Wolf skeleton, final sketch

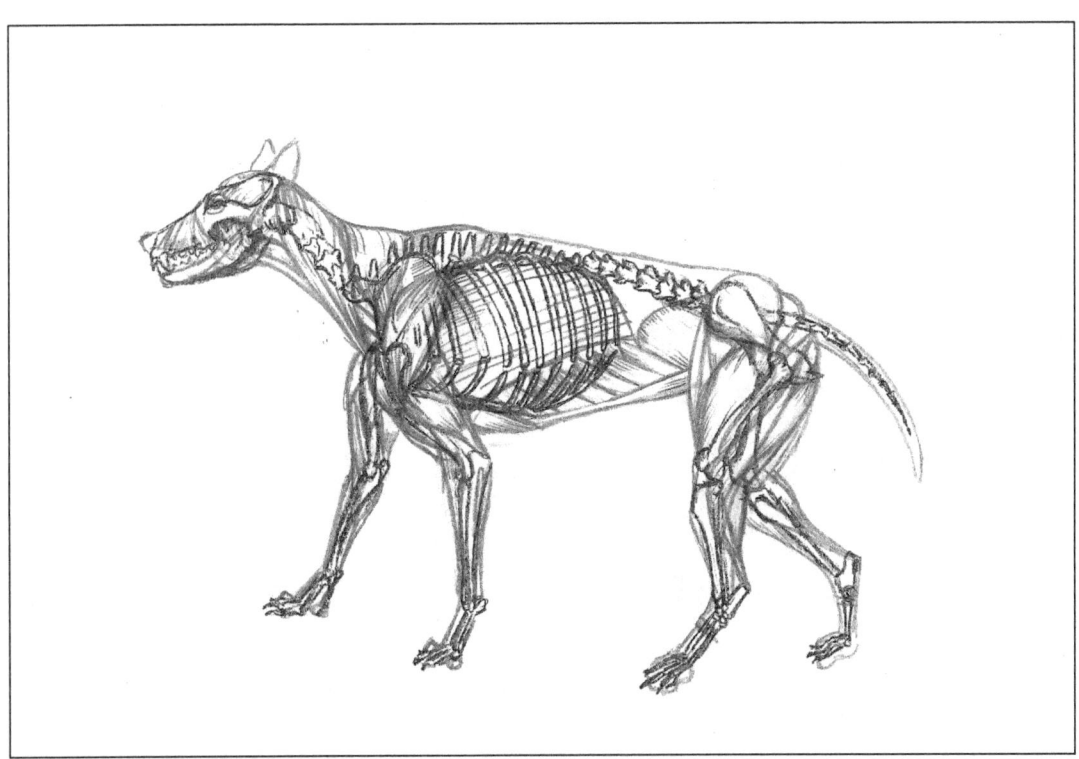

Figure 15-4. Wolf skeleton with muscle overlay, final sketch

It's slightly more difficult to get reference pictures of a wolf skeleton and its muscle structure but it's not impossible. If you can't find helpful reference material for a wolf or if you just want to expand your understanding, you can also look at the skeletons and muscles of other canines, especially the ones that are similar to a wolf in size and shape. From the standpoint of structure and shape, many breeds of dogs are basically just domesticated wolves and can be used for your research too.

Again it's good to make lots of sketches but you don't have to become an expert in canine anatomy. The main goal is to become familiar enough with the skeleton and muscles that you can make accurate wireframe and mass sketches.

Figures 15-3 through 15-9 are examples of study sketches made while studying wolf anatomy and movement patterns.

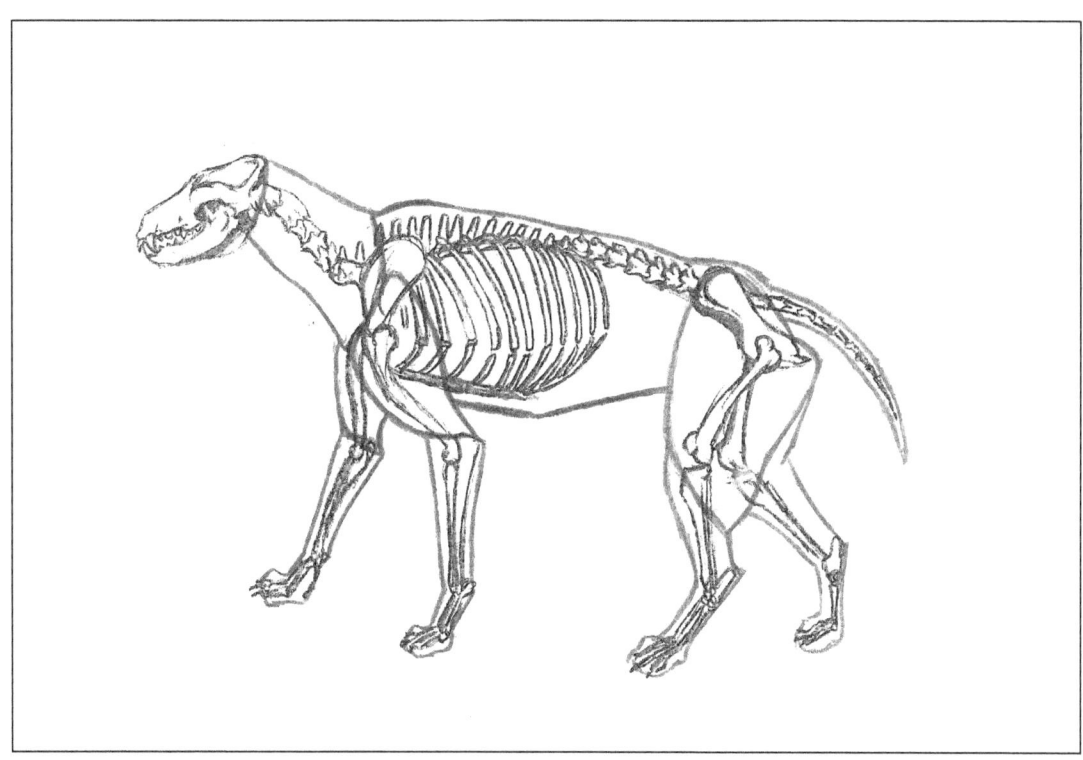

Figure 15-5. Wolf skeleton and muscle group shapes over bones

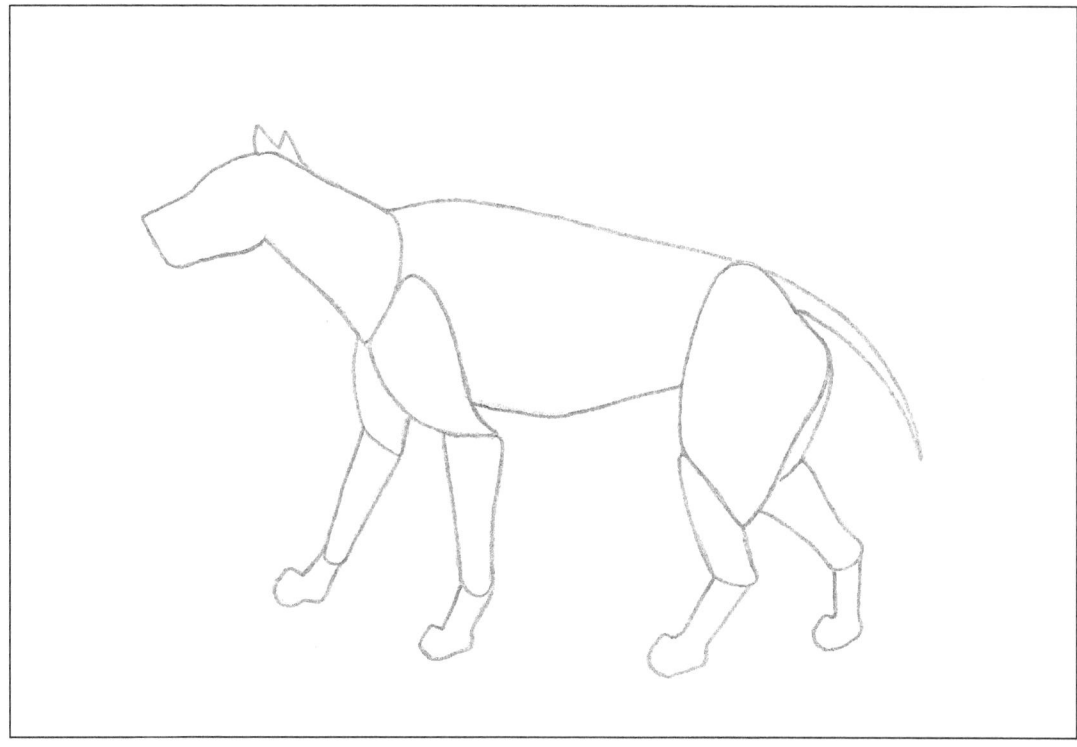

Figure 15-6. Wolf muscle group shapes

Figure 15-7. Wolf wireframe sketch

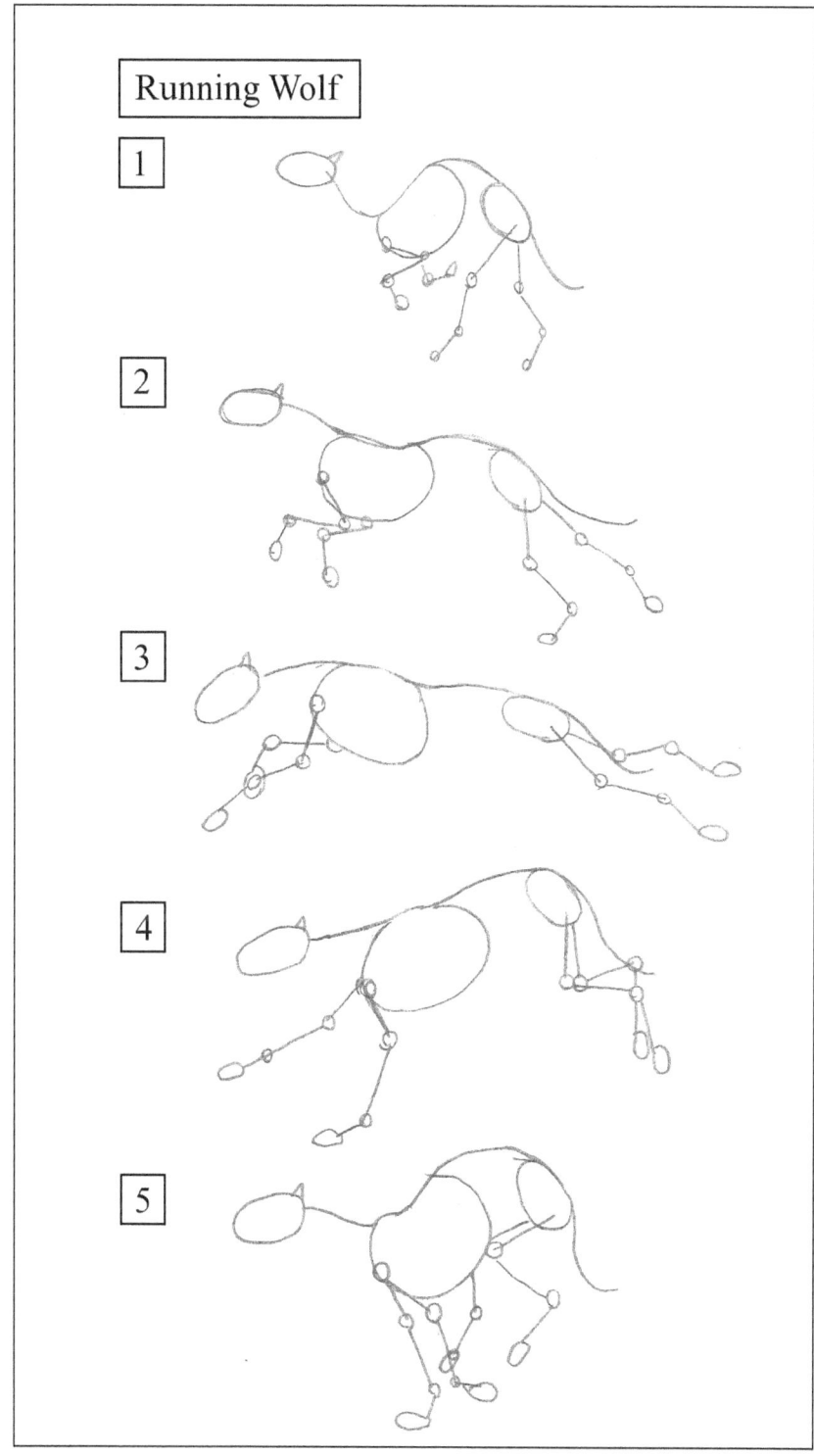

Figure 15-8. Wolf wireframe sketches, running

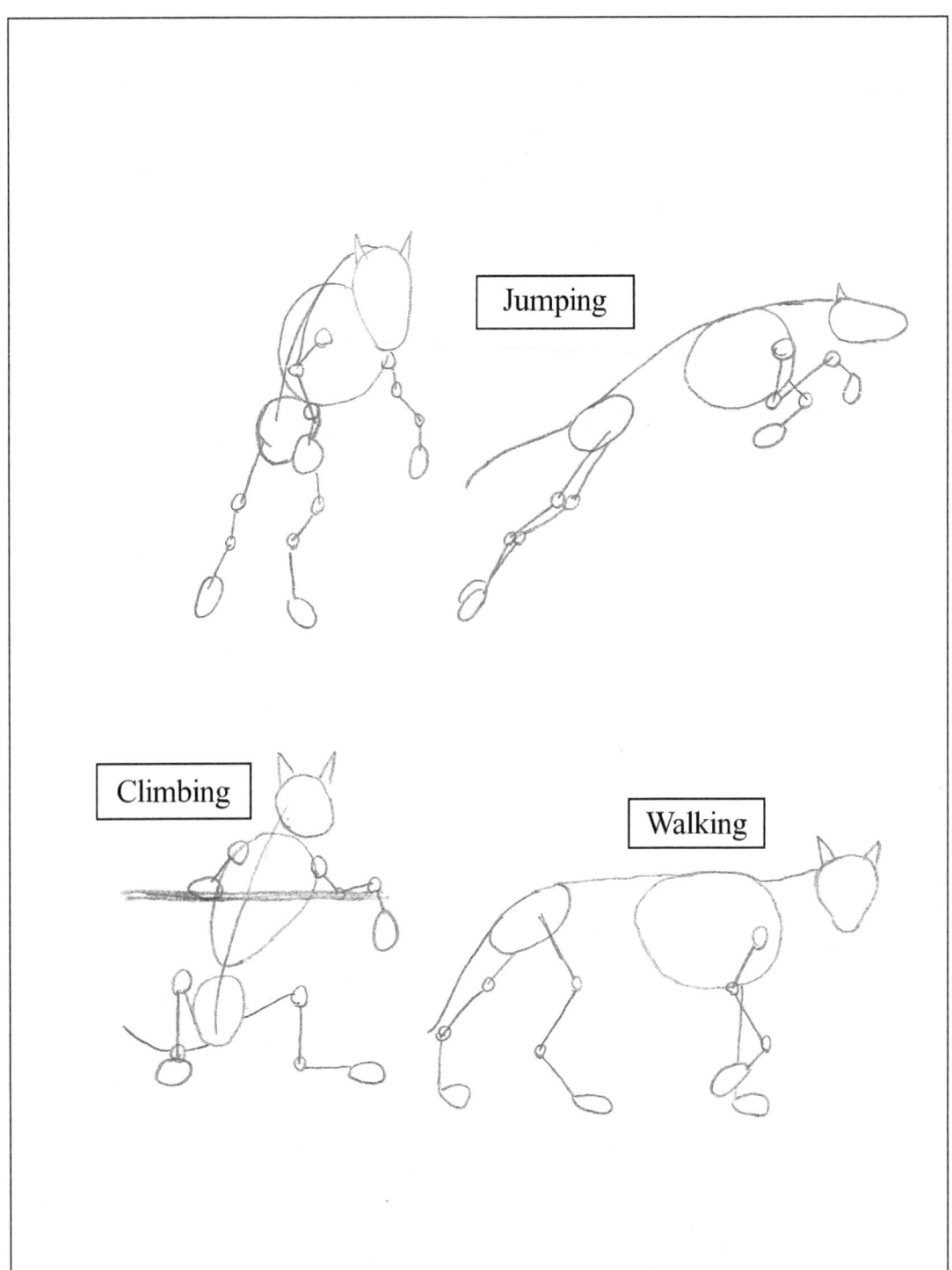

Figure 15-9. Wolf wireframe sketches, wolf in motion

In addition to the basic structure of the wolf it's also important to study and sketch the facial features and fur. Facial features on a wolf act differently than those on a human because of the elongated snout. Sketch the face at several different angles and notice how the perceived length of the snout changes. You will see that when looked at in a full frontal view the snout looks shorter than when viewed from the side.

Fur can be challenging to draw well. Taking time to practice before starting a final drawing will pay off in the end. Drawing fur generally requires combining several techniques including hatching, smudging, and erasing. Combining these techniques in varying degrees will create texture, depth of tone, and the necessary highlights to make the fur look good. Developing your technique will take time and practice.

While drawing facial features and fur from reference pictures you may notice many different colors and patterns. You may want to use some of these patterns later in your own drawing.

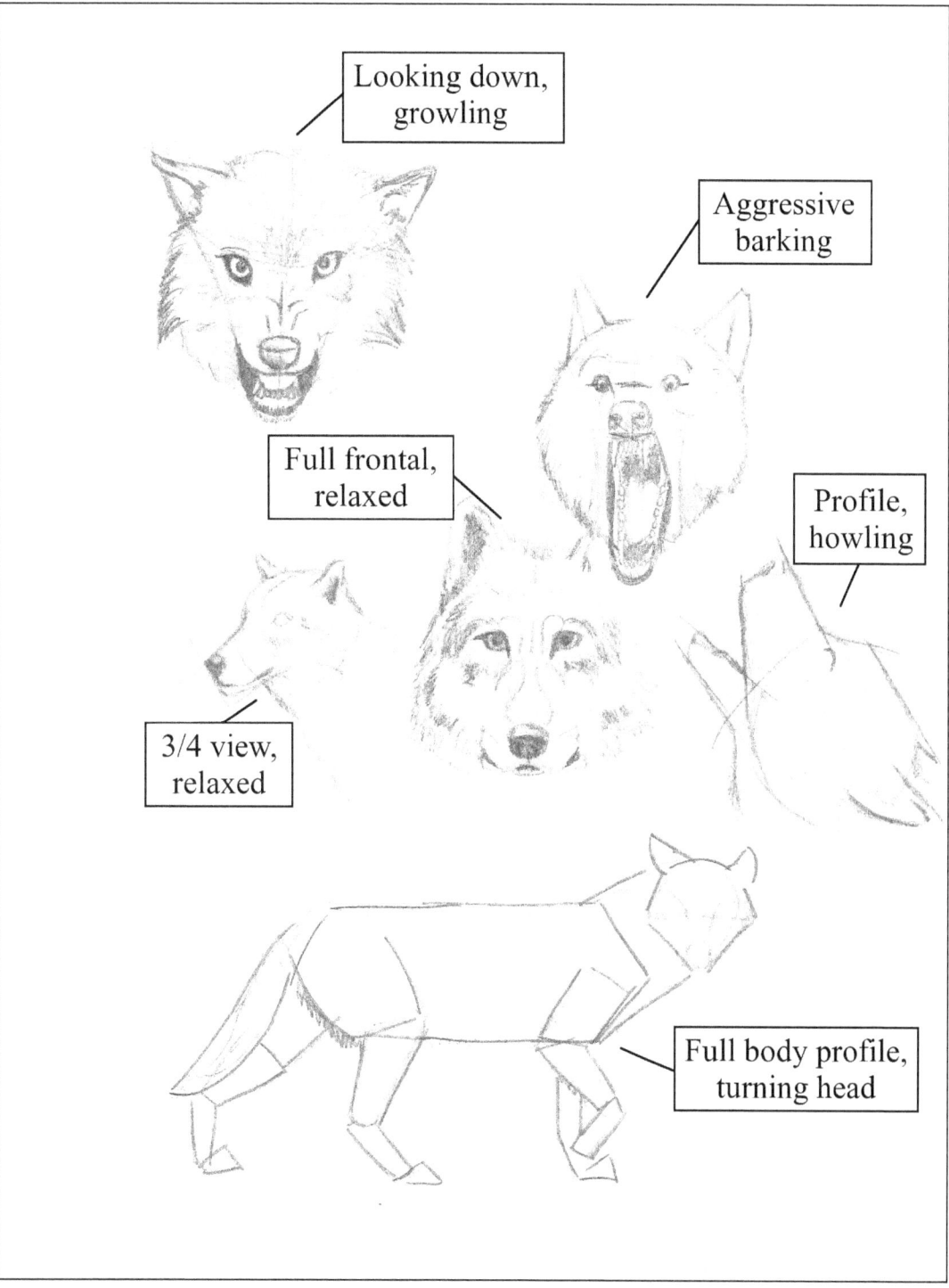

Figure 15-10. Wolf faces from different angles, and fur

In studying the human versus wolf skeletons it's easy to see that there are some major skeletal differences. These differences are mainly due to the upright walking posture of humans versus the four-legged posture of a wolf.

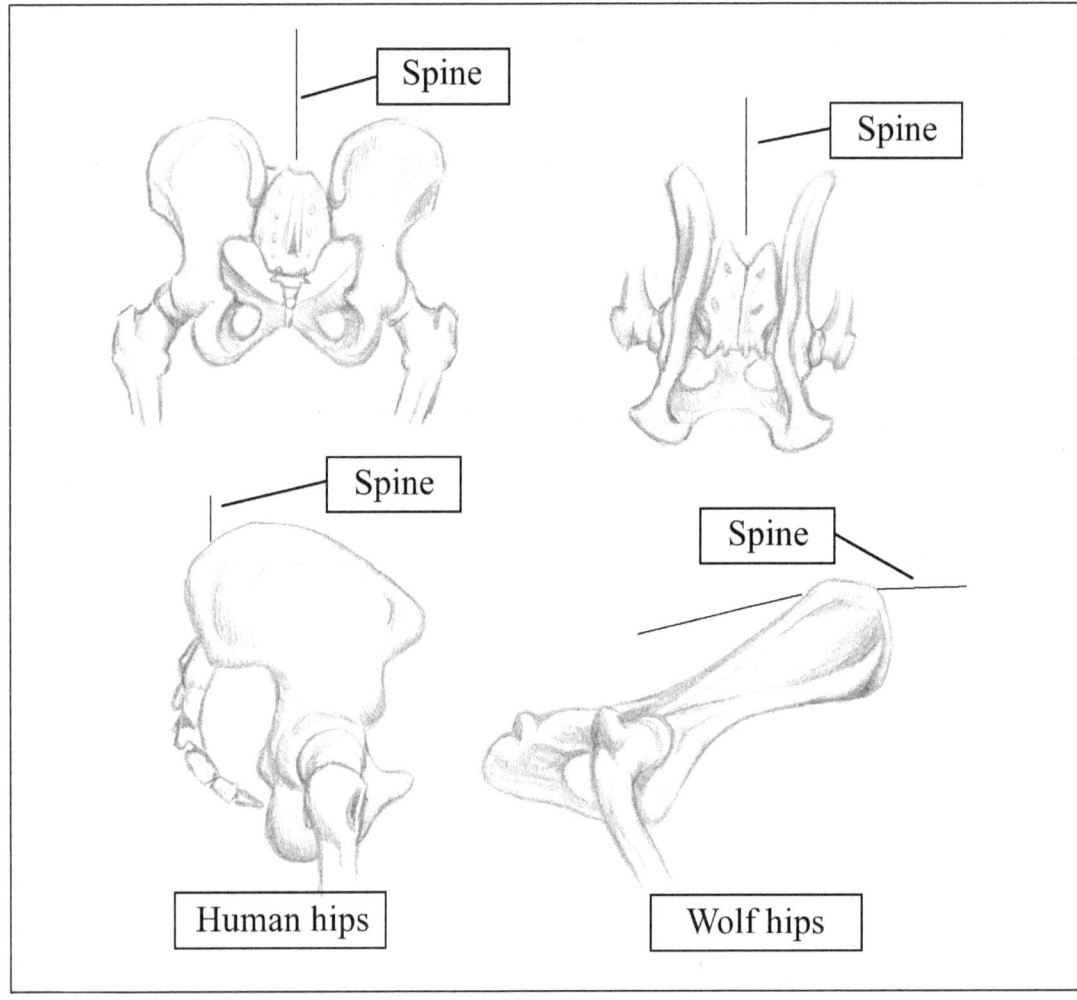

Figure 15-11. Human vs. wolf, hip bone

The different methods of walking influence the structure of the hips and shoulders more than anything else but there are also significant structural differences in the skull. These are not the only differences of course; a human's hands and feet are significantly different from a wolf's paws. The number and shape of the bones between a human hand and a wolf's paw are similar but the layout and overall function of the bones are quite different. The rib cages between the two are almost opposite. A human's chest is broad and shallow compared to the wolf's which is much narrower and quite deep. Again, this difference helps facilitate the movement of the arms or forelimbs between a human that walks upright and a wolf which walks on four legs.

Study and sketch some of the specific skeletal differences. Try to understand the reasons these differences may exist in terms of how the animal moves. This will help you be able to transfer the structural characteristics you like most, whether you prefer an upright posture or lean towards a four-legged stance.

Figures 15-11 through 15-13 illustrate some of the major skeletal differences between a human and a wolf. These differences have some of the greatest potential to influence the final form and structure of the werewolf so becoming familiar with them is important.

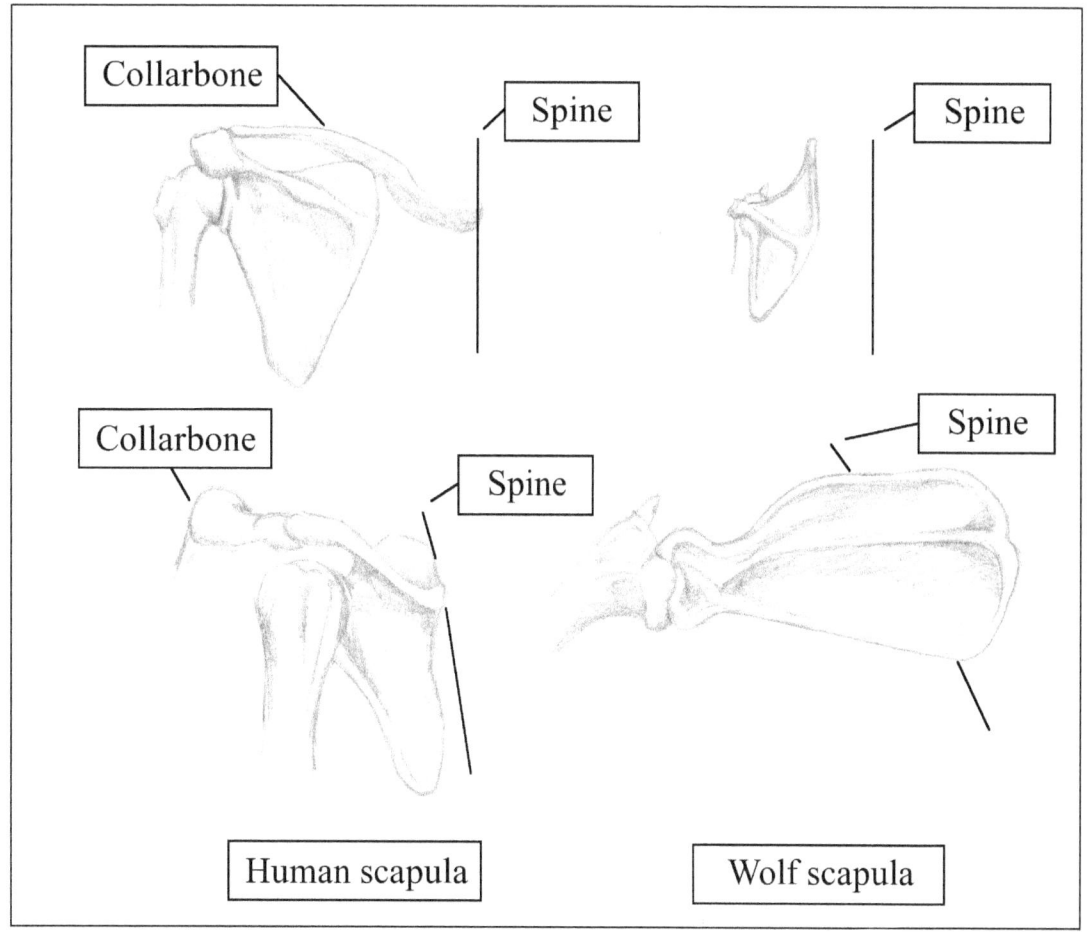

Figure 15-12. Human vs. wolf, scapula

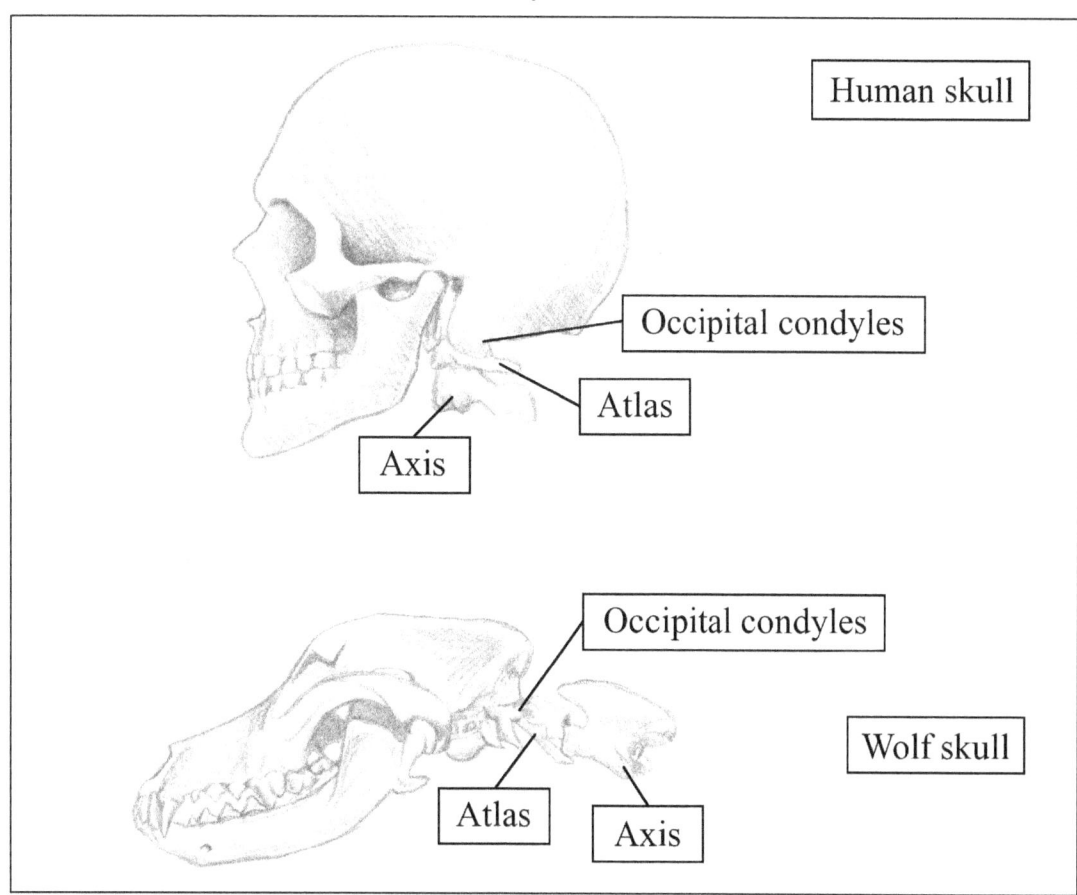

Figure 15-13. Human vs. wolf, skull and neck

Having taken the time to become familiar with the basic structure of both humans and wolves you can now easily piece together your own version of a werewolf. You may have something in mind already but if you don't, just experiment with different stances using wireframes until you're satisfied with the results.

Starting from either a wolf or a human wireframe you can make small adjustments until you get to a form you like. Once you've developed a wireframe you like, you can begin adding mass and basic muscle structures. These exercises are all just research and preparation, there's no correct way to come to a final werewolf design. You might even change your design as your style, opinion, or perception of a werewolf changes over time.

Figures 15-14 through 15-17 illustrate one possibility of what a final wireframe and mass model of a werewolf could look like.

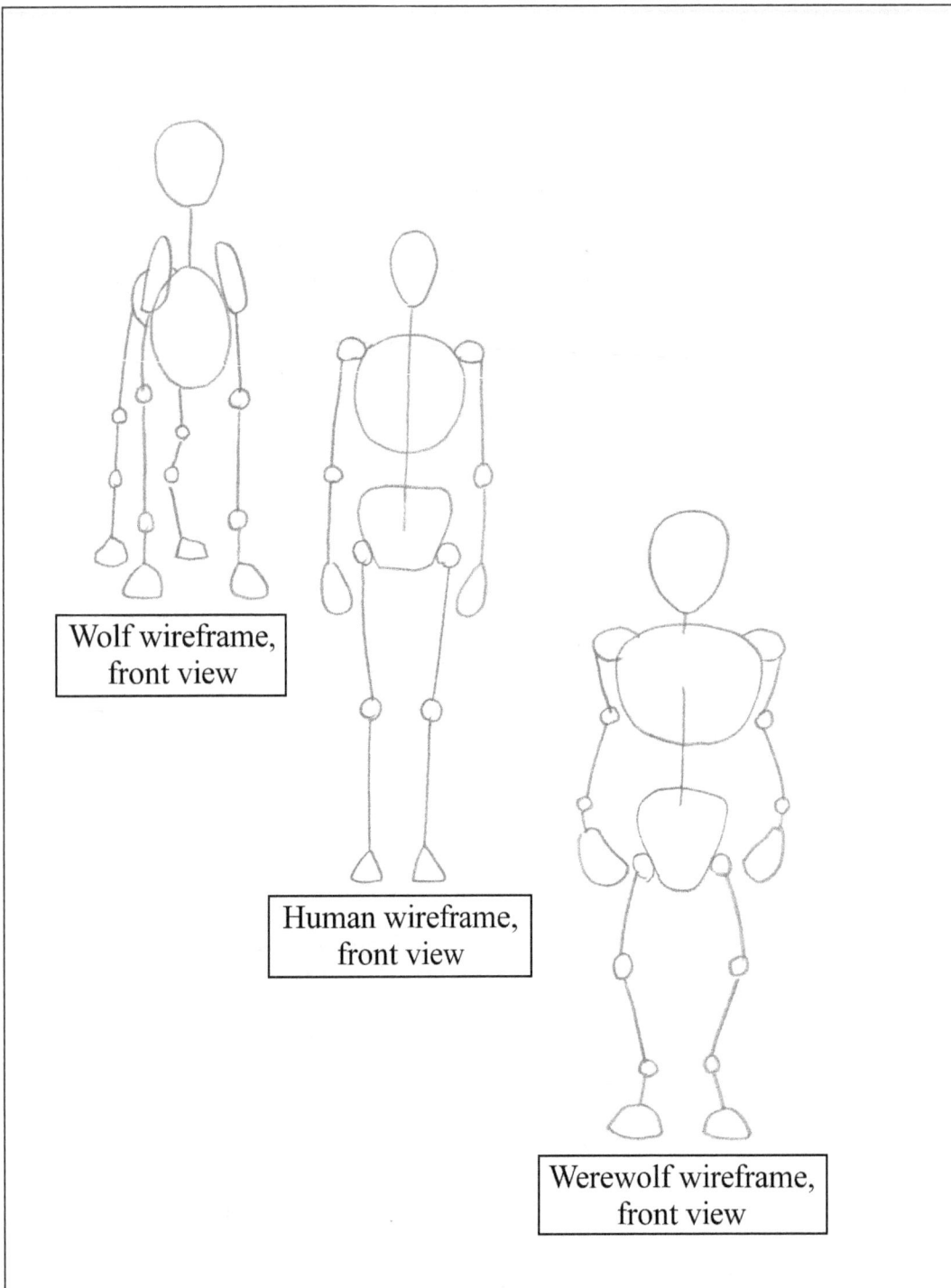

Figure 15-14. Wolf vs. human vs. werewolf wireframe, front view

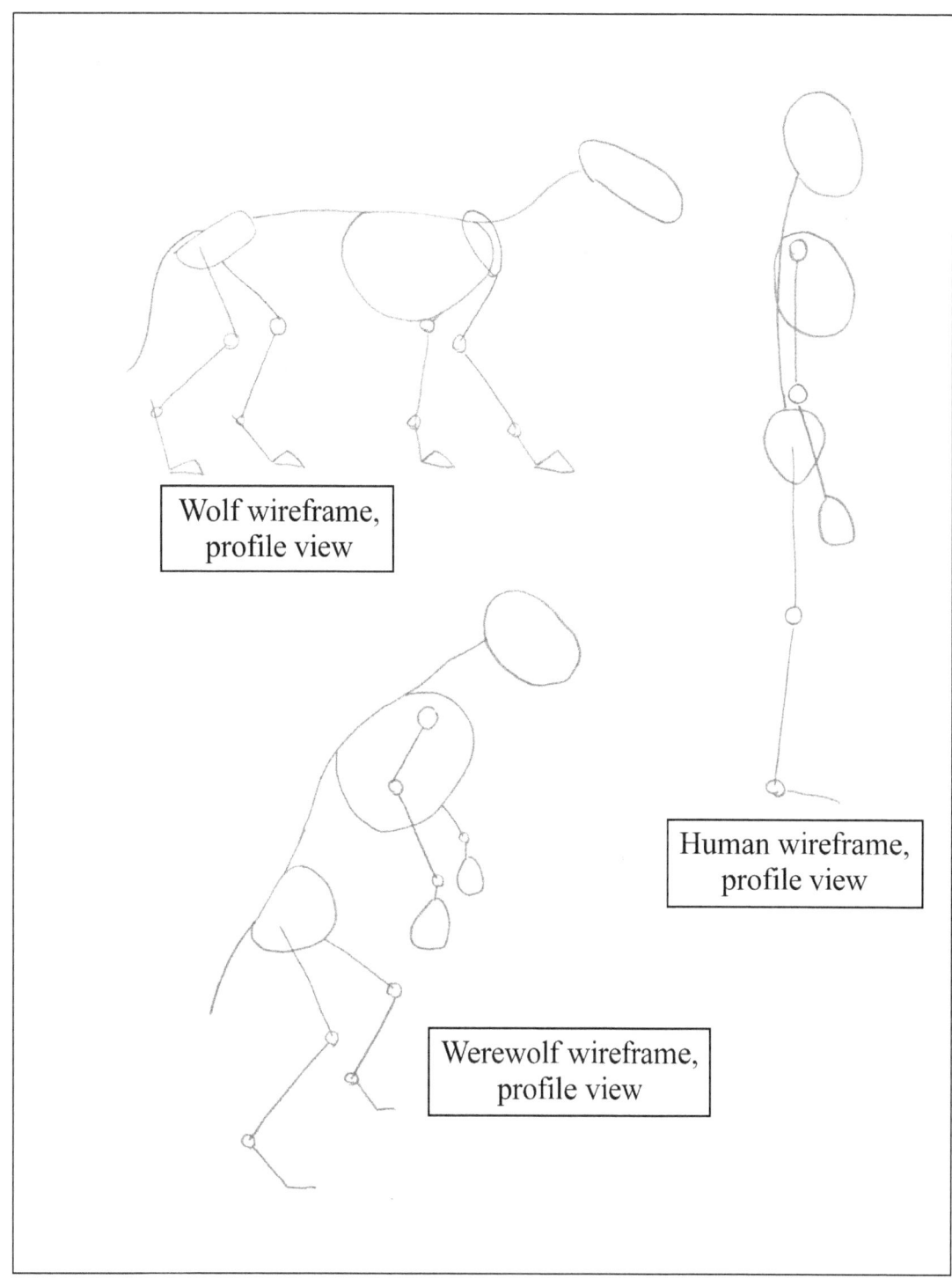

Figure 15-15. Wolf vs. human vs. werewolf wireframe, profile view

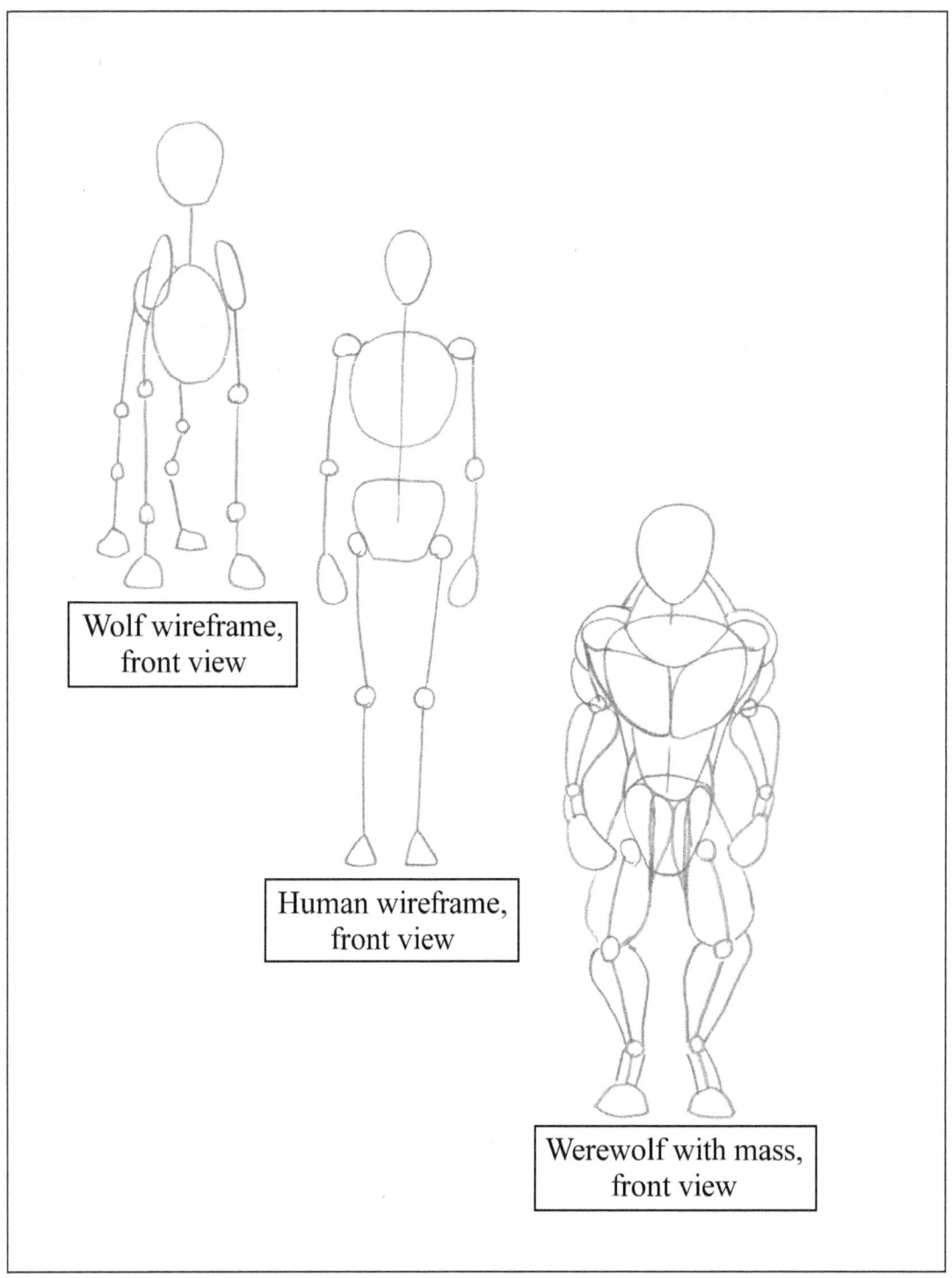

Figure 15-16. Wolf vs. human vs. werewolf, werewolf with mass, front view

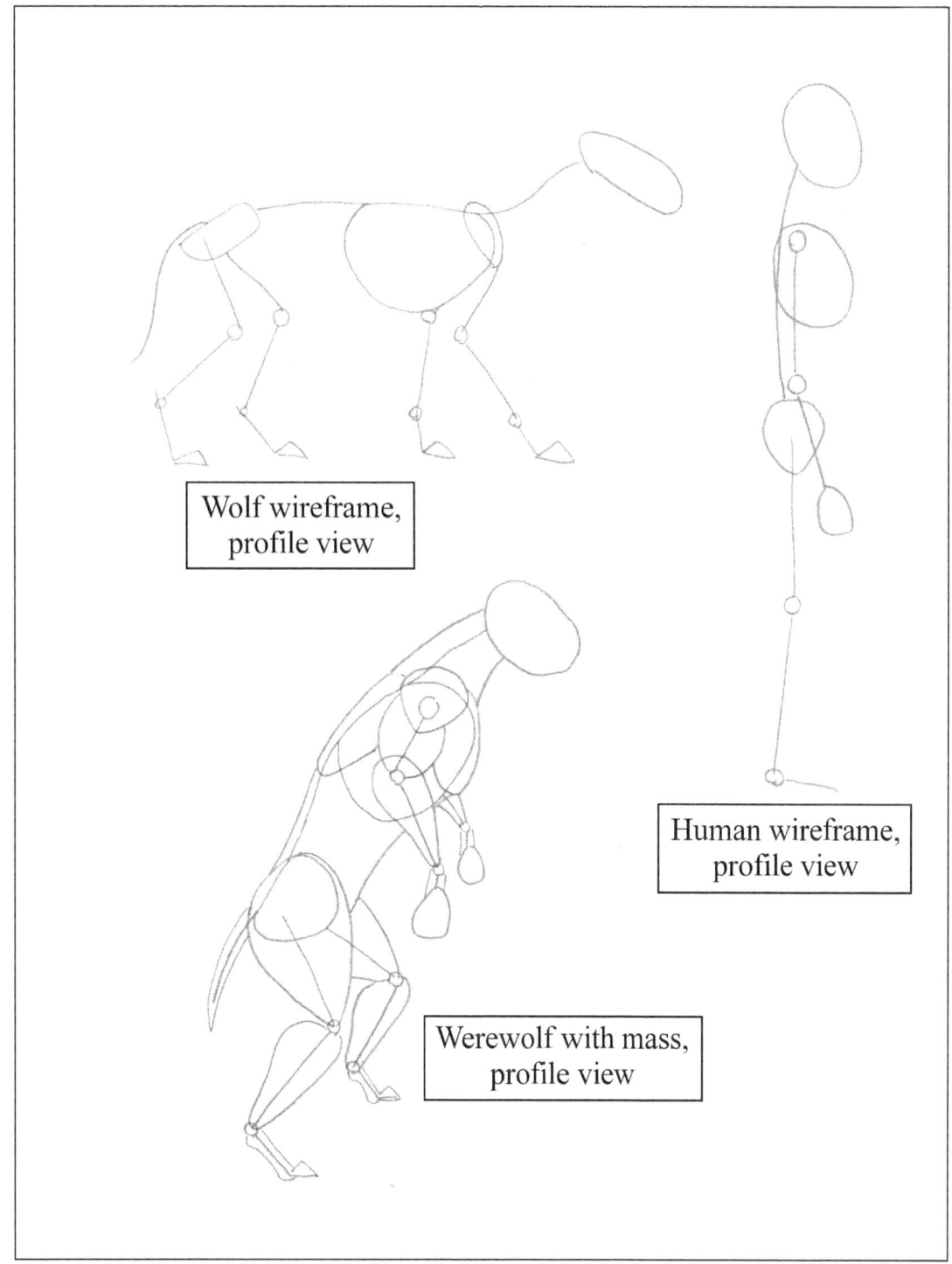

Figure 15-17. Wolf vs. human vs. werewolf, werewolf with mass, profile view

Researching a topic can take a significant amount of time. Depending on your skill level and knowledge of the subject this research can take a day, or maybe even a couple months. Take your time to research the subject well. Review the drawings in this book as well as pictures and drawings you find from other sources. Sketch everything you study until you become familiar enough with the subject that you can draw it accurately without looking much at your reference pictures.

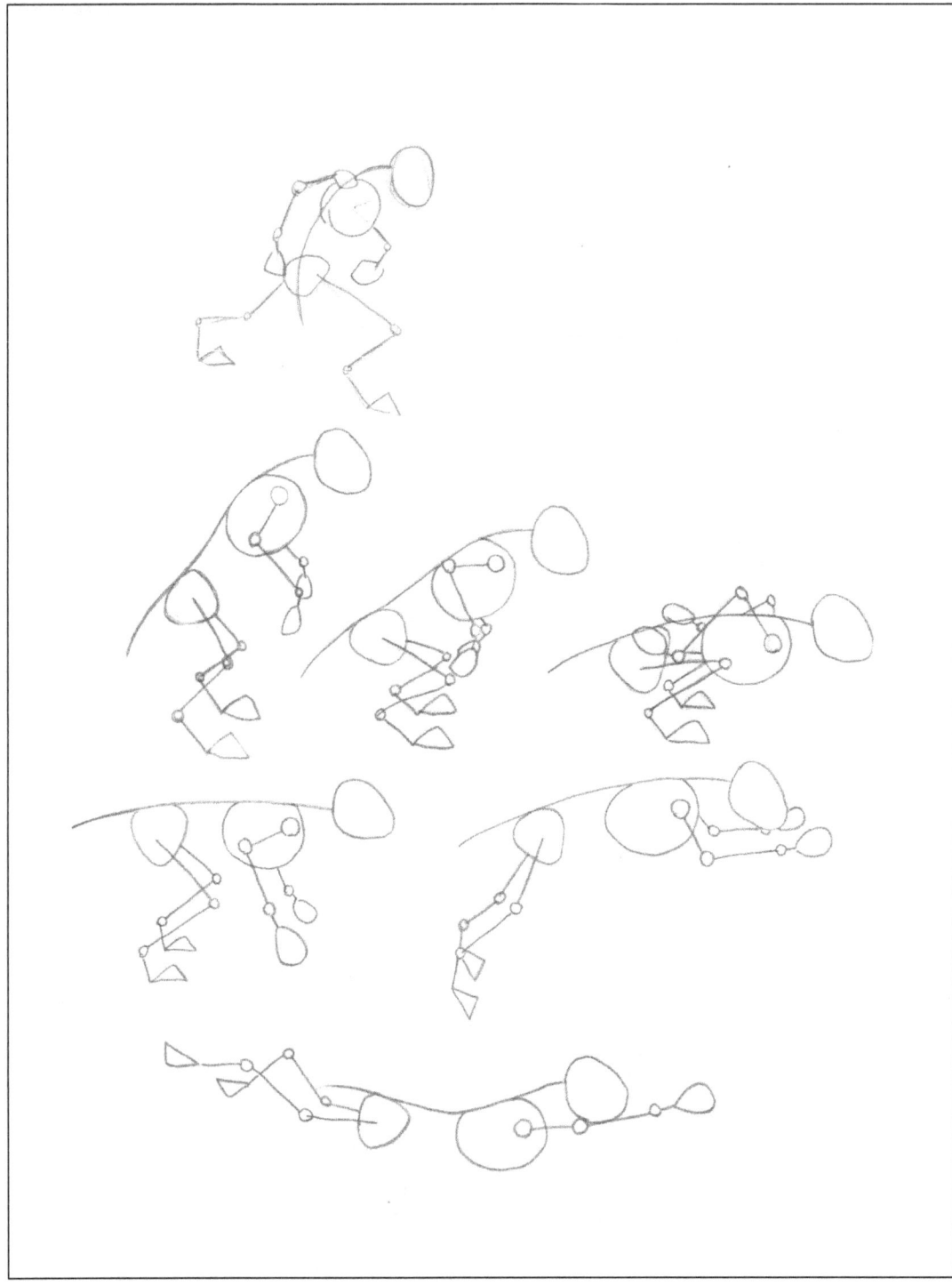

Figure 15-18. Werewolf wireframe stances I

Once you feel comfortable with your knowledge of the subject and your ability to draw it, it's time to begin brainstorming the final drawing.

The fastest way to brainstorm is sketching. Sketching allows you to produce many ideas in a short amount of time. In this example, the werewolf wireframe that was developed previously was used to generate several stances and poses that could be used for a final drawing. These wireframe sketches were completed in just a few minutes and provide an idea of what poses are possible.

As discussed in Volume 14, exaggeration is a technique that can greatly enhance a fantasy drawing. This drawing is meant to be fairly dynamic which means many of the sketches are meant to explore the extreme limits of body position and movement. Wide or very low stances, extreme arm positions and trunk rotations, all contribute to showing either great force behind a movement or a massive amount of potential energy ready to be released.

As you sketch wireframes, try to make each one more extreme until you find its maximum power limit. You'll know when you've crossed that limit because the sketched figure will look off balance or the position would be so awkward that movement out of the position would be difficult or weak.

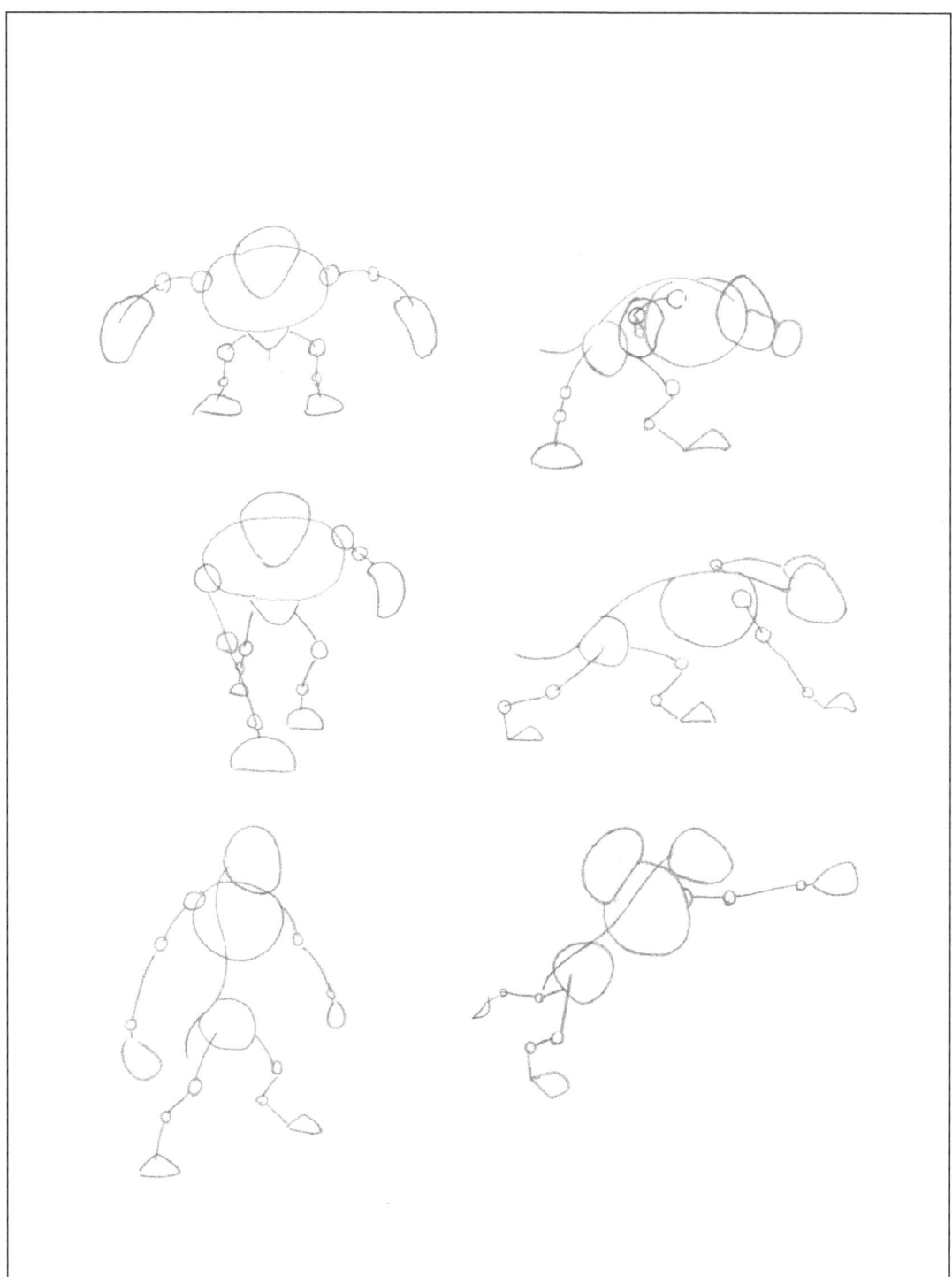

Figure 15-19. Werewolf wireframe stances II

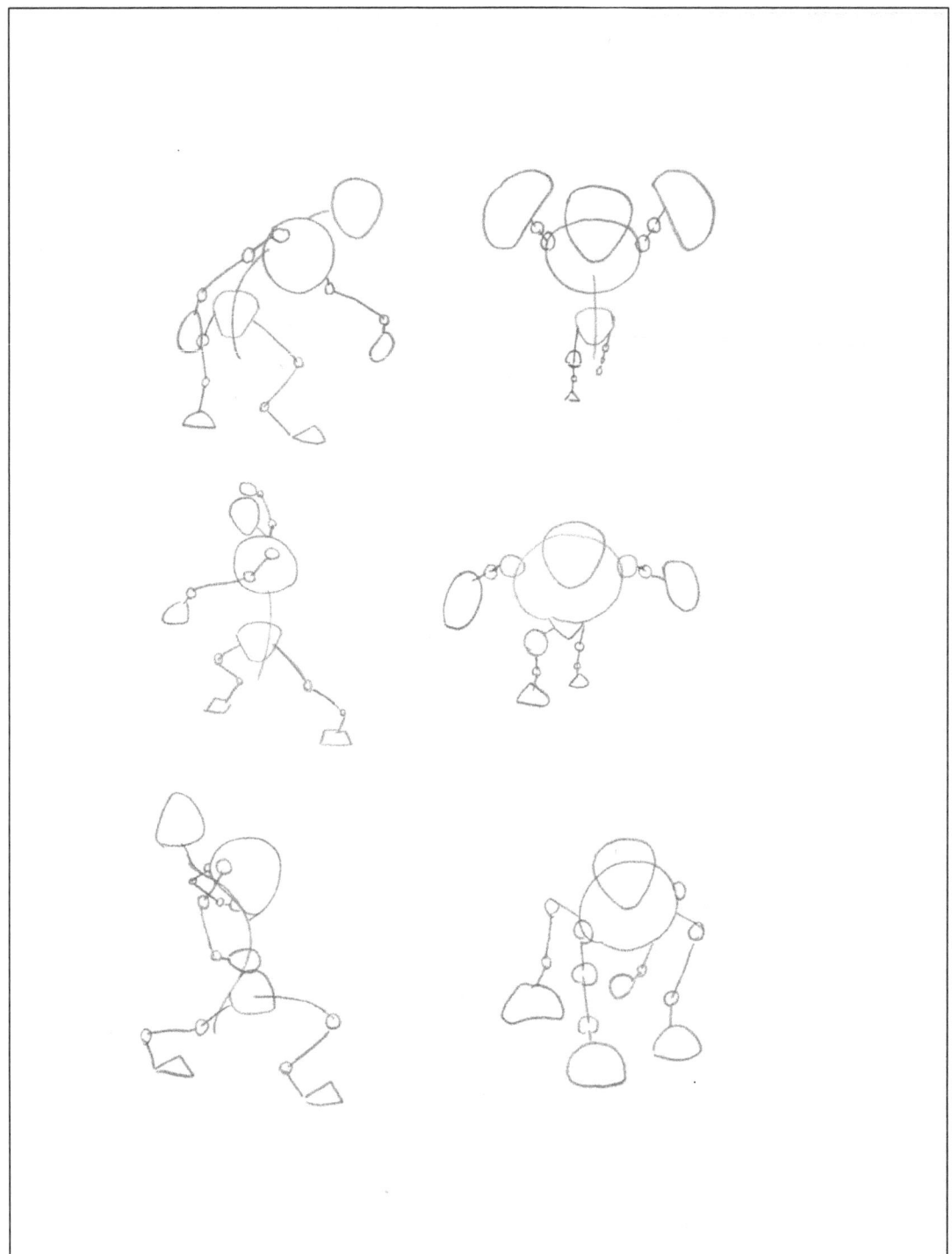

Figure 15-20. Werewolf wireframe stances III

Foreshortening

Foreshortening is the effect in which objects or those parts of an object closest to the viewer's eye appear to be larger than those parts which are farthest away. Foreshortening follows the rules of perspective (See Volume 3 for an in-depth discussion of perspective) and technically must always be shown, however, in a fantasy drawing like the one in this lesson, we take it to a more extreme level to create dramatic emphasis.

Look at Figure 15-20 above; the final drawing in this lesson most resembles the top two wireframes in the right column. These wireframes depict a motion that is similar to a lunge or the beginning of a grabbing jump. As you can see from the sketches, the hands are large compared to the other areas of the body and the feet appear to be

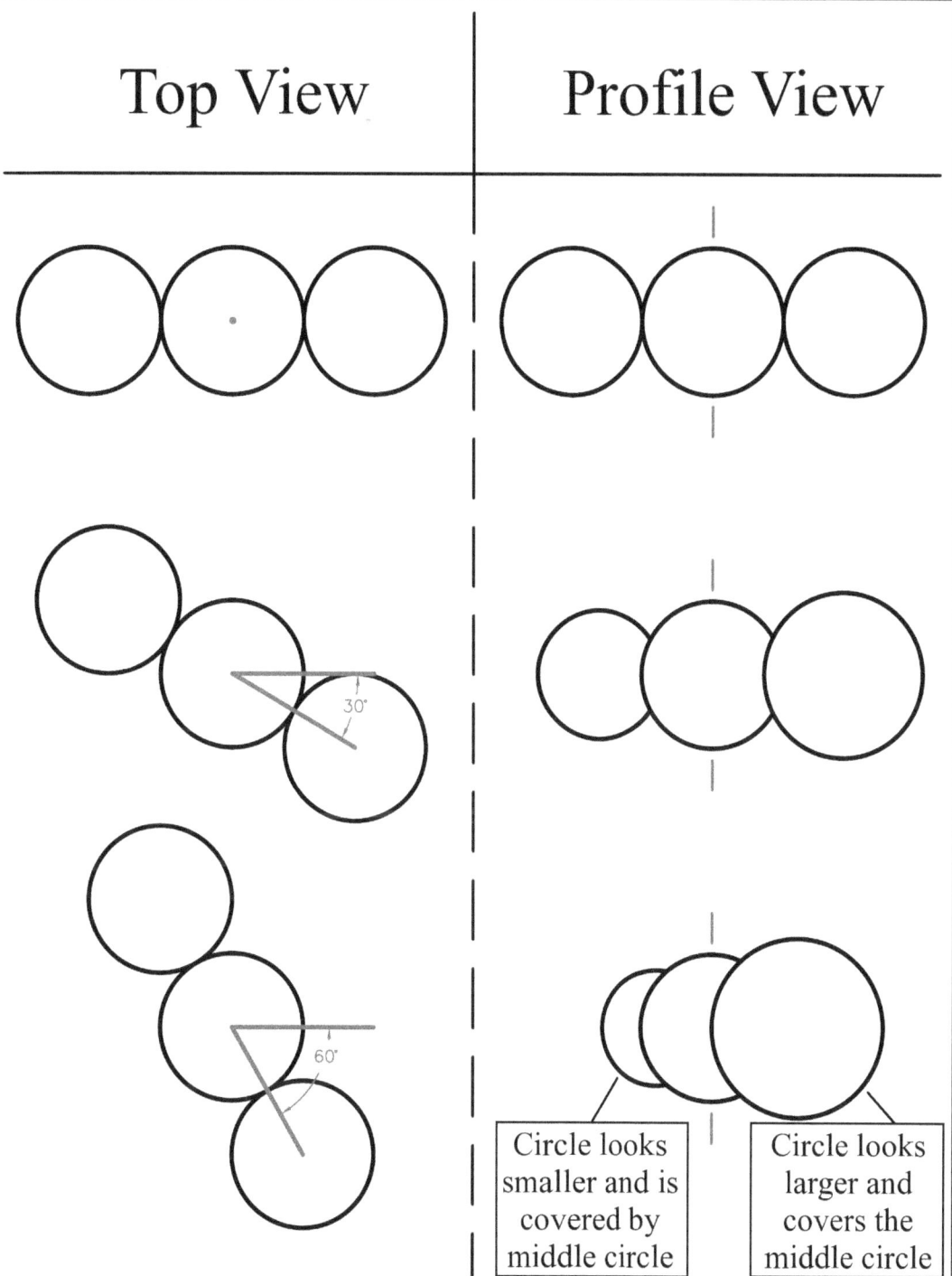

Figure 15-21. Foreshortening example, top and profile view

very small. This is due to the effect of foreshortening.

Figure 15-21 is an example of how foreshortening works. In this example, three circles are used to illustrate this effect. The left column shows the circles as if looking down on them from above, the right column shows the circles as if they were parallel to the viewer's eye. You can see from this example that as the circles rotate around the center point, the circle closest to the viewer appears larger while the circle farthest from the viewer appears smaller. This is only an optical illusion as all the circles in reality would actually be the same size.

In addition to the circles appearing to change size, they also appear to cover each other more the farther back they are, relative to each other. Look at the circles in the right column rotated sixty degrees. The circle on the left is farthest back from the viewer and appears to be more fully covered than the circle in the middle which is covered by the circle on the right. You can test this yourself with objects you have at home.

The reason circles were used in this example is because bodies have many curves. The circles demonstrate what happens when one curved object covers a second curved object. If you can imagine the three circles as a fist, a forearm, and an upper arm, then you can get a feel for what it might look like when looking down an outstretched arm. The fist will cover some of the forearm and the forearm will cover some of the upper arm. This effect should be applied to any part of the body that covers another because it's closer to the viewer's eye. It can be applied realistically or be exaggerated to create emphasis.

Foreshortening is a skill that can require a lot of time and practice to do well. Exaggerating can actually be beneficial as you learn to use it. Practice this technique with simple shapes before moving on to body parts.

Step by Step Exercise

Having researched the subject extensively you should feel confident about starting a final drawing. Feel free to follow the example in this lesson, or just follow the steps as you develop your own drawing.

Step 1.

The first thing to do is construct a wireframe of the body. A basic stance was chosen during the sketching stage so this is pretty straightforward; the selected wireframe just needs to be drawn larger and near the center of the paper.

Notice in Figure 15-22 how foreshortening is already being taken into account. The circles for the hands are the largest part of the wireframe because they're reaching forward toward the viewer. Next, the head, chest, and hips appear to be very close together. This is because the torso is leaning forward which decreases the appearance of its overall length, similar to how the three circles rotated sixty degrees in Figure 15-21 don't appear to be as wide as the three circles that aren't rotated.

The wireframe is slightly modified to help maintain understanding of how the foreshortening is working. Instead of using the standard straight lines to connect the joints, two lines in a tapering "V" are used. The "V" tapers to a point as the limb moves farther away from the viewer and widens as the limb gets closer. This is a good technique to use to help avoid confusion as you do your layout.

Figure 15-22. Wireframe model of the werewolf

The hands are closest to the viewer which is why they look so large compared to the body.

The body is leaning forward which is why the head is so far down on the chest and the chest so close to the hips. This is foreshortening in action.

Step 2.

After drawing a wireframe you can begin adding mass to it. There are several ways you can do this. The most simple but least accurate way is by drawing ellipses over each segment of each limb. Another option is to draw the shape of each muscle group over each segment of each limb. The last and most time consuming way is to lightly draw each major muscle in its correct location.

In Figure 15-23, the second option for adding mass was used. The shapes of the major muscle groups were lightly drawn over each segment of each limb. The chest area was expanded slightly to add the mass of the pectoral muscles connecting to the arms under the shoulders. The abdominal wall was added covering a portion of the hips. Finally, the lower jaw was added to the head.

To finish the basic mass outline, the last joint or tip of each finger was sketched around the ellipse-hand of the wireframe. Thumbs and the pads of the palms were also sketched.

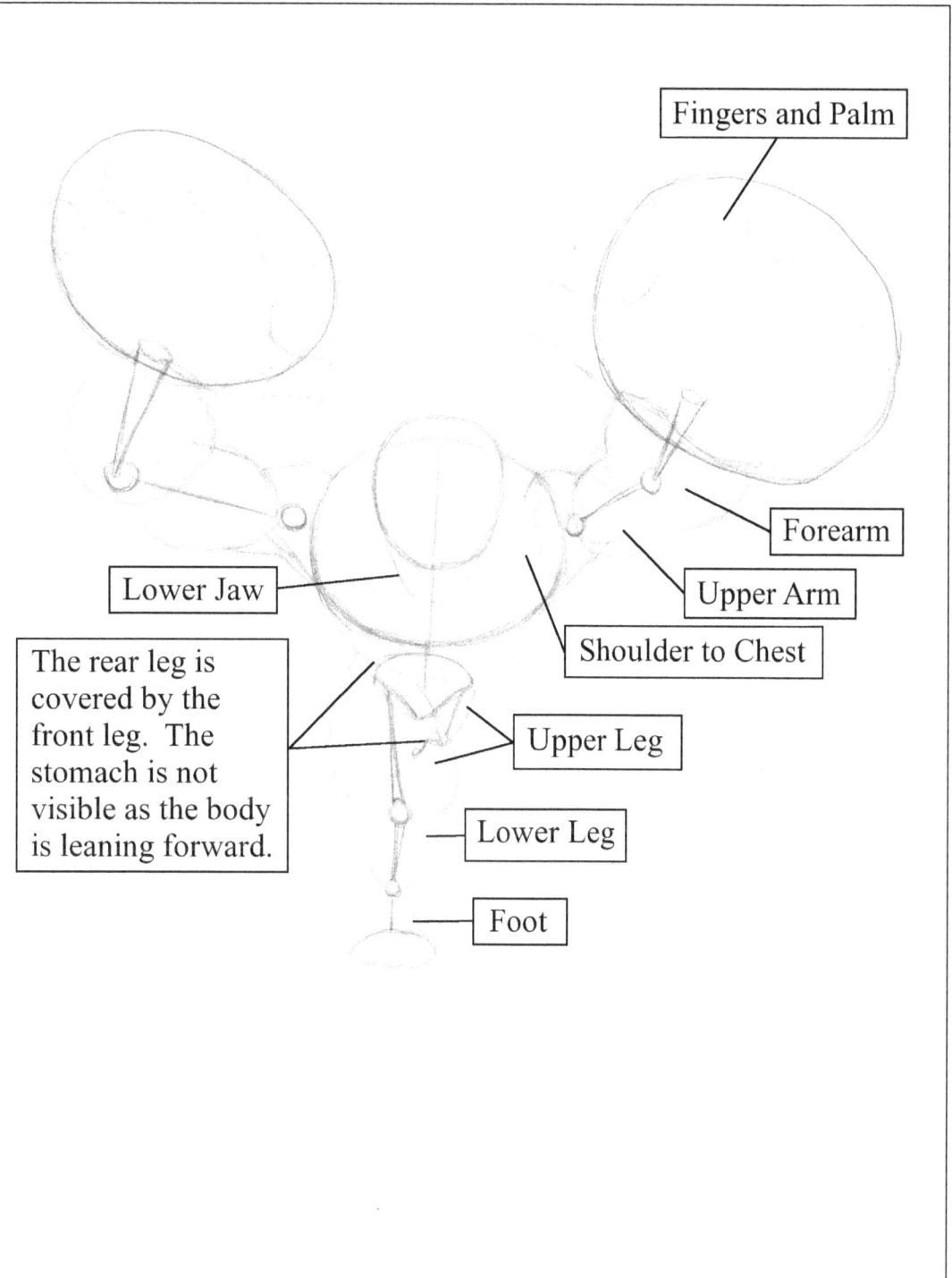

Figure 15-23. Basic mass over wireframe

47

Step 3.

After the initial mass of the werewolf is sketched over the wireframe, refine the musculature of the arms and legs. Only the most prominent muscles need to be added and they don't have to be extremely detailed. Biceps and triceps are the major upper arm muscles and there are a few prominent muscles in the forearm. The most noticeable muscles in the legs are the quadriceps. The pectorals in the chest and deltoids in the shoulders are the main muscles in the upper torso. The top of the abdominals are also visible.

Next, refine the fingers. Notice how the fingers appear to be very short. This again is due to the effect of foreshortening. Several of the fingers are pointing more or less directly at the viewer; this can cause the fingertips to block the view of the rest of the finger. When refining the fingers, only include those joints that would be visible. If you have a hard time visualizing it, use your own hand as a model. Close one eye and position your hand so that your fingers are slightly curved and the tip of your middle finger is pointed directly at your open eye. Trace around the visible parts of your fingers with your open eye or do a blind contour sketch on a scratch piece of paper as explained in Volume 5. This will help you get a feel for how to draw the fingers on your final drawing. Finally, a claw-like fingernail can be added to the end of each finger.

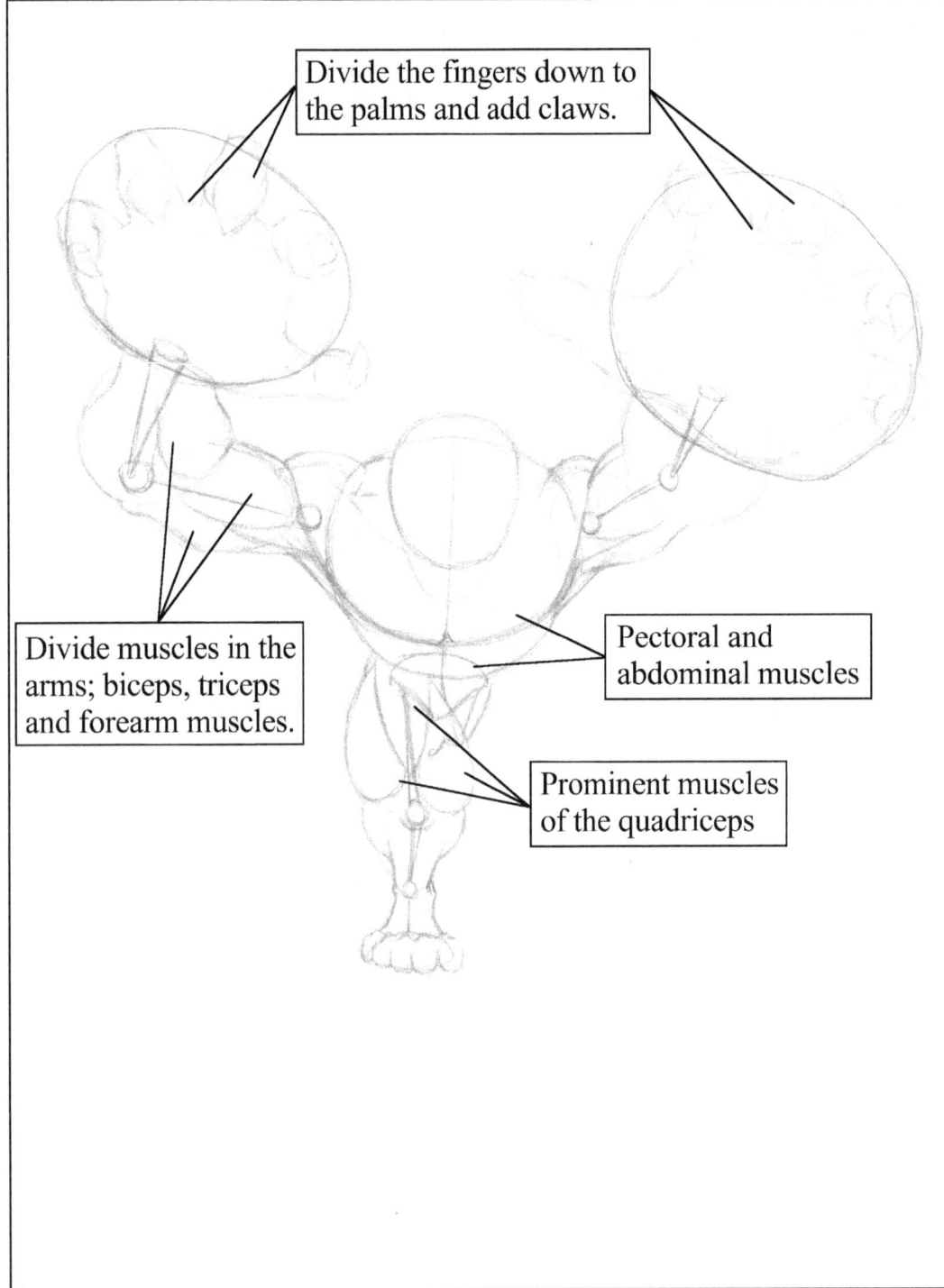

Figure 15-24. Basic mass refined and muscles added

Step 4.

With the mass and musculature completed it's time to clean up the werewolf outline. Erase all the wireframe lines as well as any extra lines left over from developing the musculature.

A kneaded eraser is easier on the paper because it's much less abrasive and should be your first choice when erasing these lines. If you find there's still evidence of the wireframe on your paper you may need to switch to a more aggressive eraser. Increase pressure gradually as you use it so you only do what's necessary to erase the lines.

Retrace and reconnect any of the final lines that may have been erased. Touch up the outline so it's clean but keep the lines light. The purpose of the outline is to guide the placement of shading, highlights, and textures; you don't want to be able to see these lines when the drawing is complete.

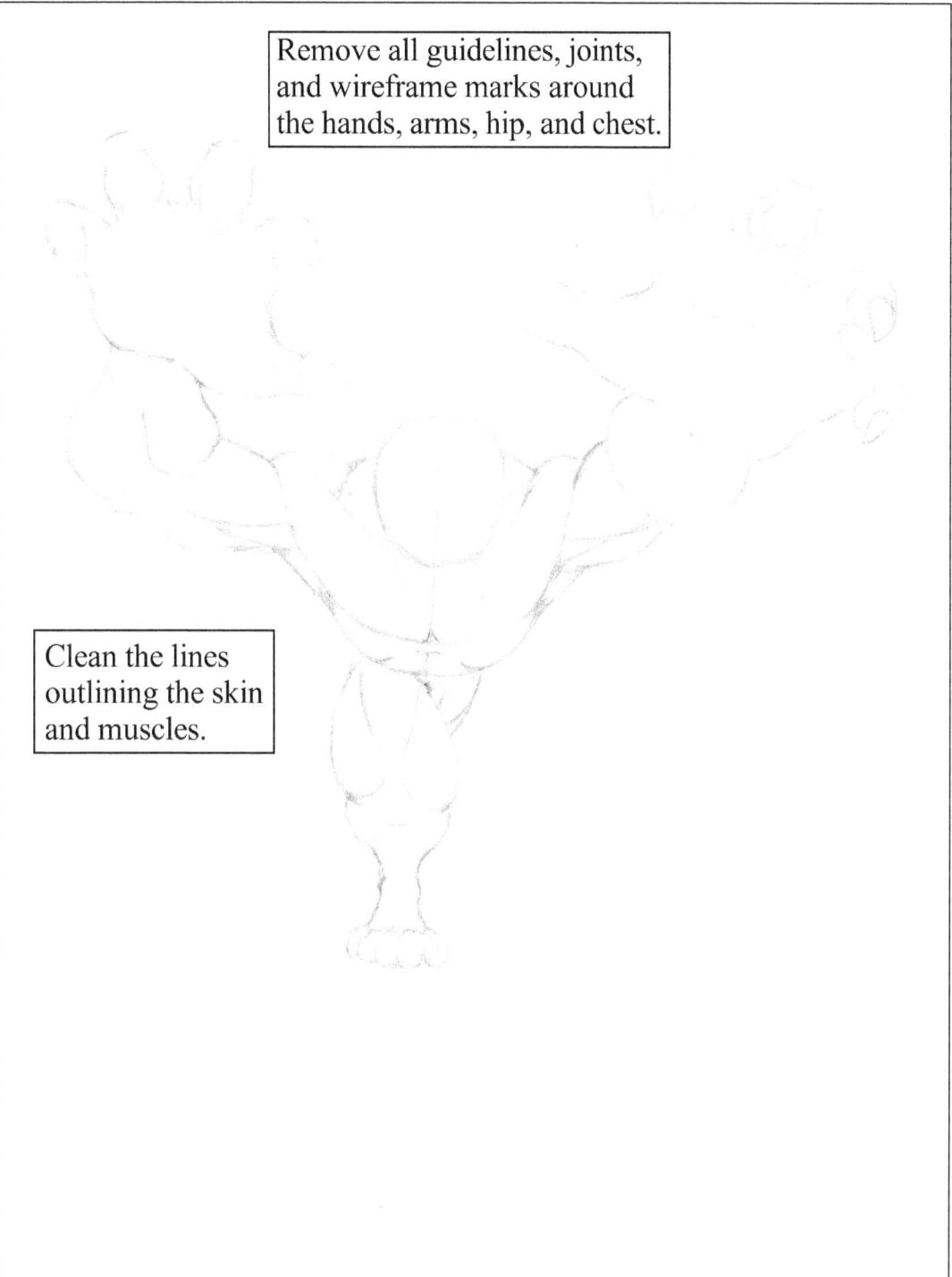

Figure 15-25. Werewolf outline completed and cleaned

Step 5.

To finish the outline of the werewolf, add facial features, fur, and any clothes or accessories you want. If you didn't do so before, or aren't comfortable with this step, use a scratch piece of paper to sketch these features before drawing them on the final copy. Adding these smaller details can be time consuming and frustrating if you're unsure of what features you want in your final outline. Take the extra time to do this step right because if you're unhappy with your final outline you probably won't be very satisfied with the finished drawing either.

The fur outline shown in Figure 15-26 was done using random hatching around the edges of the limbs and some of the muscle lines. The fur doesn't have to be the same length everywhere; it can be longer in some places and shorter in others. Add the fur lightly and erase some of the smooth lines it is replacing.

Fur on the arms is generally directed down towards the fingers and away from the body. Fur on the torso and legs should be directed down the body toward the feet. Remember to take the pull of gravity and the direction of any wind into account and draw the hair and fur accordingly as it resists these forces very weakly. The longer the hair or fur the more it will be affected by gravity and wind.

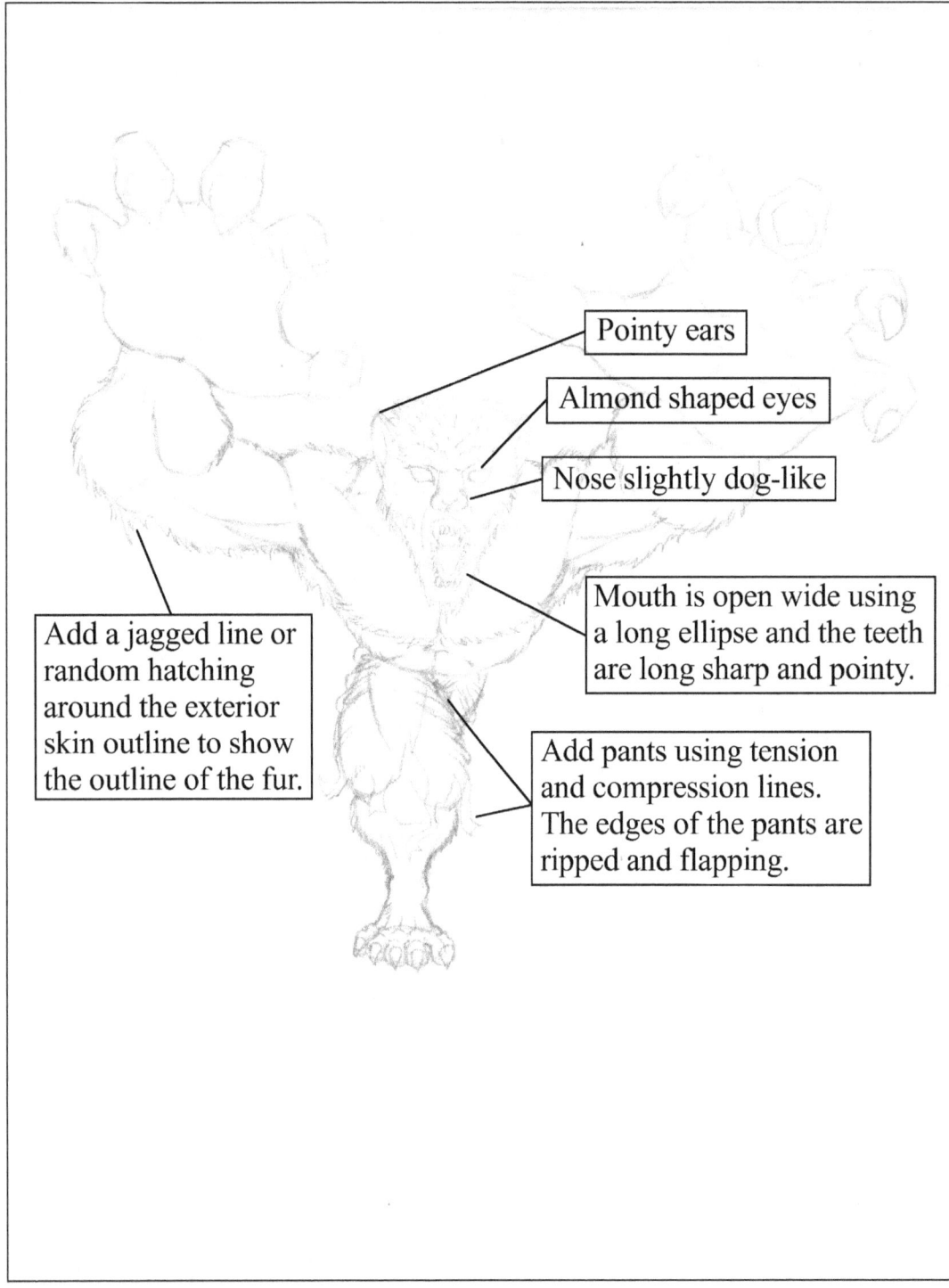

Figure 15-26. Final werewolf outline

This is the time to decide if the facial features will be more human-like, wolf-like, or an even mix. The head in this case is pointed directly at the viewer so it's hard to tell how long the face is. The length and size of the nose is usually the best indicator of this. In Figure 15-26 you can see that the nose is large and the mouth is opened much wider than a human could naturally open its mouth. These are the only clues indicating that the face is slightly elongated. The ears are pointy but not as large as a wolf's and they don't stick up as high. The eyes are almond shaped and rotated down slightly toward the tip of the nose.

Step 6.

Now that the outline is complete, the next step is to add shading and texture.

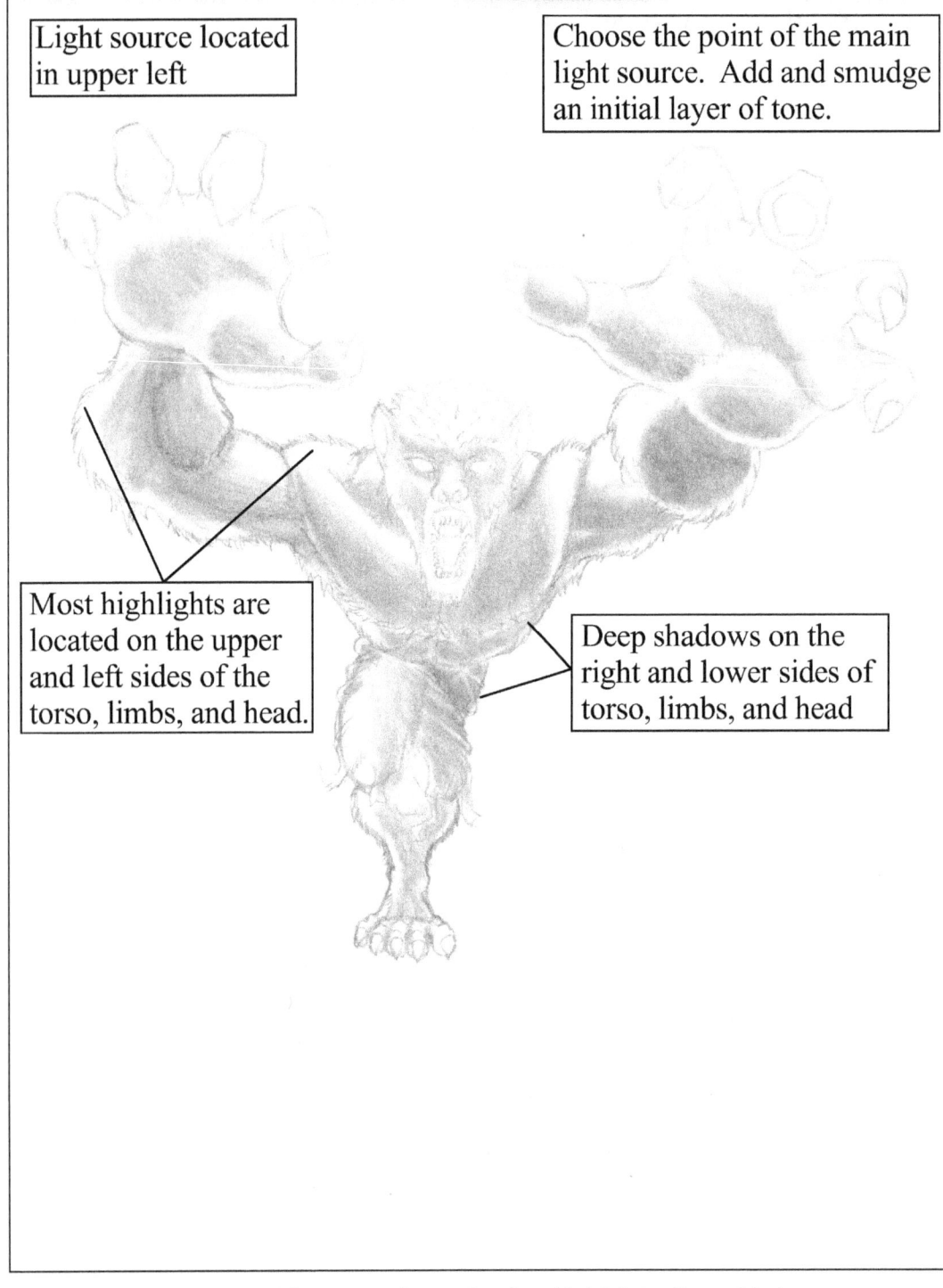

Figure 15-27. Light source determined and initial shading added

The first thing that must be done to maintain consistency in shading is determine where the light source is located. Because this is a werewolf it can be assumed that the main light source is a full moon. A full moon at night can create a lot of light and cast very deep, defined shadows. For this example the light source is chosen to be coming from slightly behind and to the upper left. This will cast shadows forward and to the right. This must be kept in mind during all shading activities.

The perimeter of the werewolf and any part of its body exposed to the light source will be highlighted; any parts of the body covered or positioned away from the light source will be shaded.

Start with a very basic shade. The shading doesn't need to be dark at this point; just dark enough to get a feel for where the shadows and high-lights are. Smudge the shading to make it softer and so it gradually transitions into the highlighted areas.

Step 7.

Now that the shaded areas have for the most part been designated, go back over these areas with hatching to add a fur texture. This hatching can be somewhat random but should be generally aligned in similar directions. The hatching in the chest, shoulders, and arms is generally directed down the arm towards the hands, and the hatching below the chest and into the legs is directed towards the feet.

The direction of the fur is only the starting direction. Remember that wind and gravity are the main forces acting on the fur, the longer the hair or fur, the more these forces affect it. This means that regard-less of the starting direction, these forces may act on the individual furs to bend them. Many of the hatch marks are not going to be straight but will be slightly curved.

The last thing to note about the fur hatching is that the hatch marks aren't a constant thickness. Greater pressure is applied to the beginning of the stroke and decreases across the stroke. This makes the mark fade to a slightly tapered point. To do this, don't allow the pencil tip to touch the paper over the whole stroke. Start with the pencil firmly on the paper and with a bit of a flick in the direction of the fur, move the pencil up off the paper. The result is a line with a solid base that fades to a thin point at the tip, similar to fur.

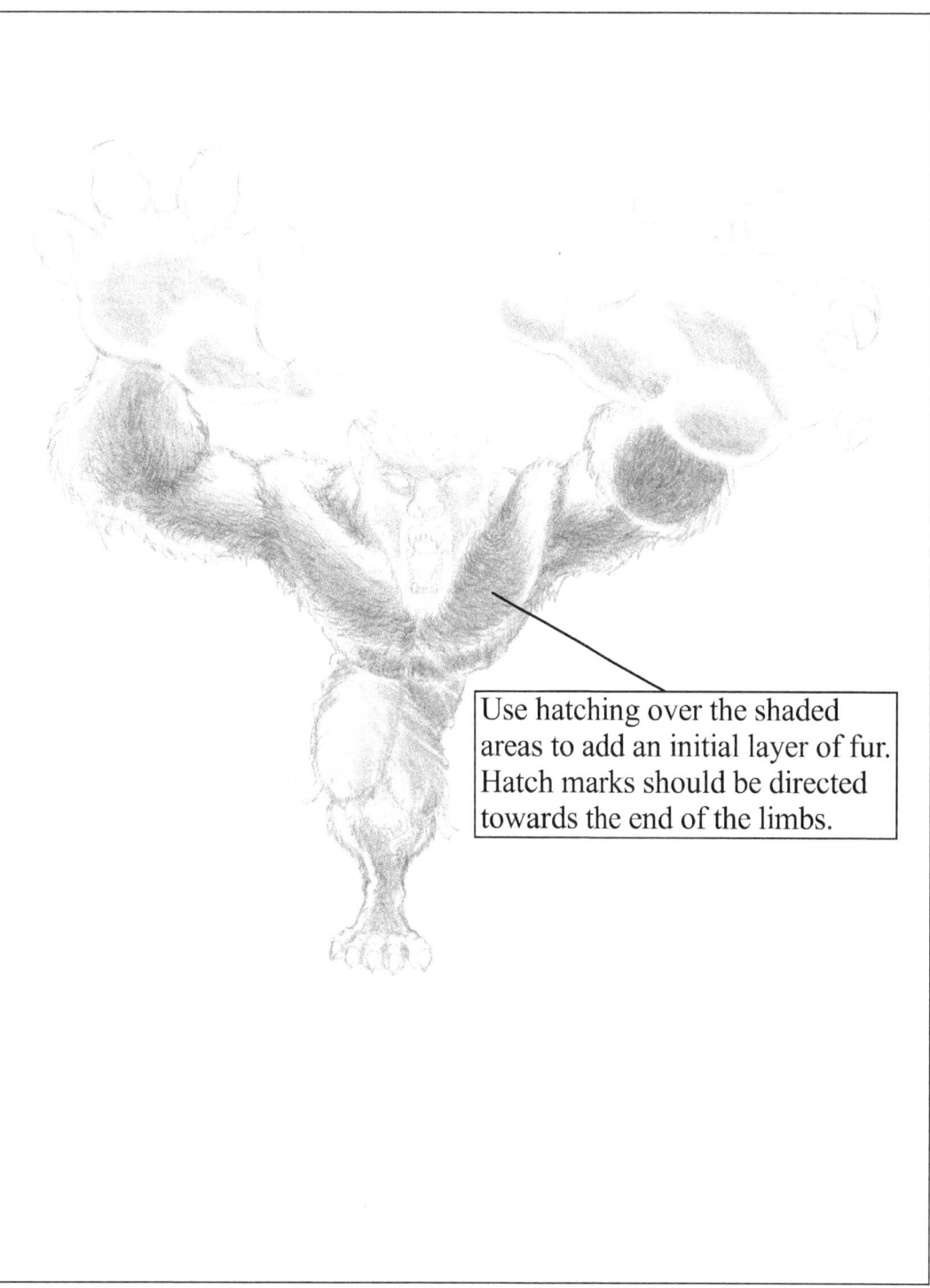

Use hatching over the shaded areas to add an initial layer of fur. Hatch marks should be directed towards the end of the limbs.

Figure 15-28. Initial fur hatching

Step 8.

Add fur to the face similar to how it was done on the body. The fur below the eyes and nose is directed down toward the chin. The fur above the eyes and nose is directed up and to the back of the head. At this point there's still a lot of cleanup and detail work left to do on the face, this will be done later when final details are addressed.

Enhance the shading on the pants. The right side of the leg and the leg extended backwards are heavily shaded because they're covered by the body and positioned away from the light source. Fabric creates peaks and valleys as it folds around joints and seams. Valleys are heavily shaded; this shading can extend deep into highlighted areas. Alternatively, the peaks of the fabric are highlighted and can extend into the shaded areas. Folds in fabric depend on the type of material. Thick materials create fewer but larger folds while thin materials can potentially create lots of small folds. Folds radiate from joints and are created by both tension on the outside of the joint and compression on the inside of the joint.

> Add initial fur and shading to the face with hatch marks. From the eyes, the fur goes up and back over the forehead, and down toward the chin.

> Deepen the shadows around the creases in the pants. The ridges are highlighted, the creases are shaded.

Figure 15-29. Initial fur hatching on face, deepen shadows on pants

Drawing creases in clothes is a skill that can take time to develop. This is a step you may want to practice on a scratch piece of paper before doing it on your final drawing.

Step 9.

Complete the initial layout of the werewolf by shading the hands and fingers. The palms for the most part are completely shaded except around the edges and at the base of the fingers. Each finger is shaded on only one side and projects a shadow away from the light source.

The hands of the werewolf in this example are more human-like than wolf-like and a human hand can be used to model the shading and skin fold details.

The initial layout of the werewolf is basically done. At this point, if the werewolf is all you wanted to draw you can skip to Steps 17 and 18 for direction on the final fur hatching, shading, and highlight development.

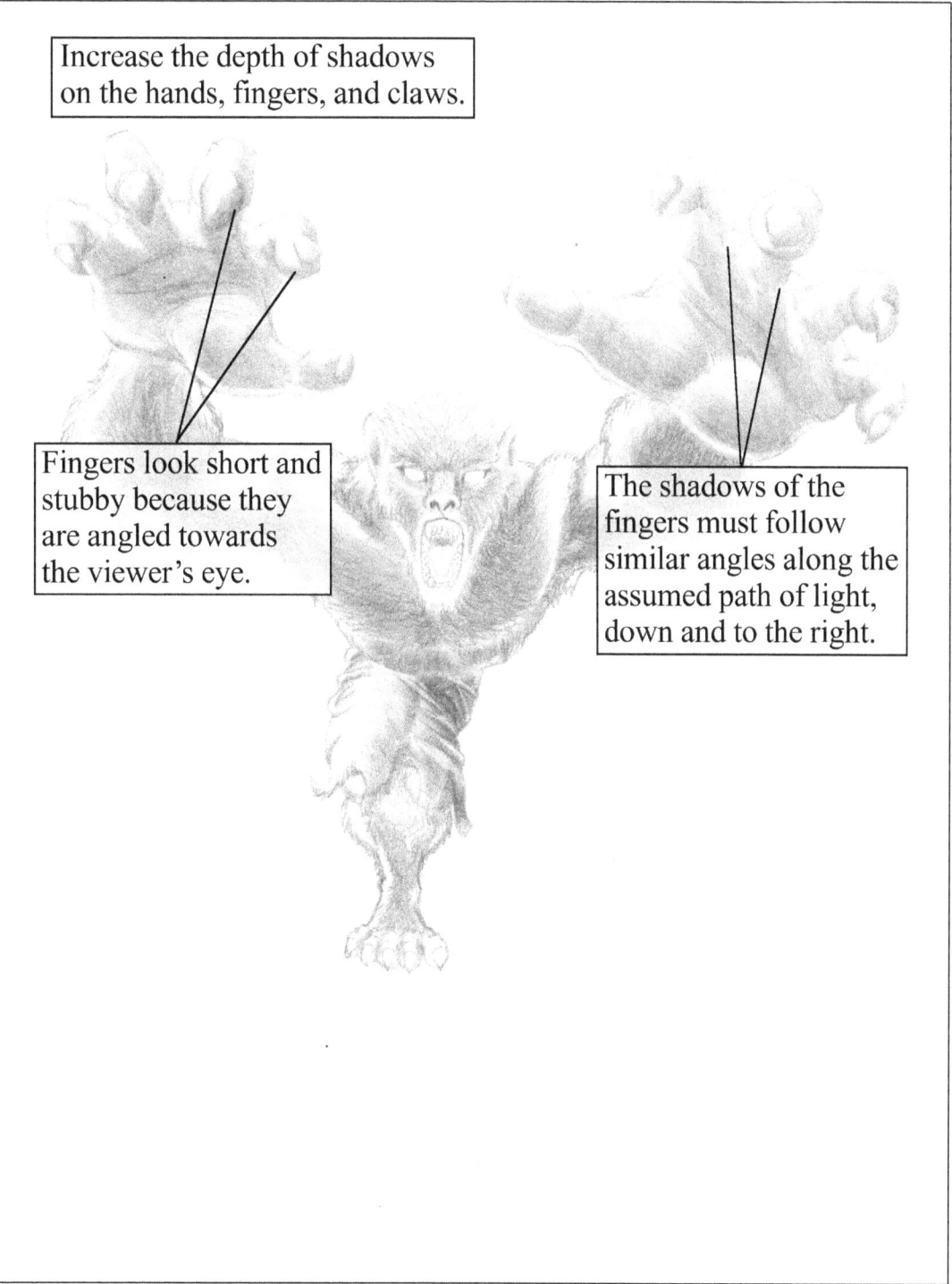

Figure 15-30. Initial detail and shading on the hands

Step 10.

Begin the background layout.

In this example the werewolf is in a forest filled mainly with tall fir trees. Fir trees grow tall and straight, if they grow close enough together the lower branches will fall off because they don't receive adequate sunlight. It also reduces the amount of sunlight that reaches the forest floor, which makes it so only a few small plants can grow rather than lots of thick bushes. This is the assumed condition in this example.

Draw sets of parallel lines to represent tree trunks. It's easy to become confused about which sets of lines belong together so come up with a method for keeping them separate, otherwise you may end up with lines that don't belong to anything (light shading inside the tree is usually very helpful).

The werewolf is relatively close to the viewer so the tree trunks will need to be wide if you want the trees to look old, or thin if you want a forest that appears younger.

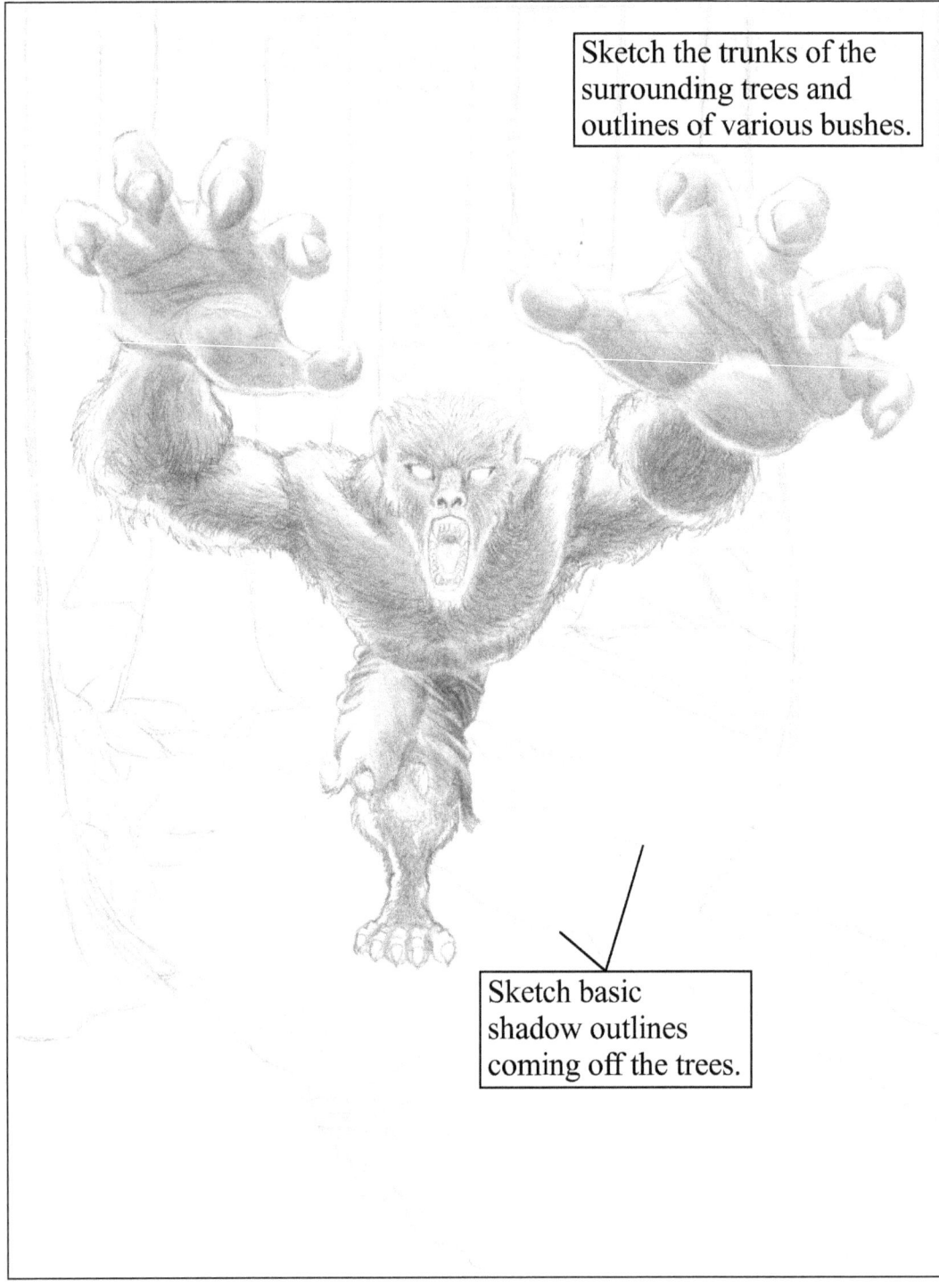

Figure 15-31. Basic tree layout

56

Tree trunks don't grow straight up out of the ground, they actually widen slightly near the base to accommodate the roots. Make sure the bases of the trees flare out near the ground. Connecting each side of the tree by drawing a straight line from one side to the other is also incorrect. Trees are cylindrical so at the very least there will be a slight U-shaped curve connecting the two flared out ends, however, usually there will also be some root starts at the base that will cause the nice U-shaped curve to be jagged and uneven. Look at figure 15-31 to see how the bases of the trees are drawn.

Step 11.

Shade the tree trunks the same way you would shade a cylinder. The left side of the trees will remain highlighted while the right sides of the trees are deeply shaded. Somewhere slightly past the middle of each tree the tone must transition from shadow into highlight.

Add more trees in the far background behind the main trees you've already drawn. These trees in the far background will be less detailed than the main trees because they're farther away and in the dark. Both distance and darkness obscure details and highlights.

Use a light random hatching with a wide section of pencil lead to add bushes to the background. These also aren't very detailed so thick hatching lines will work for now.

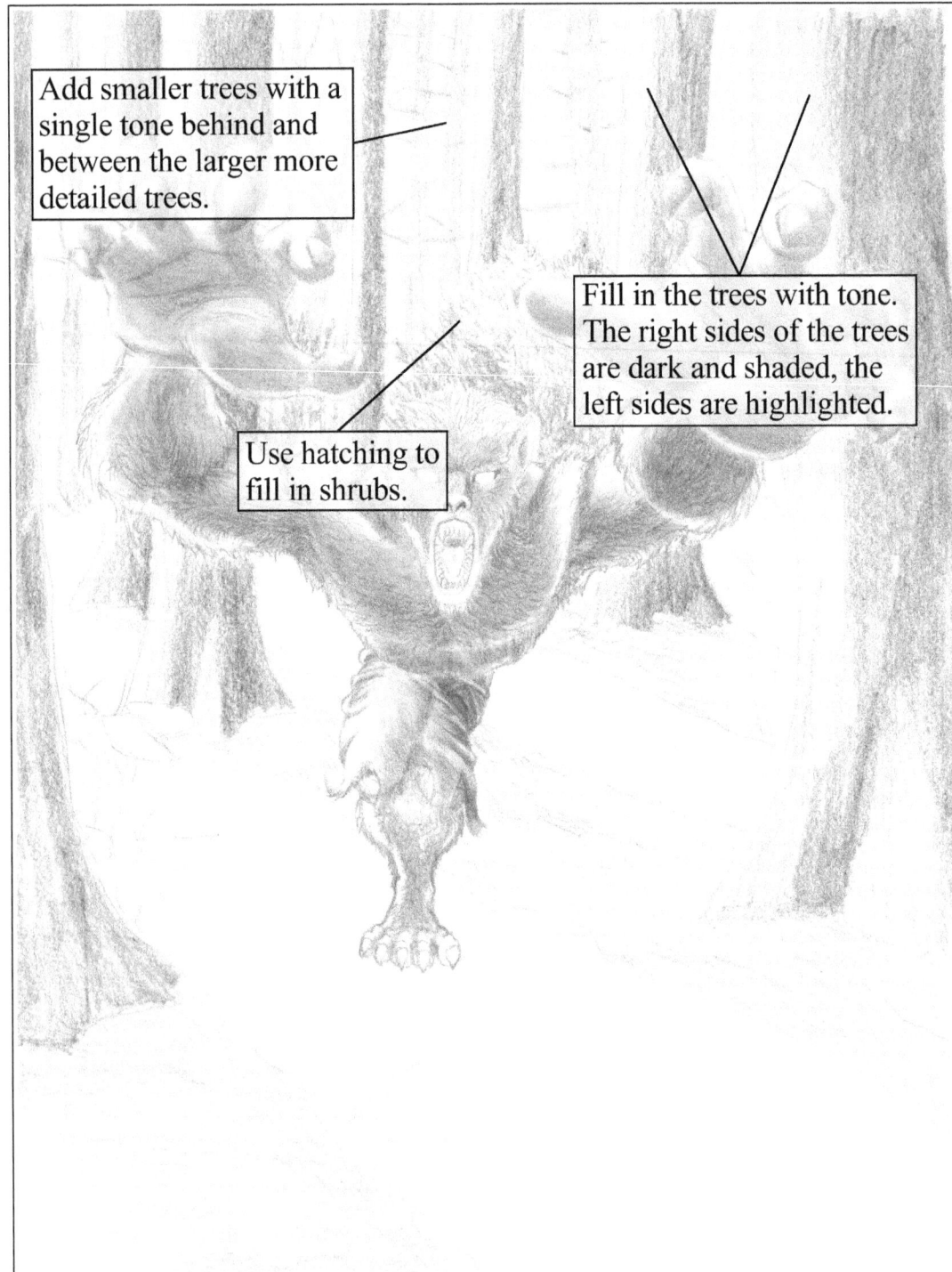

Figure 15-32. Initial shading on trees and projected shadows

Step 12.

Add detail to the trees with hatching and shading. By using longer vertical hatch strokes and shorter horizontal and diagonal strokes, you can make a random pattern that will resemble bark. The continual line and movement technique as explained in Volume 5 can be helpful in creating this bark detail.

The sides of the trees that are highlighted should receive thinner hatching lines. As you work across to the shaded side of the trees the hatch lines should get thicker or closer together. The hatch marks in the most heavily shaded areas are basically short thick overlapping lines. At some point you can stop hatching altogether and simply fill the area with a dark tone.

The trees closest to the viewer should have the most detail. As the trees recede farther into the background the clarity of the hatching should diminish. The trees in the farthest background are shaded outlines with no bark detail at all.

Make the shrubs darker with another layer of hatching.

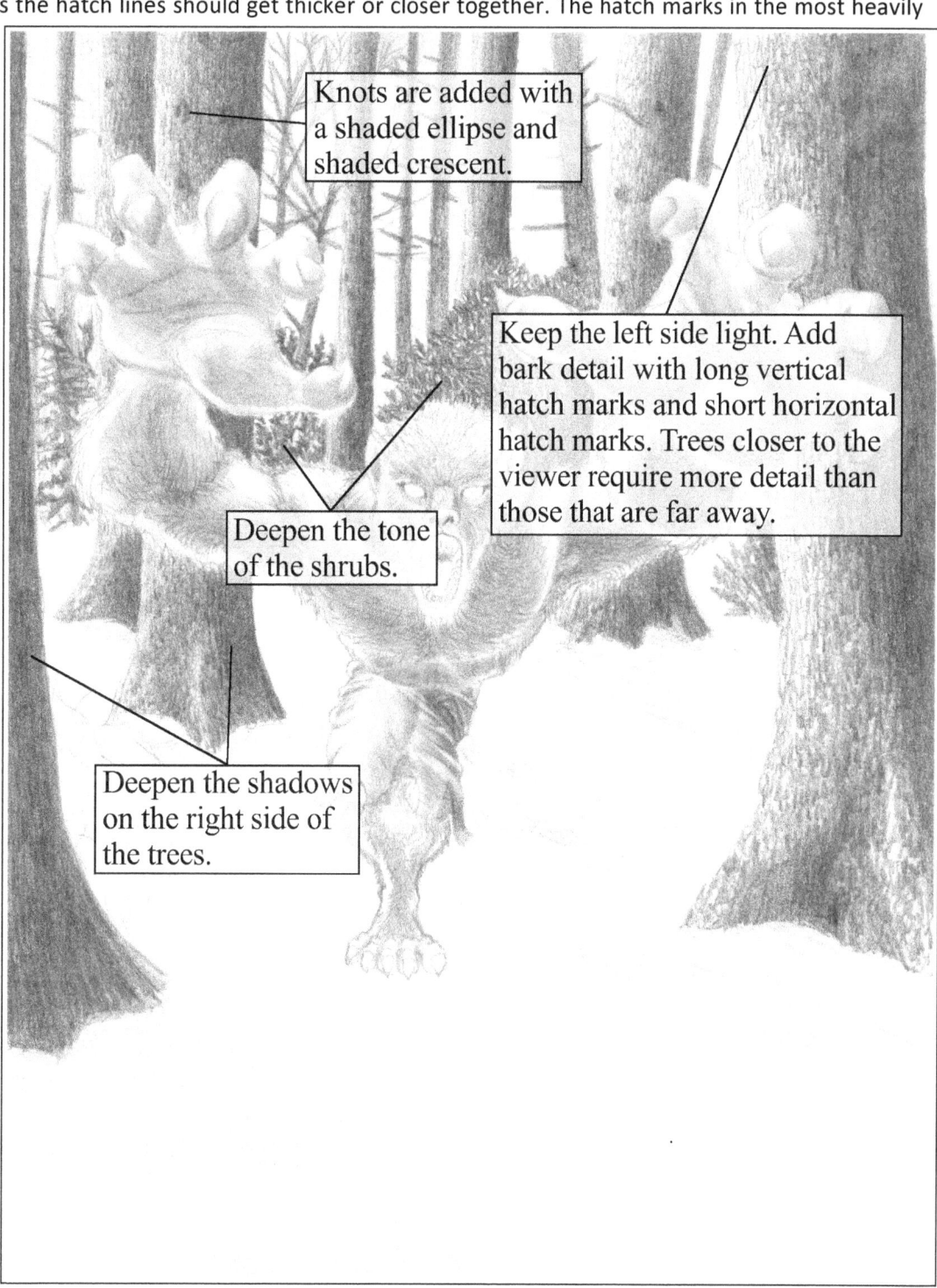

Knots are added with a shaded ellipse and shaded crescent.

Keep the left side light. Add bark detail with long vertical hatch marks and short horizontal hatch marks. Trees closer to the viewer require more detail than those that are far away.

Deepen the tone of the shrubs.

Deepen the shadows on the right side of the trees.

Figure 15-33. Enhance bark detail and shading

Step 13.

Complete the background by filling the white space between the trees with very dark tone.

Begin detailing the ground by first projecting shadows from the base of each tree. These shadows don't need specific details yet, just preliminary boundaries.

The shadows of the trees can help describe the terrain. Shadows that bend up or down, create sharp points, or change direction, indicate that the ground slopes up or down, has holes, depressions, or bumps. Shadows that are more or less straight indicate that the ground is consistently flat or relatively smooth over that area.

Large rocks, fallen logs, and sticks must also be taken into account. These items will cast their own shadows, and the shadows from other items can cross over them too. Anything higher than the ground surface will generally make a shadow curve up and over it. In Figure 15-34 you can see a tree's shadow projected to, then raised up and over a large rock. The point where the shadow reaches and goes up the rock face isn't visible to the viewer which is why it looks like the shadow breaks and suddenly changes elevation.

Fill in the far background with dark shading.

Begin adding ground features like dips, bumps, rocks, and logs with light shadow outlines.

Project shadows across the ground in the opposite direction from the assumed light source.

Figure 15-34. Fill in background and project shadows

Step 14.

Enhance the quality of the tree shadows using a dark dense hatching. This gives the ground texture and starts to set the degree of contrast between the shaded and unshaded areas.

Make the shadows on any large rocks distinct. Because rocks are hard they typically create shadows with clean crisp lines. Straight lines will make the rocks look angled and blocky while curved lines will make the rocks appear rounded.

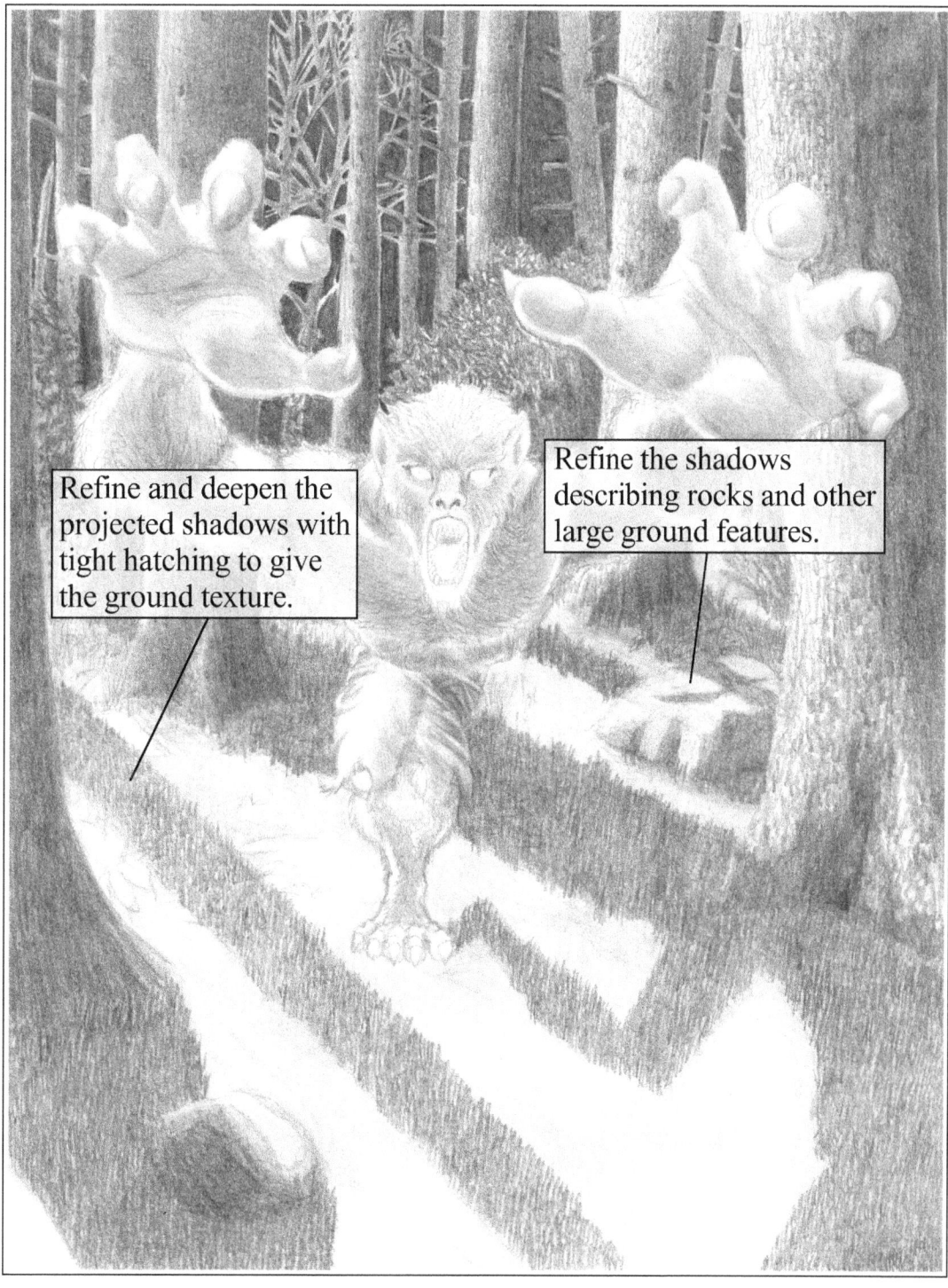

Figure 15-35. Add texture to projected shadows

Step 15.

Lightly smudge the hatching drawn in Step 14. Try to retain some of the texture of the hatch and at the same time fill in the white spaces between hatch marks. If smudging causes the hatch to lose too much texture simply re-hatch those areas.

The forest floor can be littered with debris and many different kinds and sizes of plants, or it can be relatively clean. Lay out any remaining forest floor details you want in the un-shaded areas. This can be done quickly and with less accuracy than usual because under-growth and debris is typically very random. Draw patches of grass with differing heights and tone, add sticks randomly and shade small depressions and rocks. Work on the forest floor until you're satisfied with the amount of undergrowth and debris.

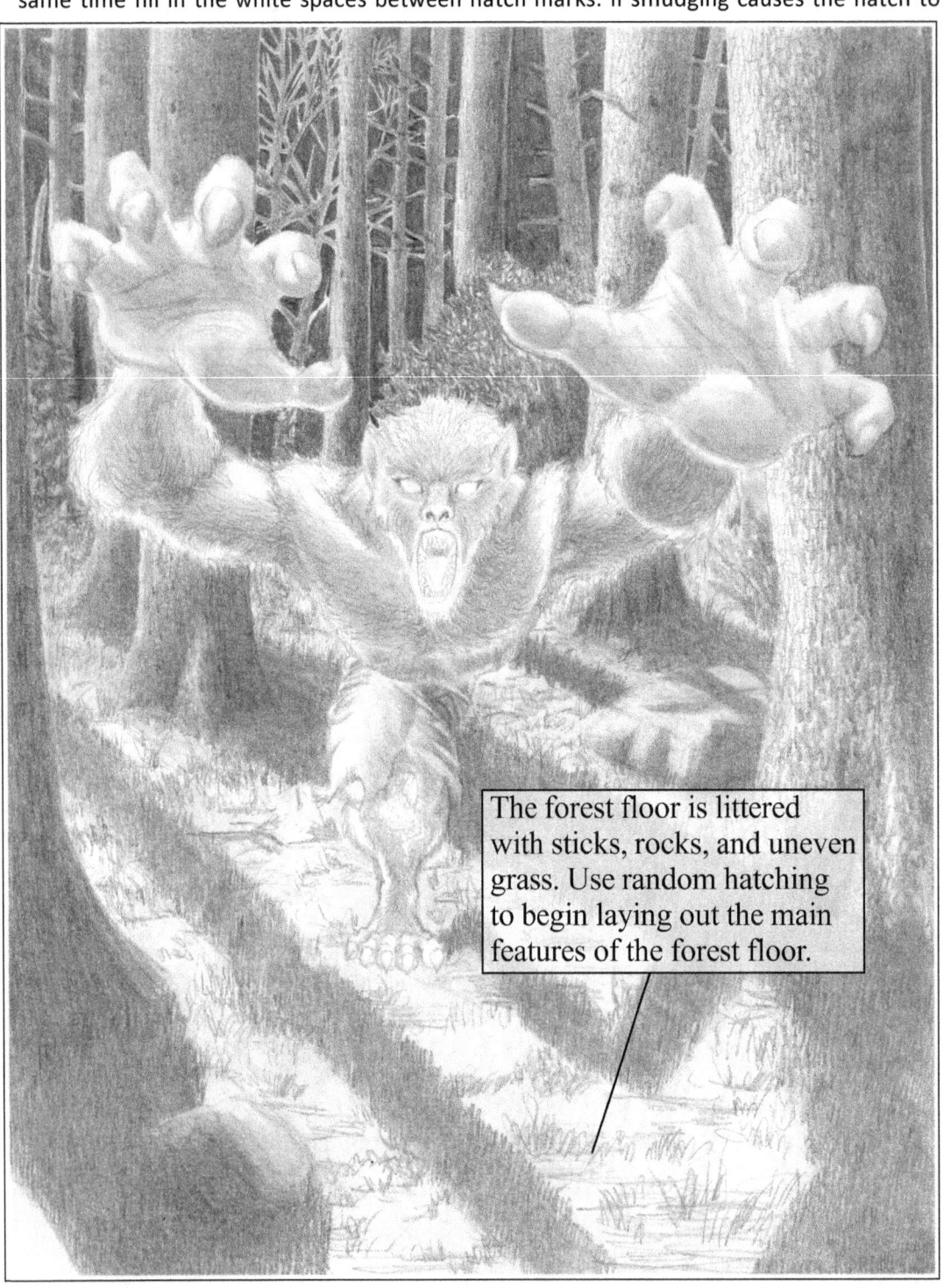

The forest floor is littered with sticks, rocks, and uneven grass. Use random hatching to begin laying out the main features of the forest floor.

Figure 15-36. Initial forest floor layout

Step 16.

The forest floor can be developed by alternating between layers of hatching and smudging. The final details of the ground can be somewhat vague because darkness typically decreases the amount of detail that can be seen. A strong light source, a full moon in this case, will cast heavy shadows which can further distort the appearance of objects in the dark.

Clumps of grass, rocks, sticks, and other features of the forest floor will all cast shadows. These shadows blend together and create dark patches of ground. Anything sticking up above the level of the shadow will create a highlight. The ground also casts shadows into depressions.

The final tone applied to the ground should be a layer of hatching and shadow cleanup. This will ensure that the texture of the ground is maintained and it will help keep the edges of shadows cleaner.

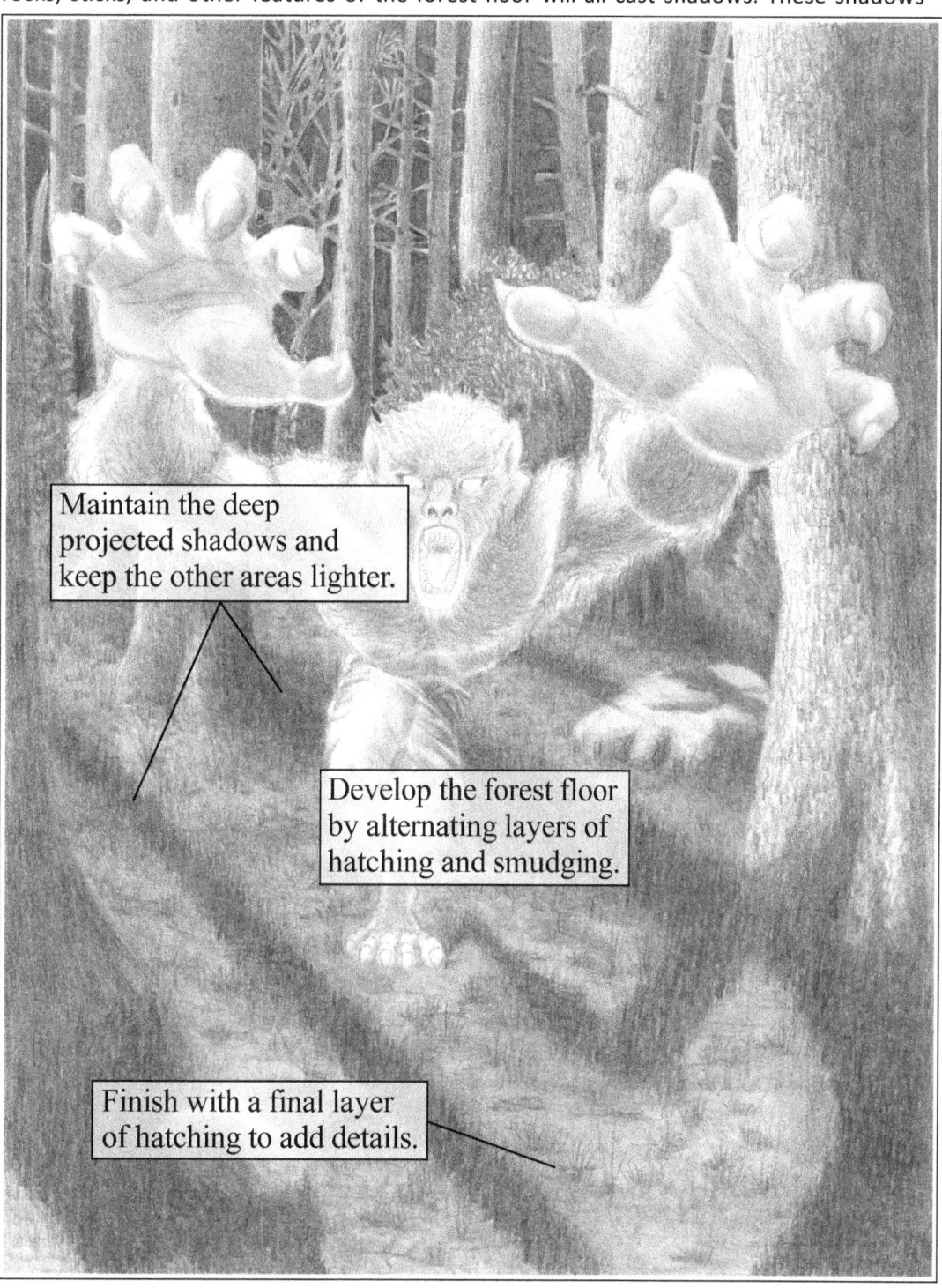

Figure 15-37. Forest floor smudged and hatched

63

Step 17.

With the background complete it's now easier to finish the werewolf.

Smudge the initial layer of fur. Next, alternate between hatching and smudging until the werewolf's depth of tone is similar to the surrounding area. Keep the edges of the fur relatively unshaded. Fur reflects light so the edges will eventually be highlighted. At this point you can create some very dark shadows around the eyes and face, across the chest and on the legs. This is also the point where you can develop a pattern in the fur. Pattern details would be most noticeable in highlighted areas. Deeply shaded areas reduce or eliminate the ability to see details. Add and smudge layers of tone on the hands to match or come close to the tone of the body.

Complete the facial features. The iris should take up nearly the entire eye and will be very dark. You should also include a small highlight in each eye. The mouth should be very dark in the back and lighten towards the teeth near the front of the mouth.

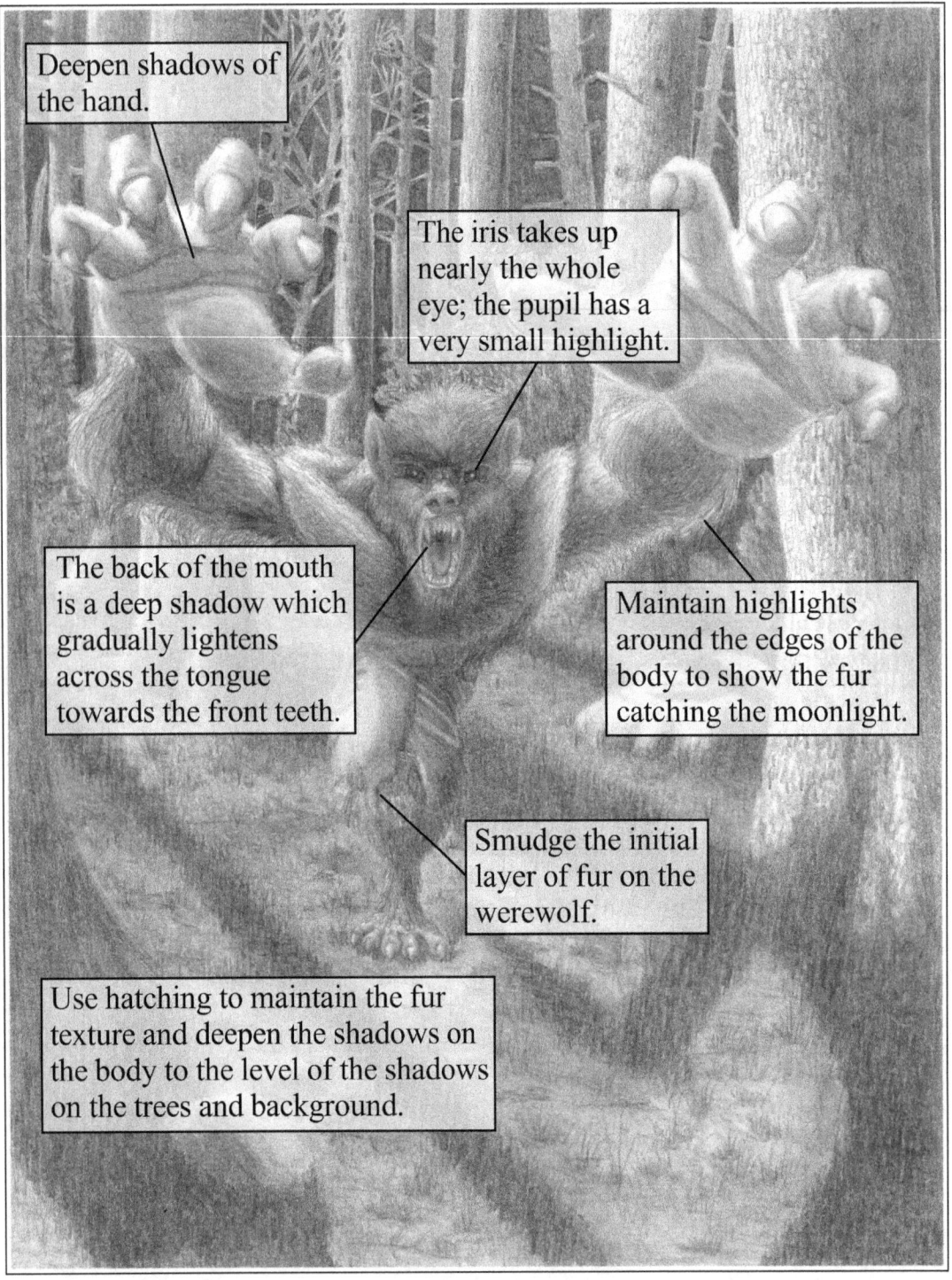

Figure 15-38. Werewolf's tone matched to the forest

Match the nose to the surrounding fur tone and texture, highlight the tip, and make the nostrils very dark similar to the back of the mouth.

Step 18.

The last step is to do the finishing touches and cleanup. As always, this step can take a long time or a short time depending on the amount, and precision of the details you add.

In this example, many of the borders between objects such as trees, rocks, and the werewolf, were slowly inspected and cleaned with a sharp pencil. Also, many of the shadows on the werewolf's body were slightly darkened.

The last series of touchups were mainly done with a kneaded eraser. Using the eraser, beams of light breaking through the trees were added at an angle from the upper left down to the lower right. Don't erase everything; just remove enough to make a fairly even line of lighter tone. Continue to use the kneaded eraser to lift small specific highlights off the left side of the trees and upper sides of prominent branches. Work the eraser into a sharp point or thin line to do this. If too much tone is removed, use a pencil to redraw the parts that shouldn't have been erased. Lastly, use the kneaded eraser to remove small quantities of tone around the perimeter of the werewolf where the fur picks up and reflects the moonlight. Here again you will need to use a pencil to refine and

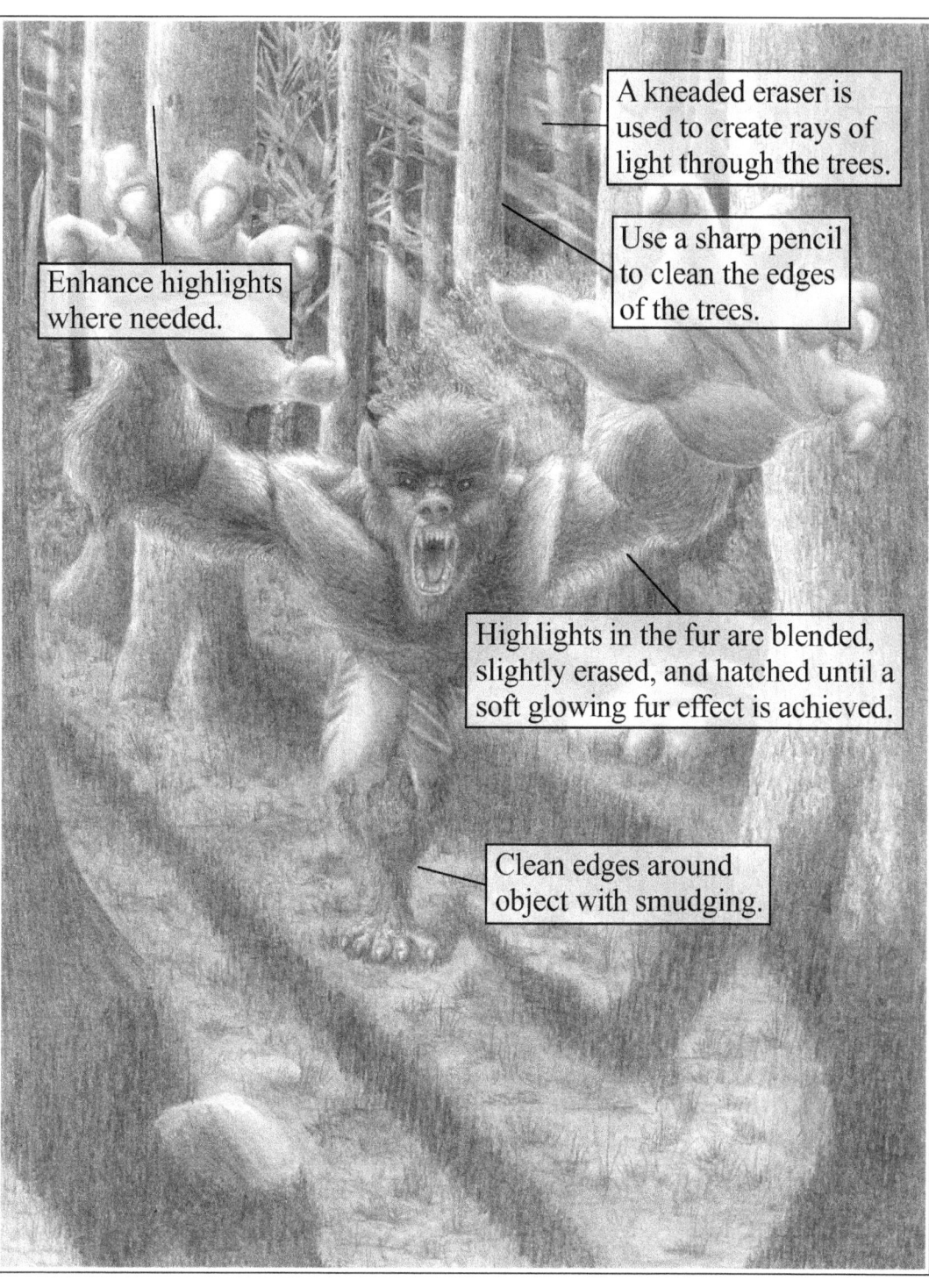

Figure 15-39. Project moonlight and enhance highlights

65

add back some texture so the edges look like bright fur and not simple clean highlights.

Figure 15-40 is the completed drawing of the werewolf. Again, there's nothing to compare it to because it's a fictional creature and a made up scene. If you like the results of your drawing count it as a win, if you don't like it, consider it a detailed sketch, learn from it, and try again. Each time you draw a fantasy drawing you'll get better at it, it'll become easier, and your personal style as an artist will start to show. There's no right or wrong in fantasy, just different.

Figure 15-40. Finished drawing of a werewolf

Conclusion

You've now completed Volume 15 which is a continuation of the fantasy genre. This subject is vast and there's always more to explore but hopefully you enjoyed this lesson and learned or discovered something new. Don't forget that the key to success in drawing is simply to practice. The more you work on your skills the easier drawing anything becomes. No matter what level you're at, continually observing and sketching can only improve your skills and help you enjoy drawing even more.

Fantasy Drawing III

Welcome to Drawing Mentor Volume 16, a continuation of the fantasy genre. This lesson discusses how to develop characters; those characters will then be used in the final drawing project. The subject for the drawing will be a battle between the two iconic fictional races, ogres and dwarfs.

In addition to the main subject, this lesson will also introduce a new medium, ink. We'll review some of the skills and techniques to use it effectively, effects that can be produced, and some pros and cons of using it. The final drawing project will combine both pencil and ink to create the finished piece.

The Subject

The subject of this drawing is a fight between two races, ogres and dwarfs. Obviously neither of these races exist but historically, in most stories that involve them, they don't get along.

Ogres seem to have originated in French folktales in and around the mid-sixteenth century. The earliest stories that feature ogres typically portray them as large, ugly, man-like monsters that seem to enjoy eating people and especially babies. They are described as being much larger than a man, often with a disproportionately large head, colored skin, and very hairy. Over the years, stories, games and movies have added or changed the features of ogres but they've always remained very large and strong and in some tales cross over into the realm of being giants. Today, depending on the source, ogres range in intelligence from very smart and cunning (which makes them an even more dangerous enemy), to extremely stupid and easily outsmarted. As far as our drawing goes the personality of our characters isn't really important, what we're most concerned about are the physical features.

The use of dwarfs in folklore goes back to Norse mythology where the dark elves, or dwarfs, were created as primordial beings and later gifted with reason by the gods who found them. Originally they were more like elemental beings associated with places, and were not friendly to other beings, human or god. They often had or guarded magical artifacts that were acquired by gods and heroes to the dwarfs' dismay. Dwarfs were always associated with metalsmithing and sometimes with death or healing as well. Originally, dwarfs were not thought to be short until the Christianization of the Germanic peoples when their description as a "lesser supernatural being" was interpreted as small supernatural being. Dwarfs in folklore have now come to be associated with images of short stocky old men with long beards; rather gruff but generally friendly if you don't get in their way of making a profit.

This lesson more or less follows the descriptions above but some prep work must be done before starting. The next section covers preliminary sketching, sizing of the subjects, and explores various body forms.

Doing the Research

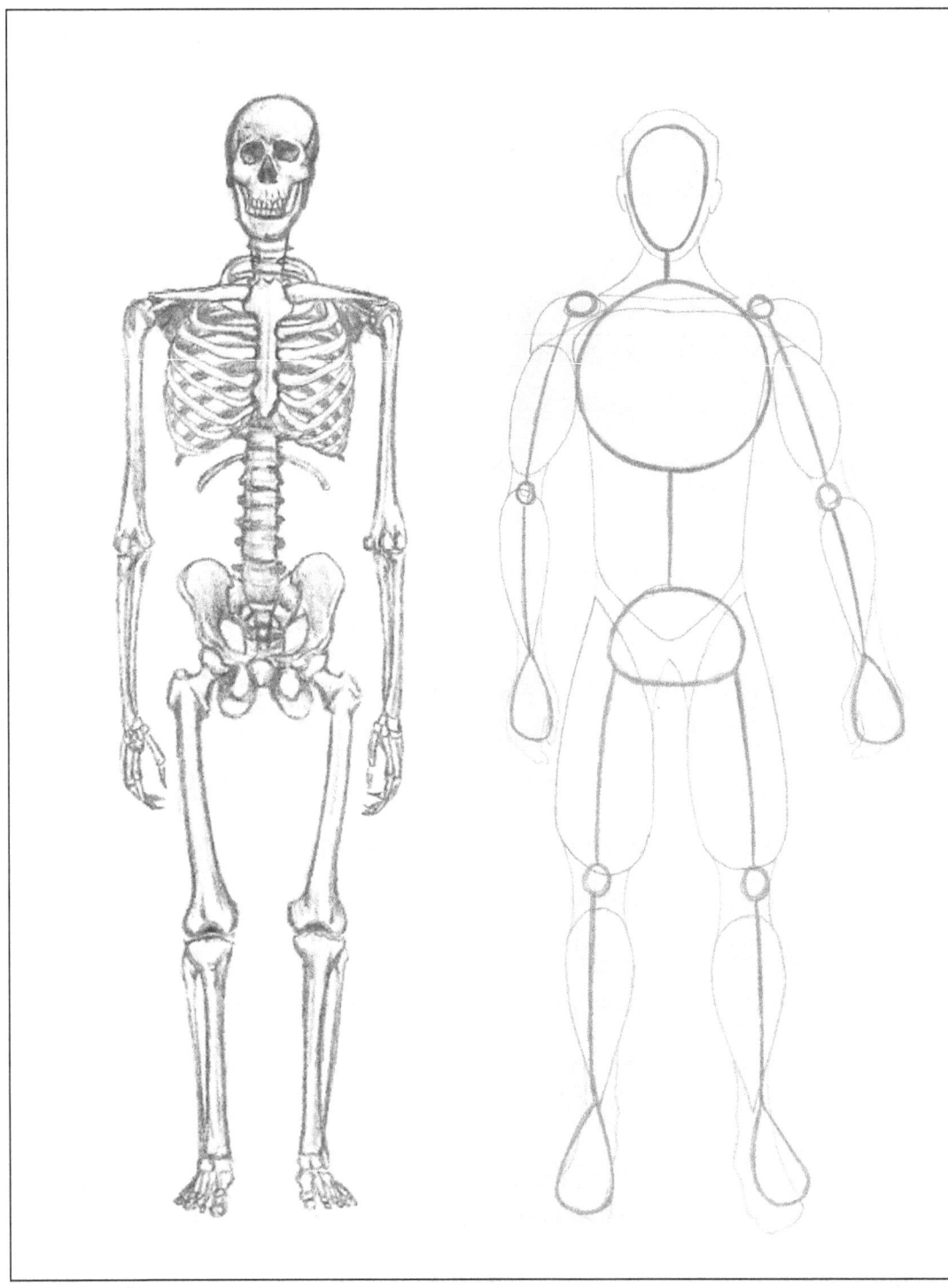

Figure 16-1. Human skeleton, wireframe and area-bubbles

Both dwarfs and ogres are humanoid. Their arms, legs and heads are basically in the same place as a human's so it's helpful to have at least a general understanding of human bone and muscle structure. If you've completed Drawing Mentor Volumes 9 and 15 this should already be familiar to you. If you've never studied the human body you should take some time to sketch human skeletons and musculature before you begin sketching ogres and dwarfs. Finding images to study is easy and the time taken to study the body is well worth it.

Figures 16-1 and 16-2 are final sketches of a human skeleton, and basic musculature. Sketching the body in different poses is also helpful. Wireframe and muscle-belly sketches can be done until you become proficient and confident at sketching bodies with correct proportions.

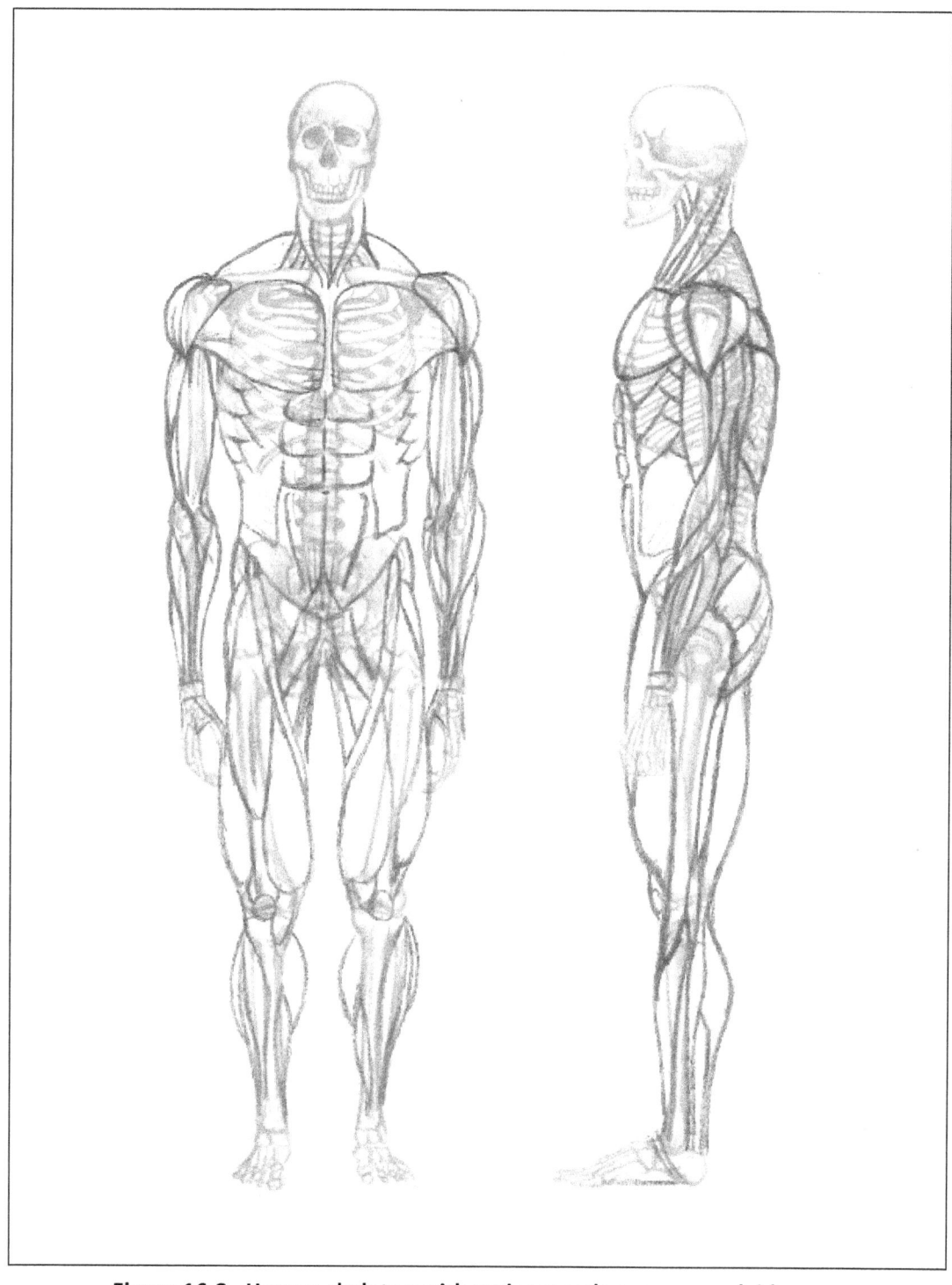

Figure 16-2. Human skeleton with major muscle groups overlaid

You can use a human body as a starting point to develop the dwarf and ogre bodies. Begin with a sketch based on human proportions then slowly alter the sketch to create bodies with similar bone structures but different proportions.

Wireframes and area-bubbles are the go-to techniques for transforming a human into many different humanoid forms. Pages of bodies with different proportions can be completed very quickly using these techniques. Changes to body parts can be made gradually to make them thicker, thinner, longer or shorter, until you get proportions you like.

Figures 16-3 and 16-4 are sketches of dwarf and ogre bodies using area-bubbles. These sketches were done in only a few minutes but guided the rest of the development of these characters.

Various dwarf body sketches using area-bubbles

Figure 16-3. Dwarf body sketches using area-bubbles

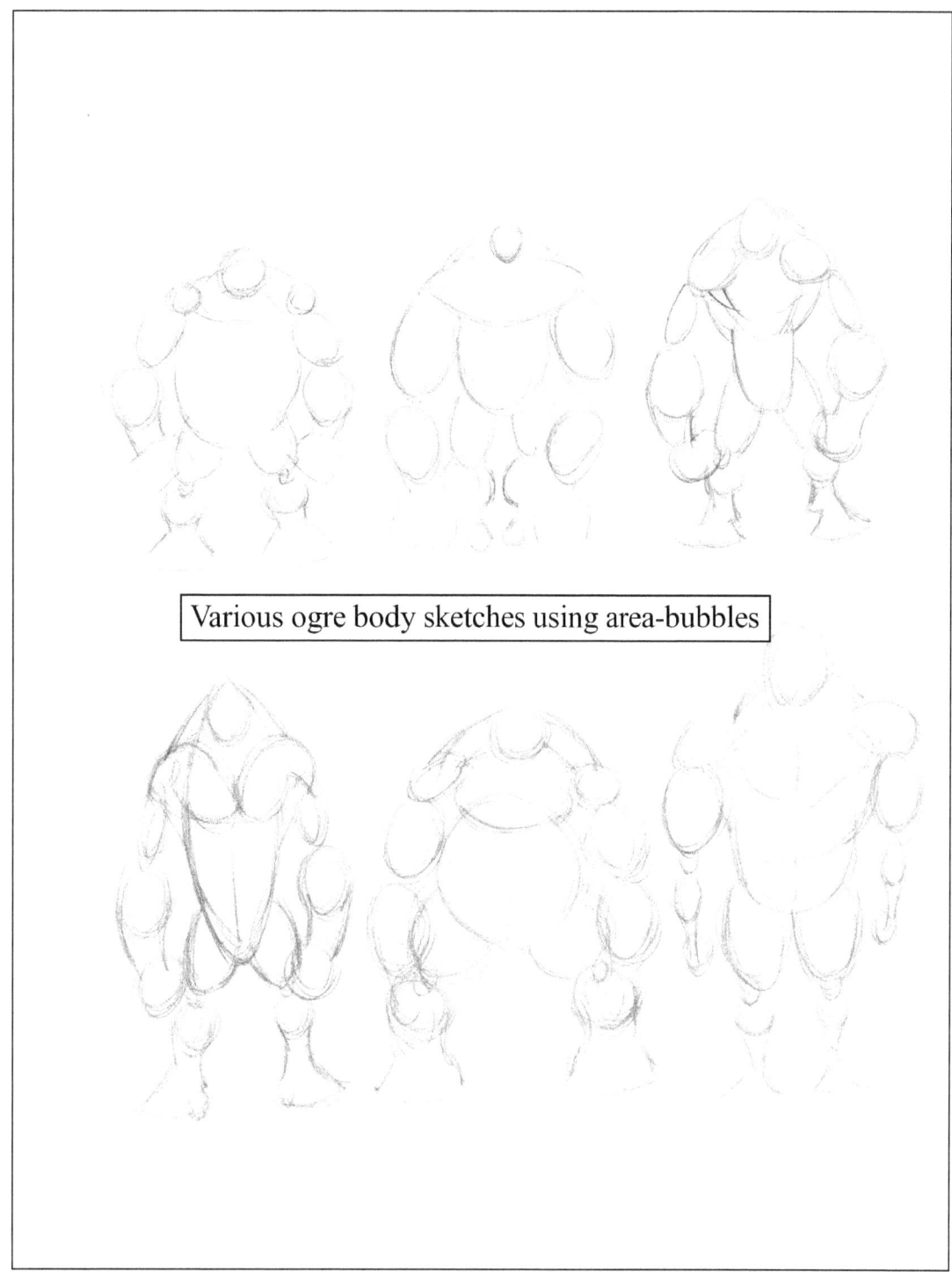

Figure 16-4. Ogre body sketches using area-bubbles

When you're happy with the basic bodies you've developed for the dwarf and ogre you can then refine their proportions and develop their gear. In all honesty, the following steps are not absolutely necessary but it's definitely easier to start a final drawing with well thought out and sketched characters. The more fantasy drawings you do the less you'll need to go into extensive detail developing characters but we're assuming we're starting from the beginning so each step, from finalizing body form, to creating clothes, armor, and weapons, is shown.

We'll begin by developing the dwarf, and then follow similar steps to develop the ogre.

Using the area-bubble sketches in Figure 16-3, we'll select the body type shown in the middle of the top row. This basic body form is refined in Figure 16-5. Muscles were then added to the area-bubbles as shown in Figure 16-6, which leads to the basic body form shown in Figure 16-7.

Dwarf proportions, area-bubbles

Shoulders at ¾ point

Waist at ½ point

Knees at ¼ point

Figure 16-5. Refined dwarf body shape using area-bubbles

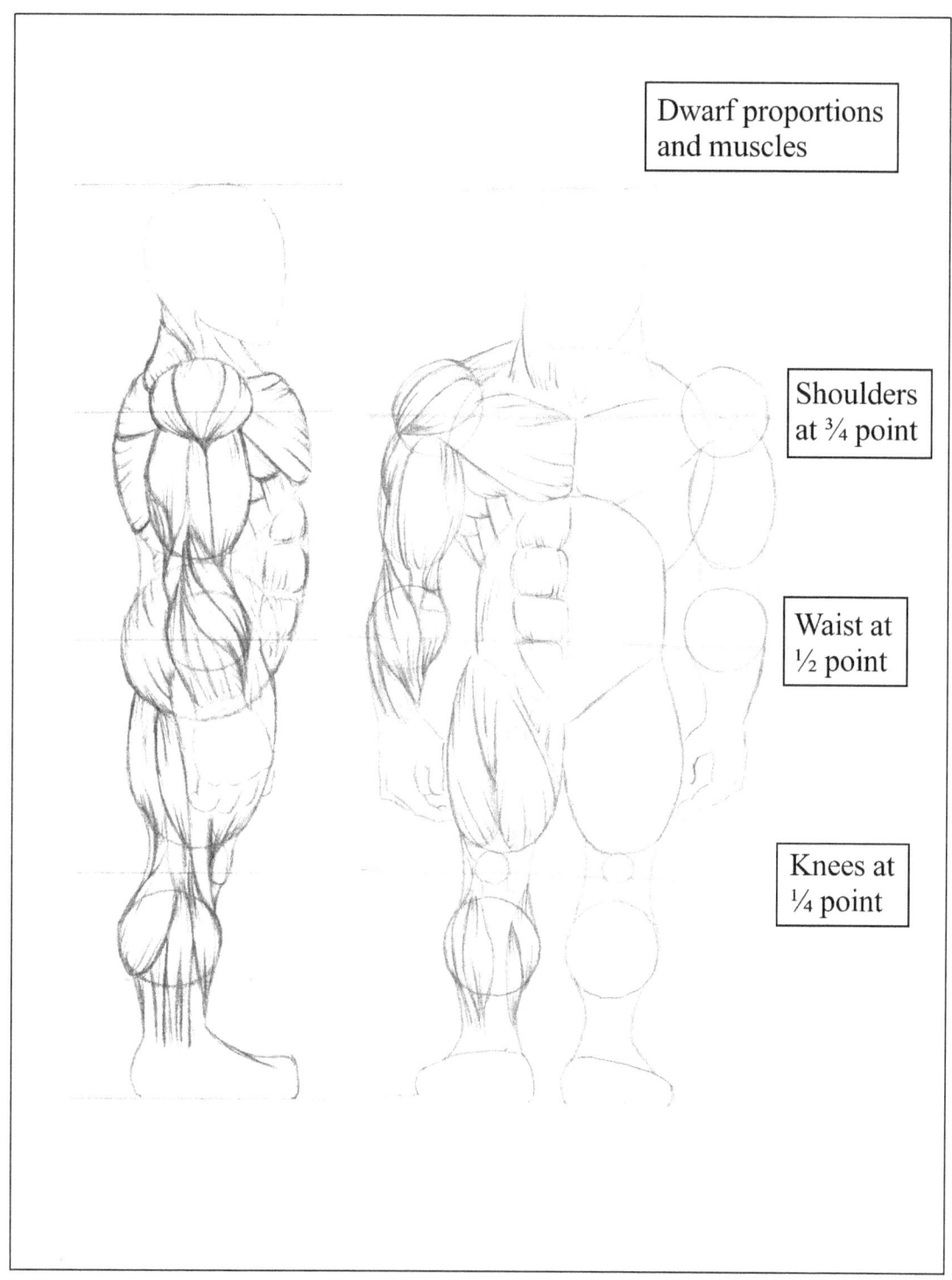

Figure 16-6. Refined dwarf body shape, muscles over area-bubbles

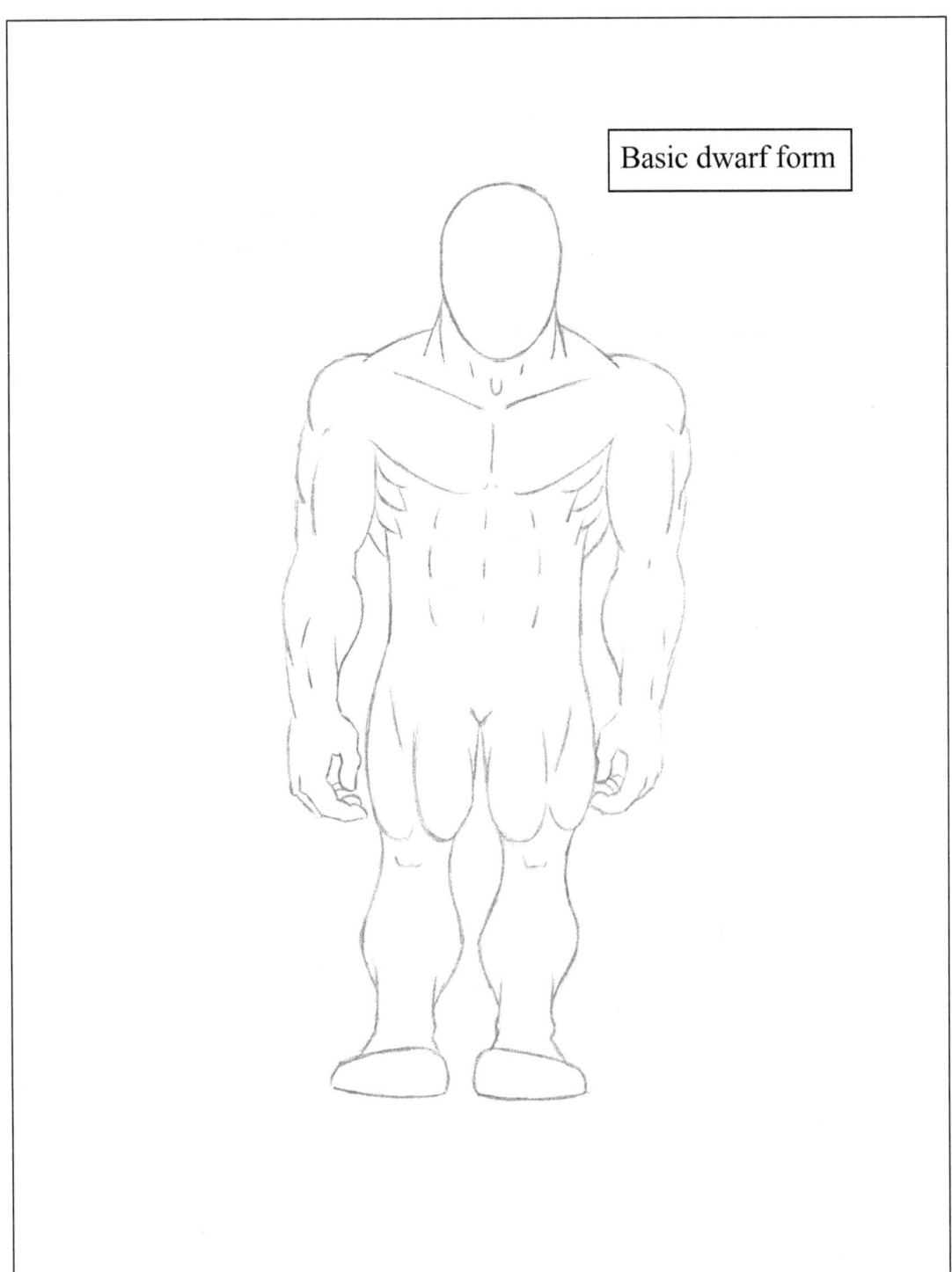

Figure 16-7. Basic dwarf body shape

After finalizing the dwarf body shape you can begin sketching details such as clothes, weapons, armor, and faces. Start with very basic sketches for clothes and armor, mainly just mimicking the shape of the body and providing basic functionality. Eventually these sketches should be refined and embellished to add style to function which makes the clothes and armor more interesting. Use the sketches in this book and other pictures for inspiration but eventually develop your own style. The sketches can then be used to create a completed look for the dwarfs in the final drawing.

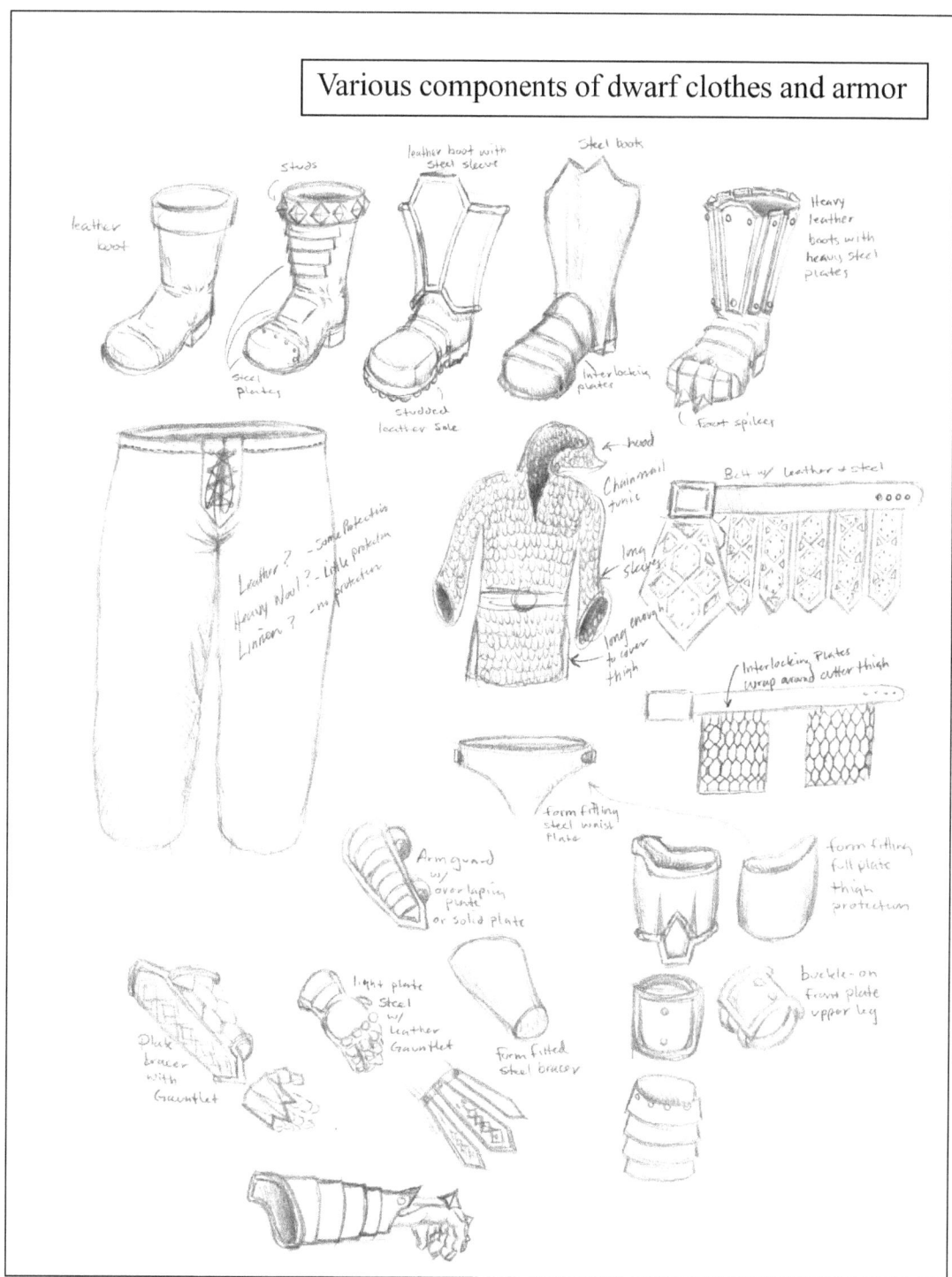

Figure 16-8. Dwarf clothes and armor sketches

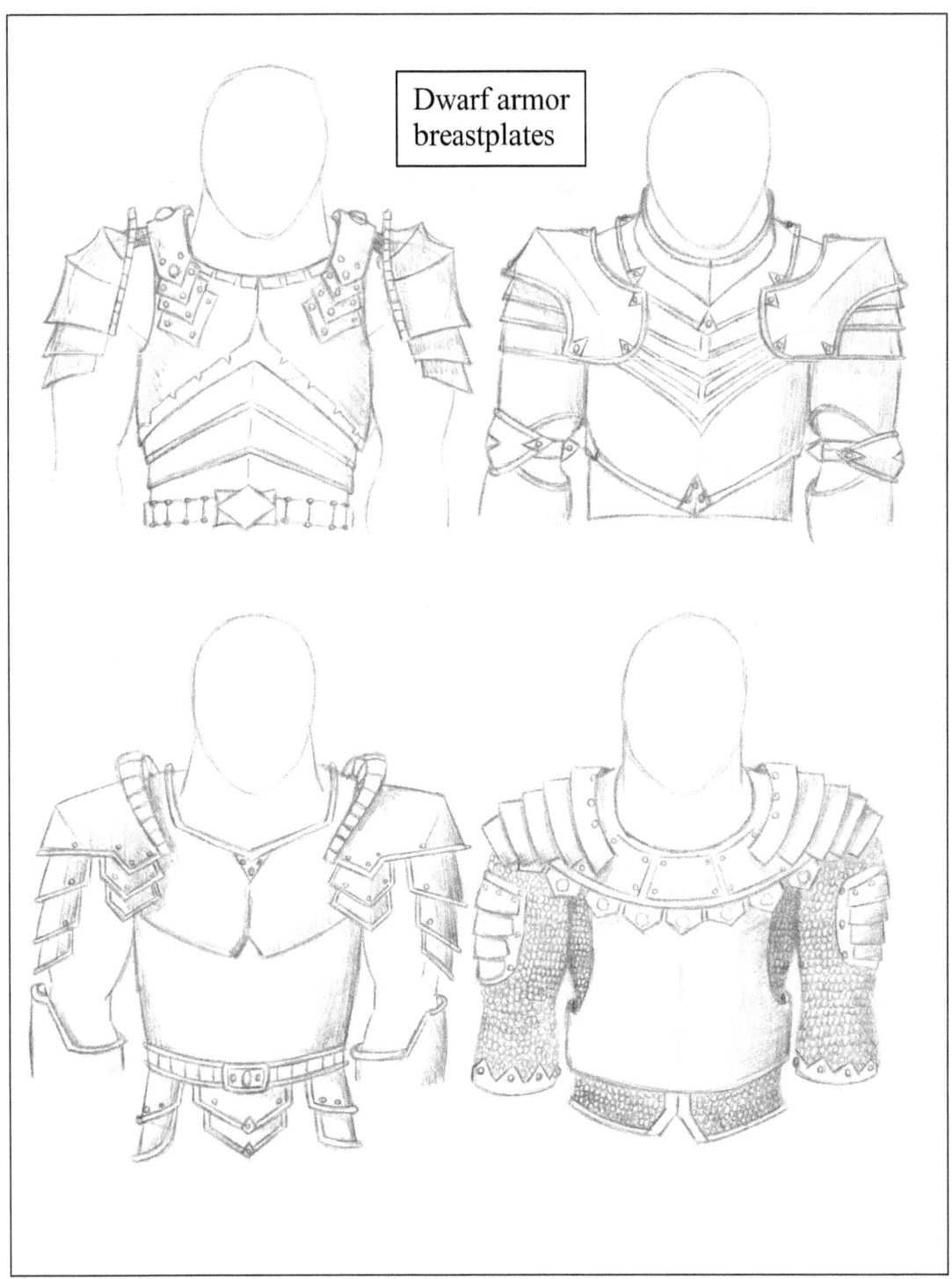

Figure 16-9. Dwarf breastplate sketches

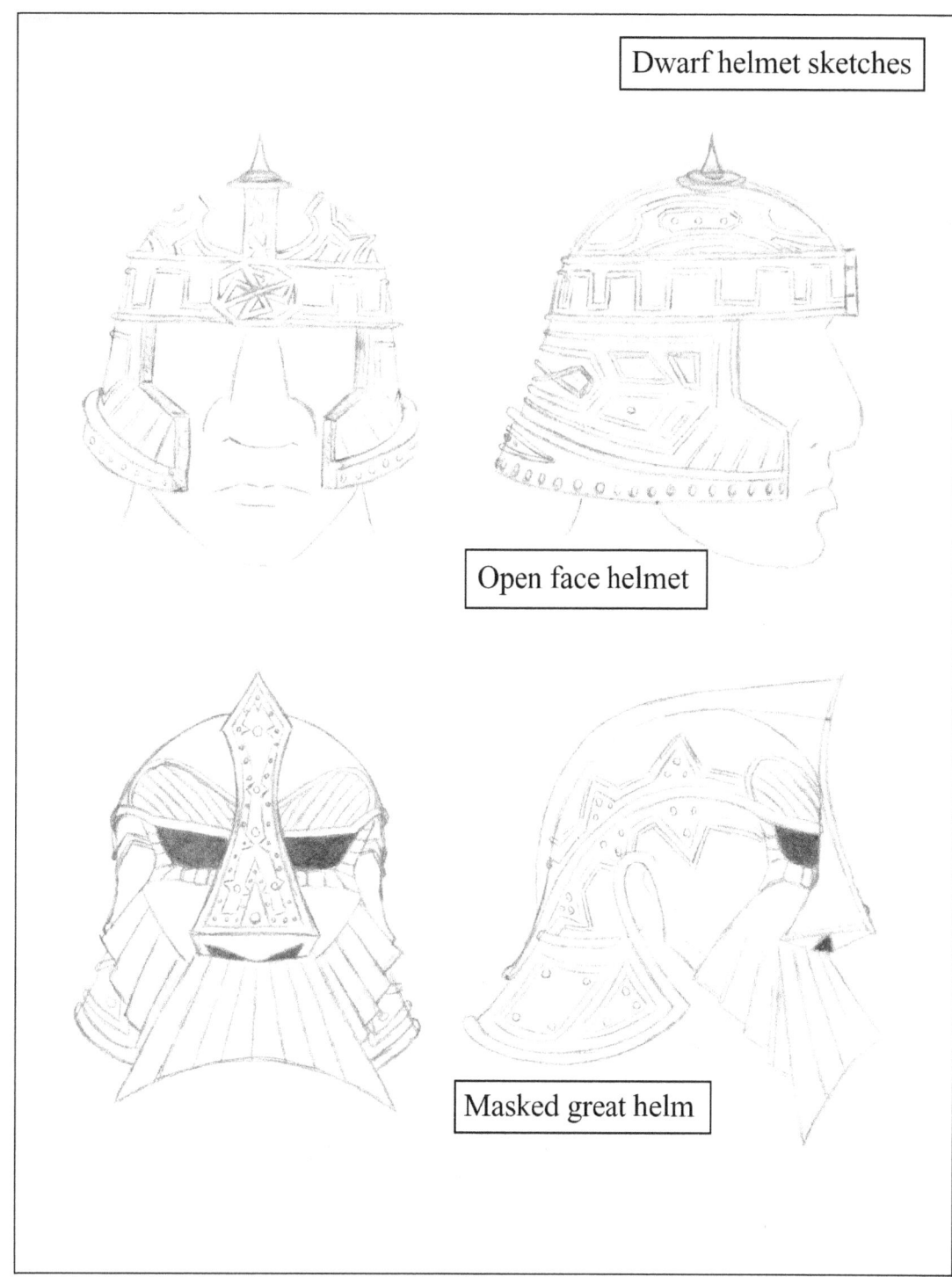

Figure 16-10. Dwarf helmet sketches I

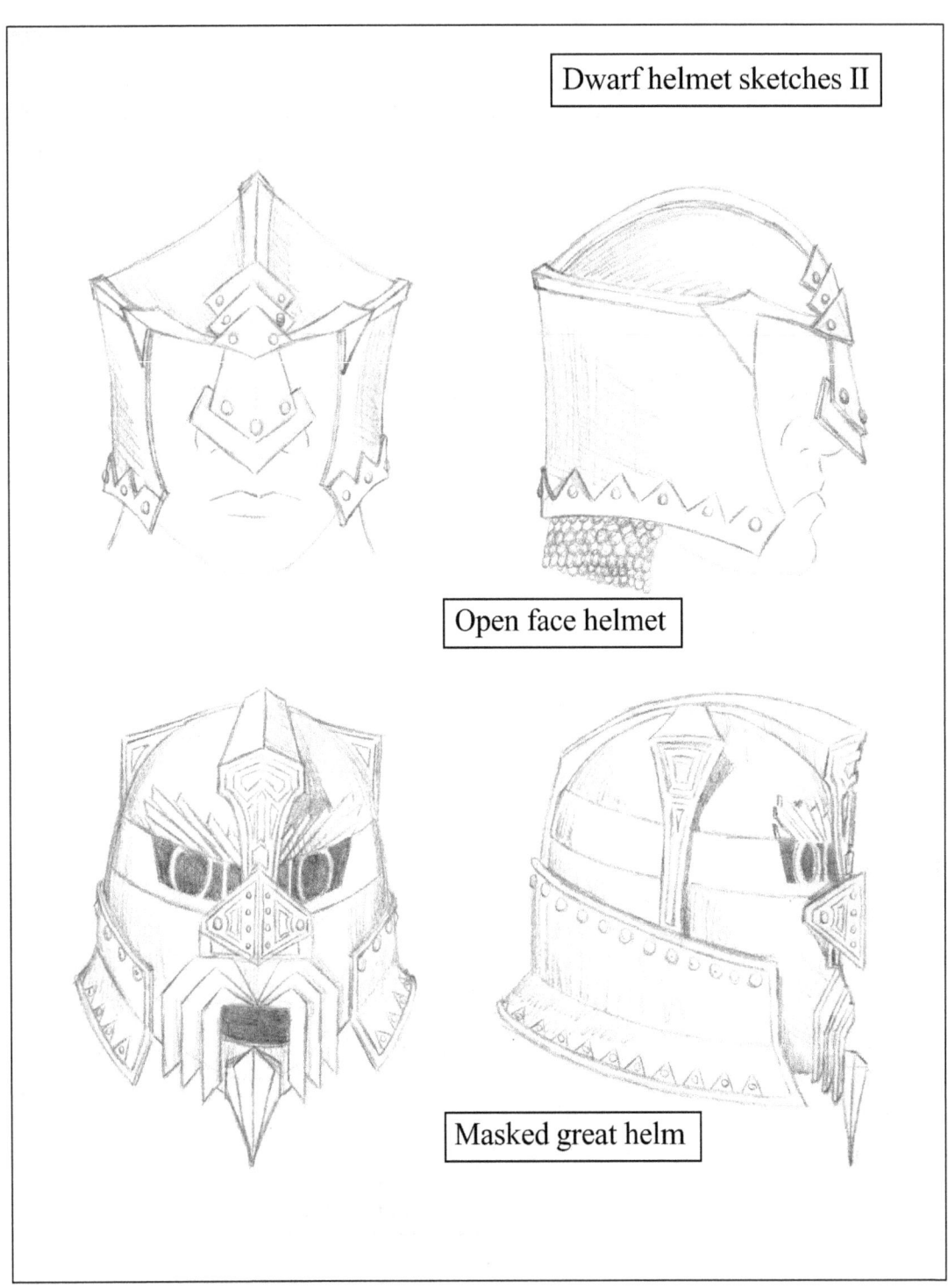

Figure 16-11. Dwarf helmet sketches II

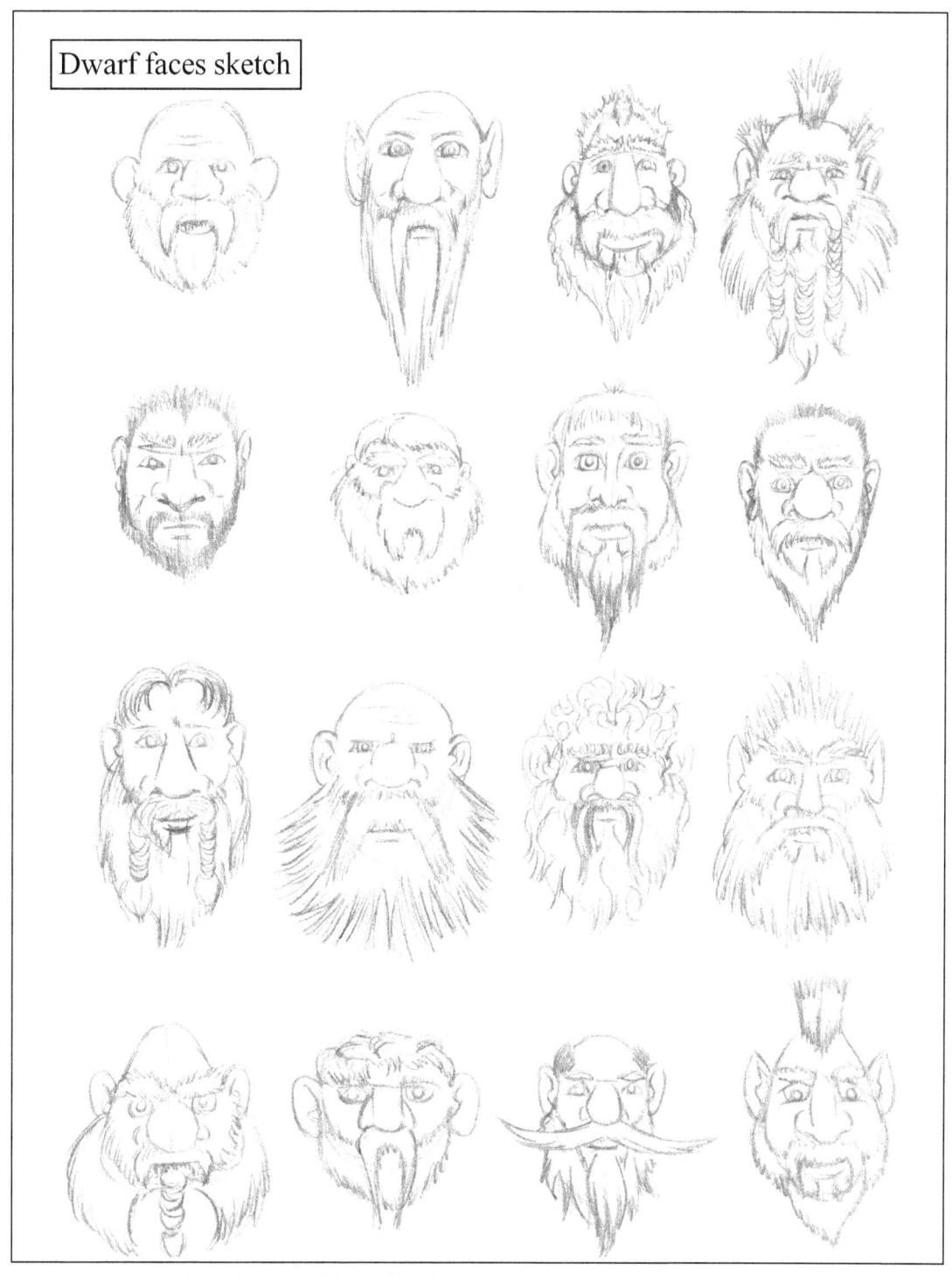

Figure 16-12. Dwarf face sketches

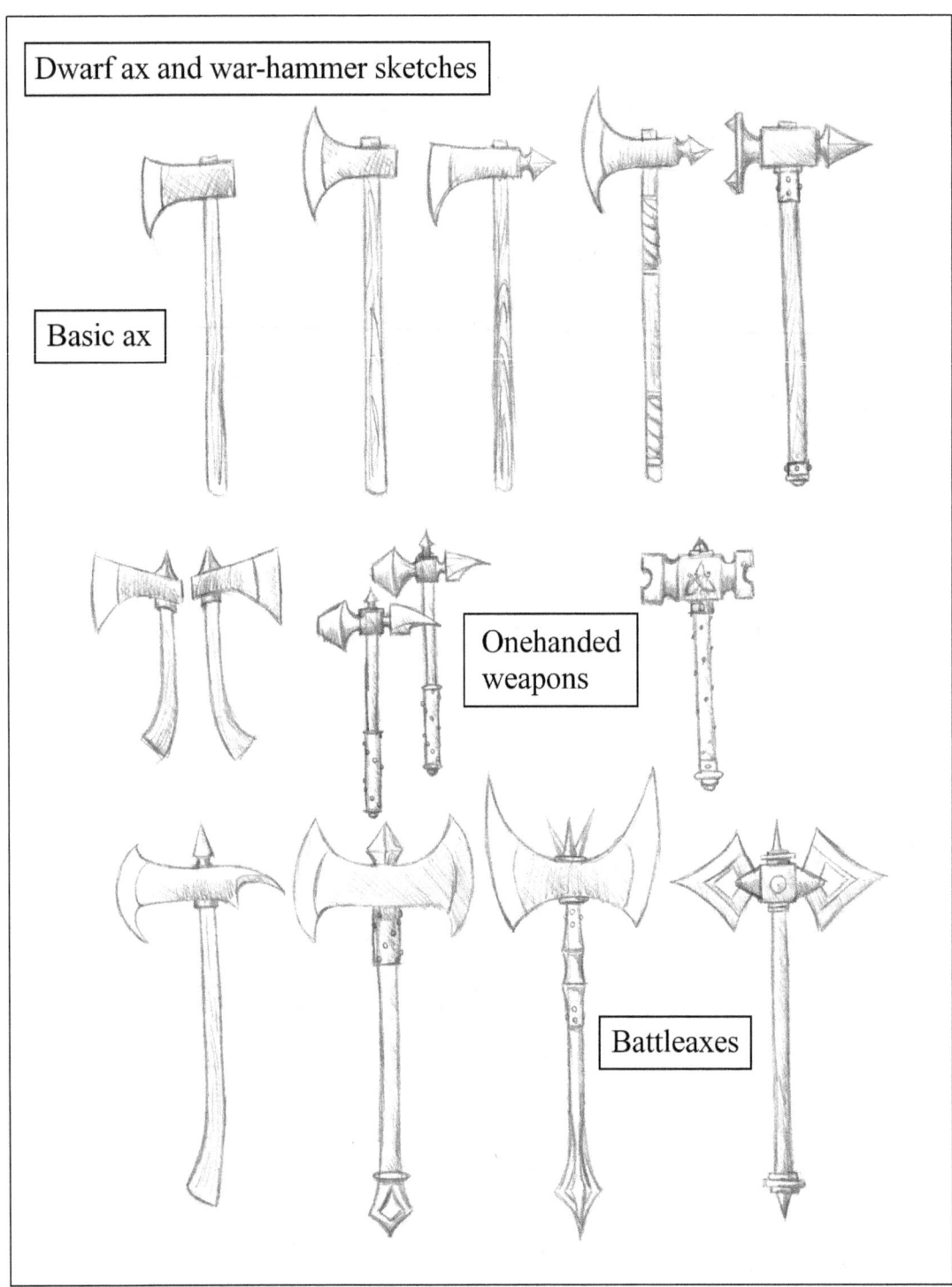

Figure 16-13. Dwarf weapon sketches

After completing several standalone sketches of the various components of the dwarf's clothes, armor and weapons, you can now go back to the final body sketch and begin to essentially clothe the dwarf with the version of the sketches you like best.

The dwarf we're developing for this drawing is a standard soldier. The outfit is based on several sketches done previously but the final outcome is unique in itself. The armor is somewhat fantastic to reflect the culture's ability to create outstanding armor and weapons but is also scaled down to a more conservative level that would represent a common soldier.

Figure 16-14. Final dwarf sketch, add pants

Figure 16-15. Final dwarf sketch, add wool undershirt

Figure 16-16. Final dwarf sketch, add chainmail jerkin

Figure 16-17. Final dwarf sketch, add armored boots and knee guards

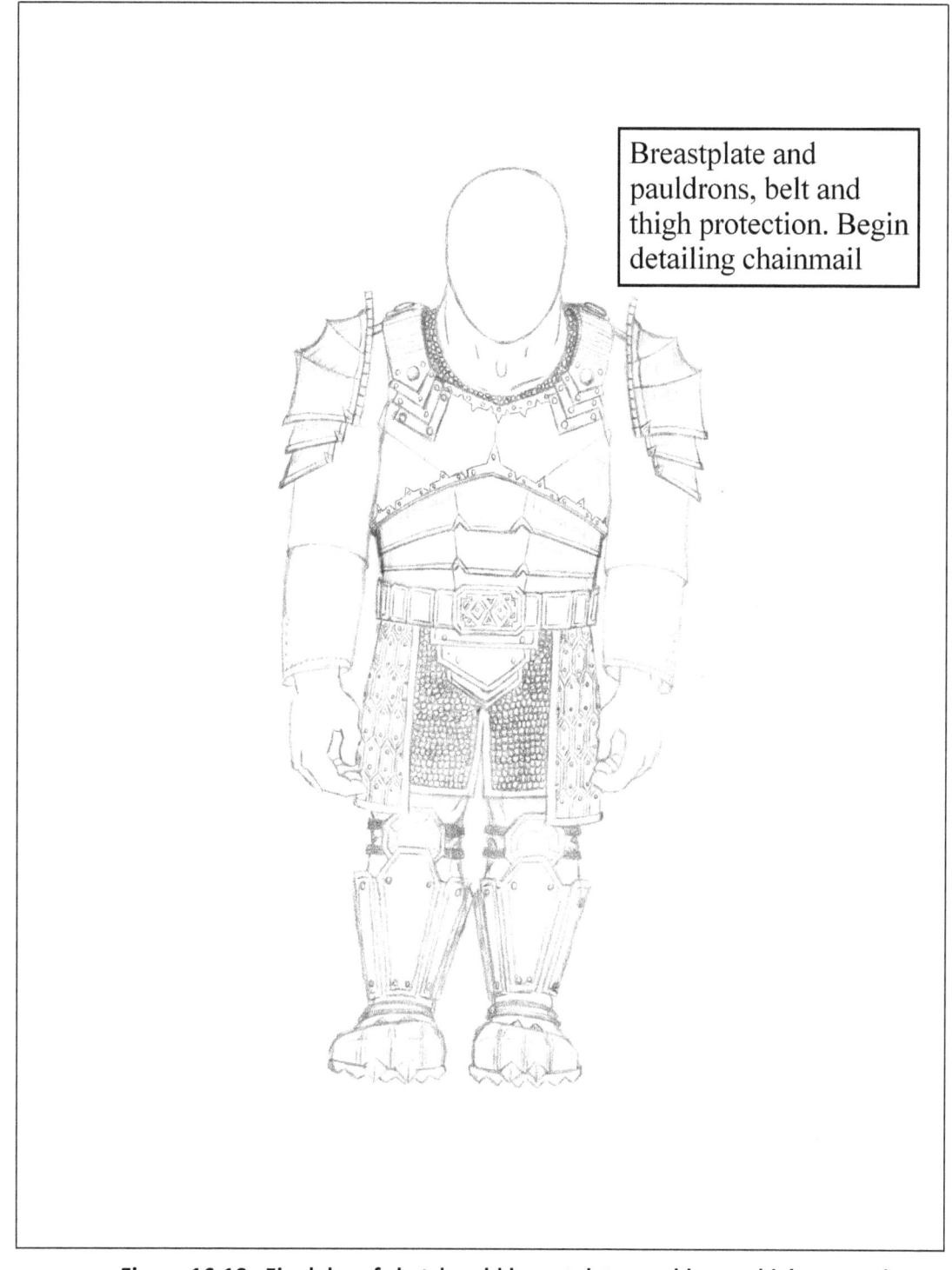

Figure 16-18. Final dwarf sketch, add breastplate, pauldrons, thigh protection

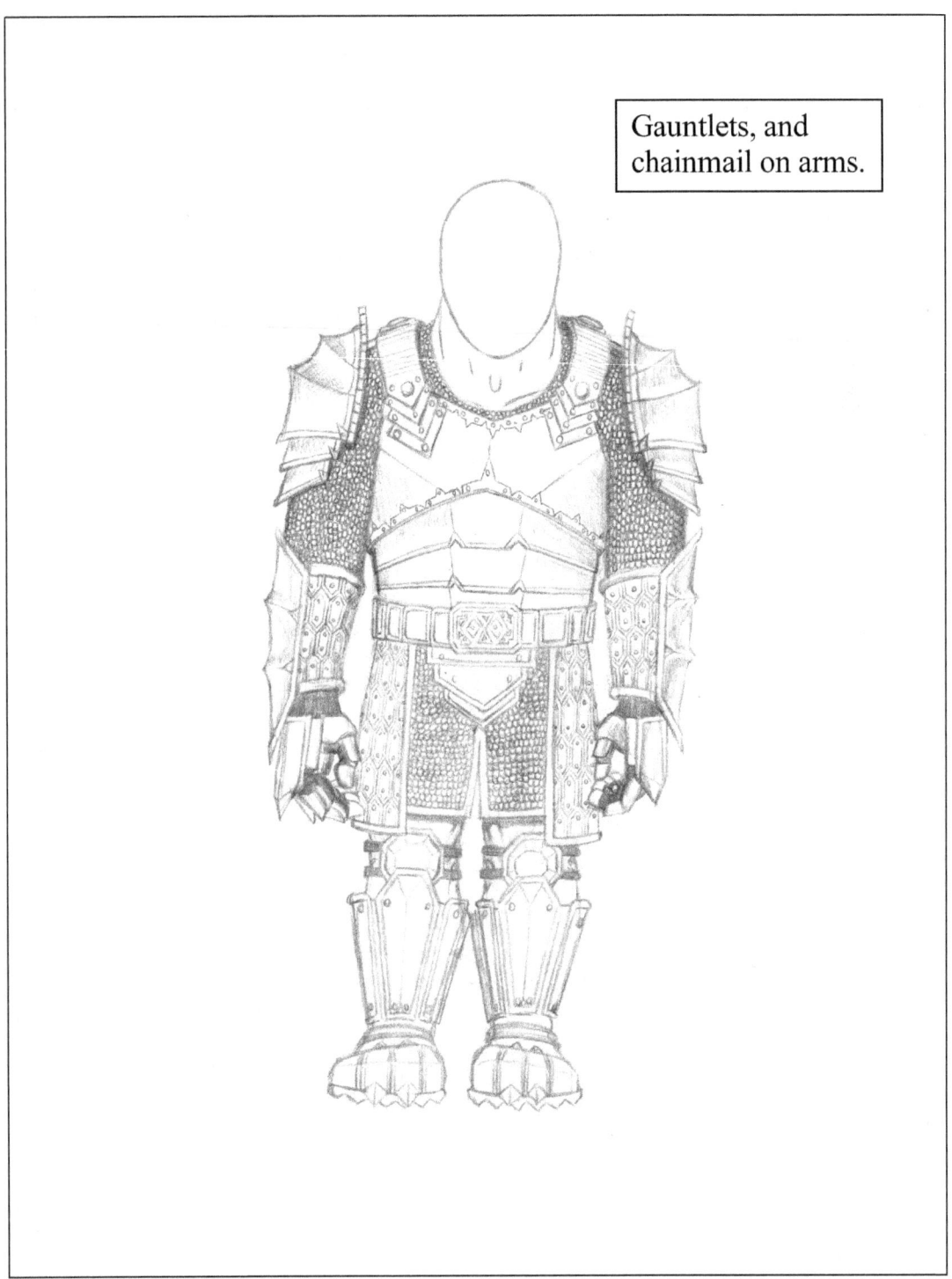

Figure 16-19. Final dwarf sketch, add gauntlets and finish chainmail

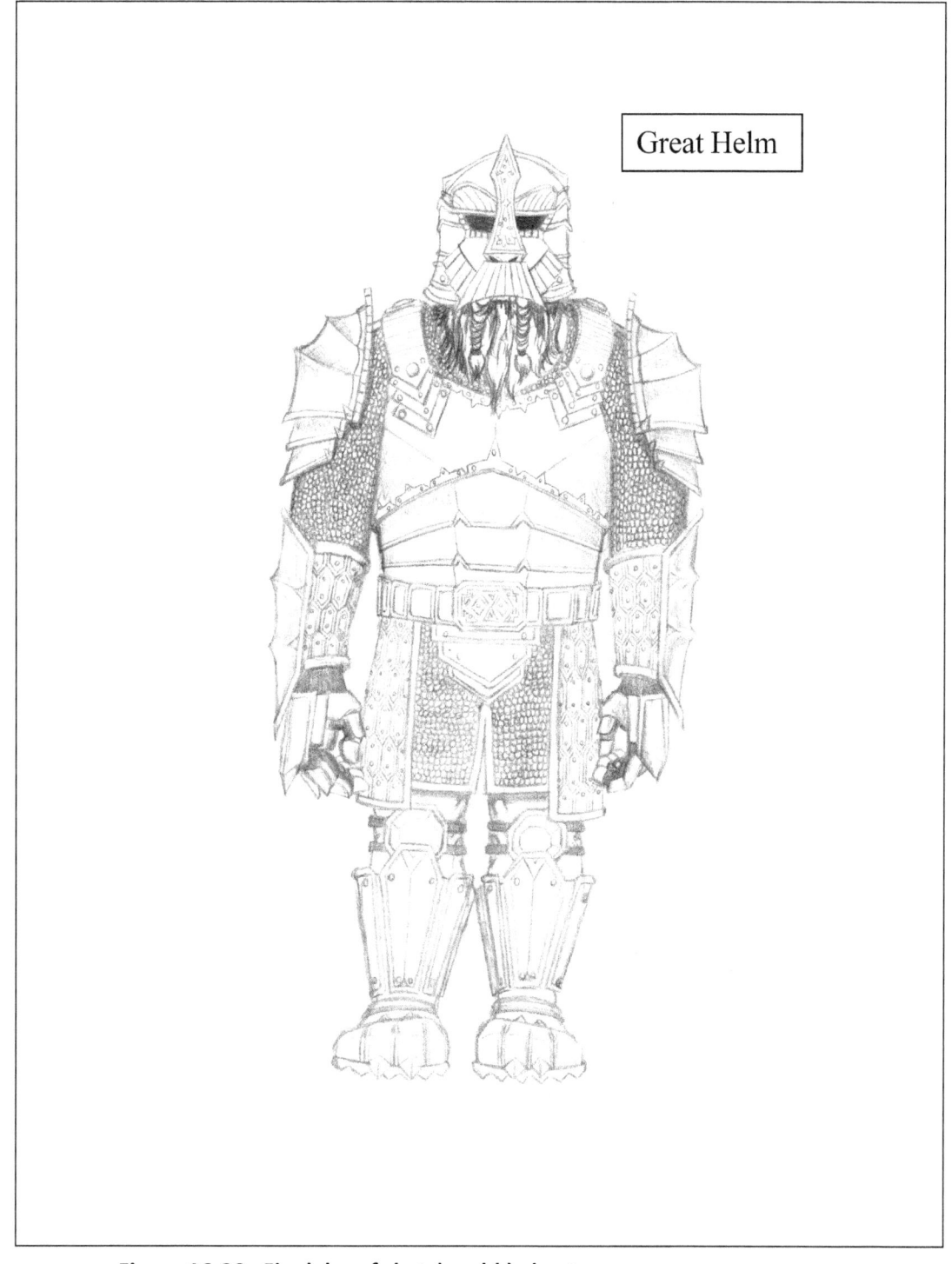

Figure 16-20. Final dwarf sketch, add helmet

After completing the dwarf, the ogre receives the same treatment. Refer back to the area-bubble sketches you made previously to select the body shape you like best. Refine the area-bubbles and then add muscles and skin. When you've finished the body, begin developing its clothes and gear.

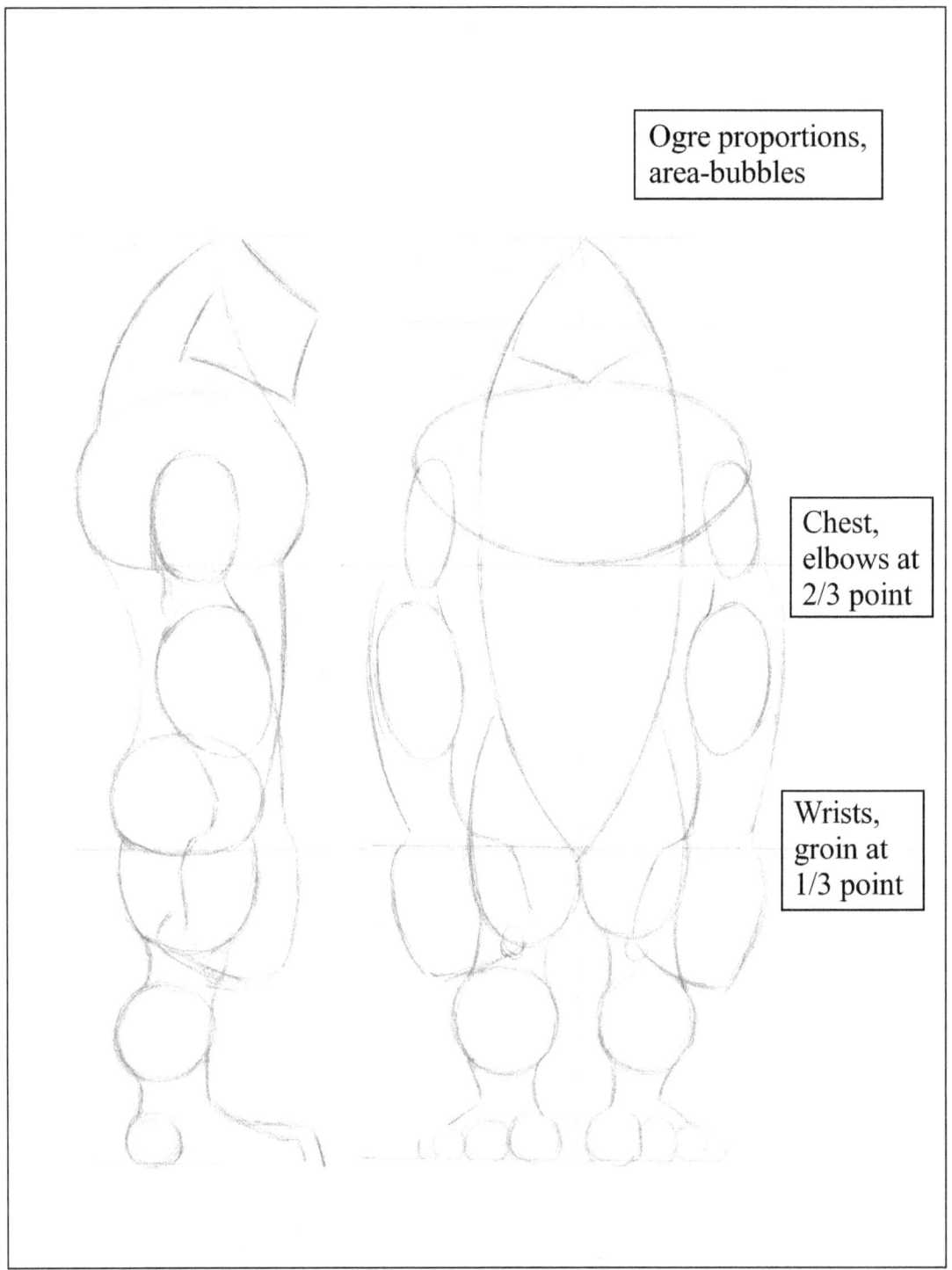

Figure 16-21. Refined ogre body shape using area-bubbles

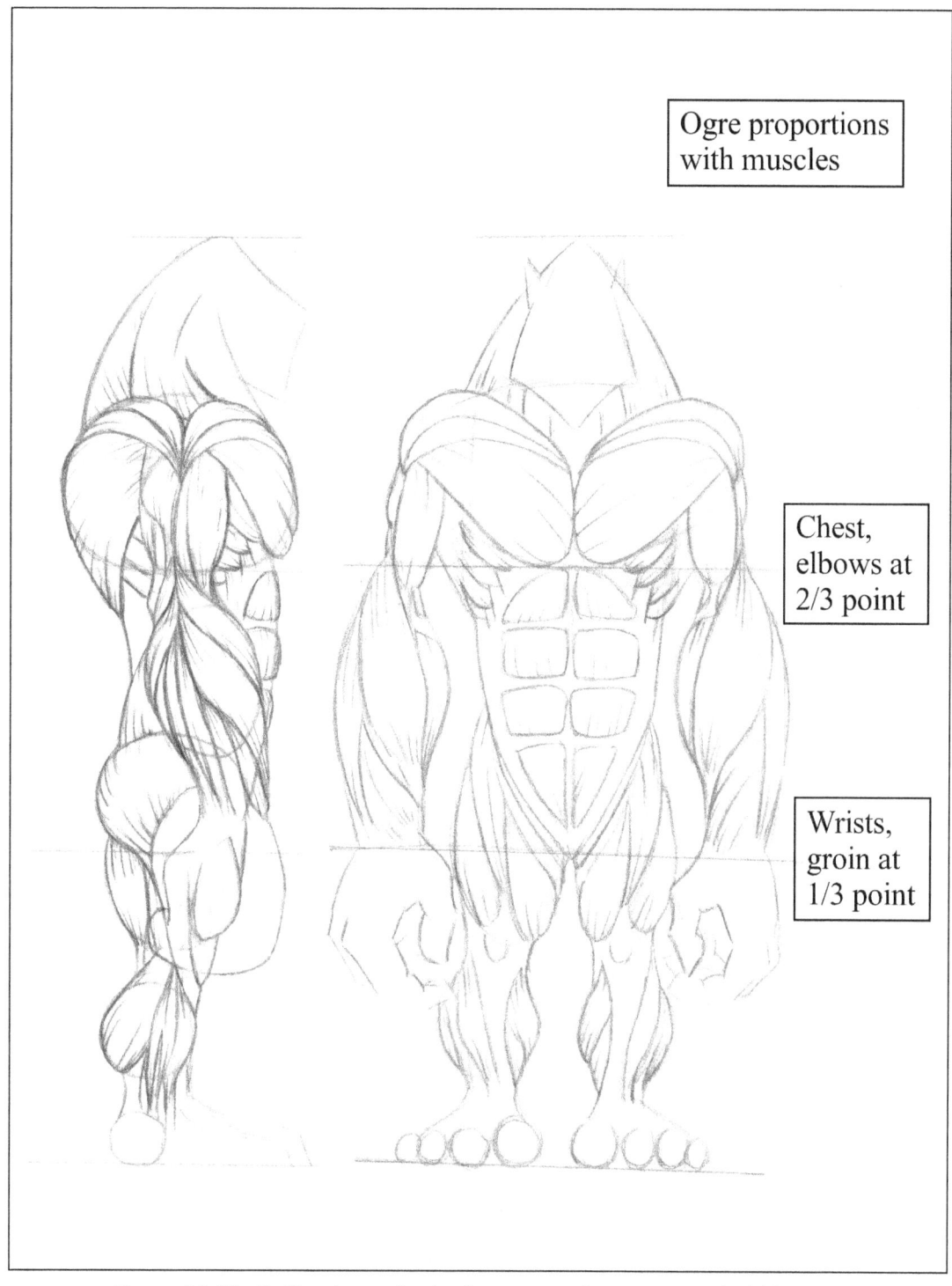

Figure 16-22. Refined ogre body shape, muscles over area-bubbles

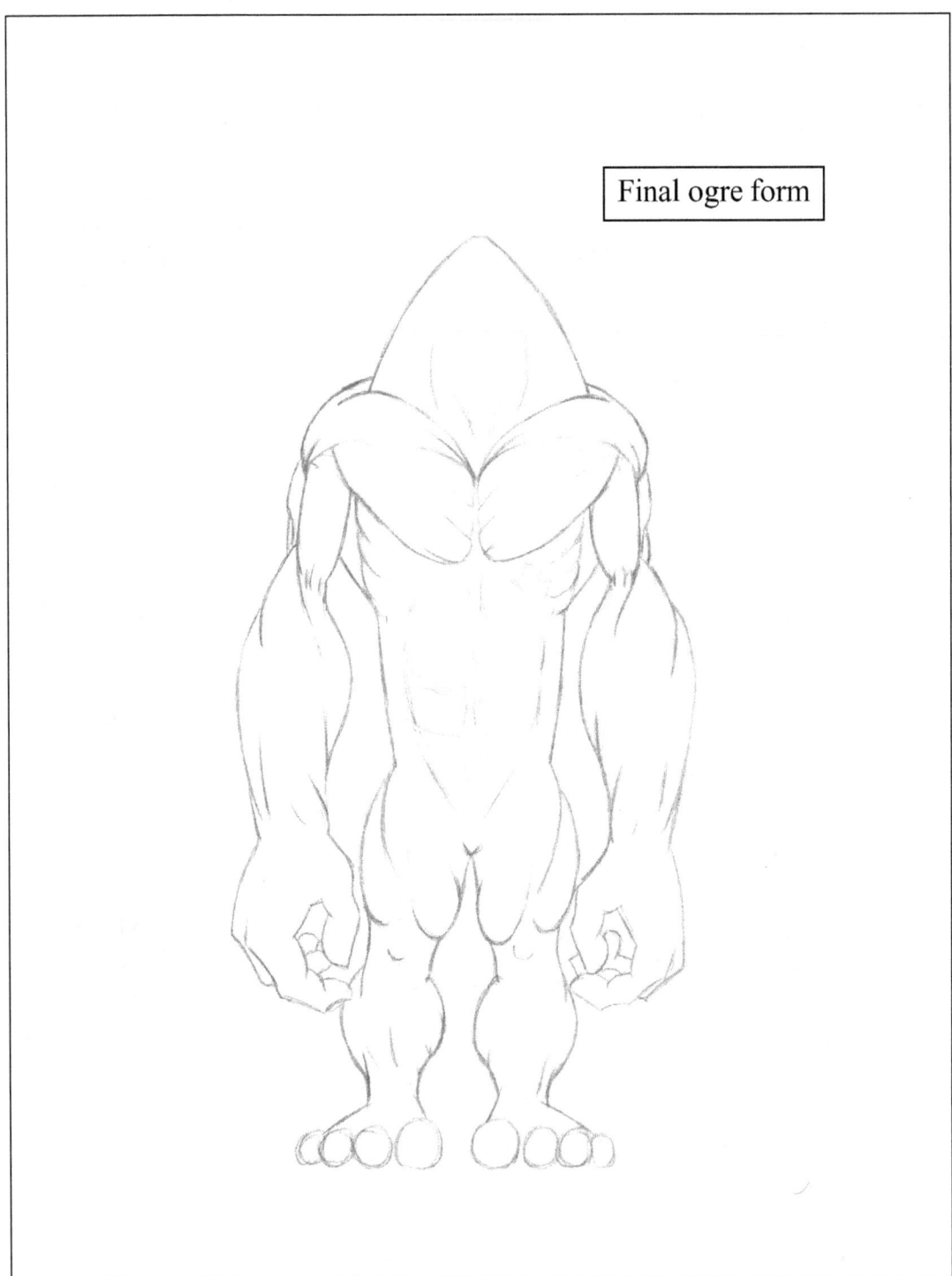

Figure 16-23. Basic ogre body shape

The ogre body is humanoid but quite different in proportion to a human or dwarf. For example, the torso and head of humans and dwarfs are roughly half the total length of their bodies but the torso and head of this ogre is about two-thirds the length of its body; this makes the ogre very top-heavy. The ogre also has very long arms. These extreme proportions warrant a more detailed look at how the ogre might move and some of the positions he could be in and still maintain balance. Several small sketches were done to explore this. You can see that in order to stay balanced, the ogre must either take a wide stance or post an arm on the ground if it leans in any direction. These sketches aren't required but they do help illustrate how this particular ogre would move and they'll help during the initial layout of the final drawing.

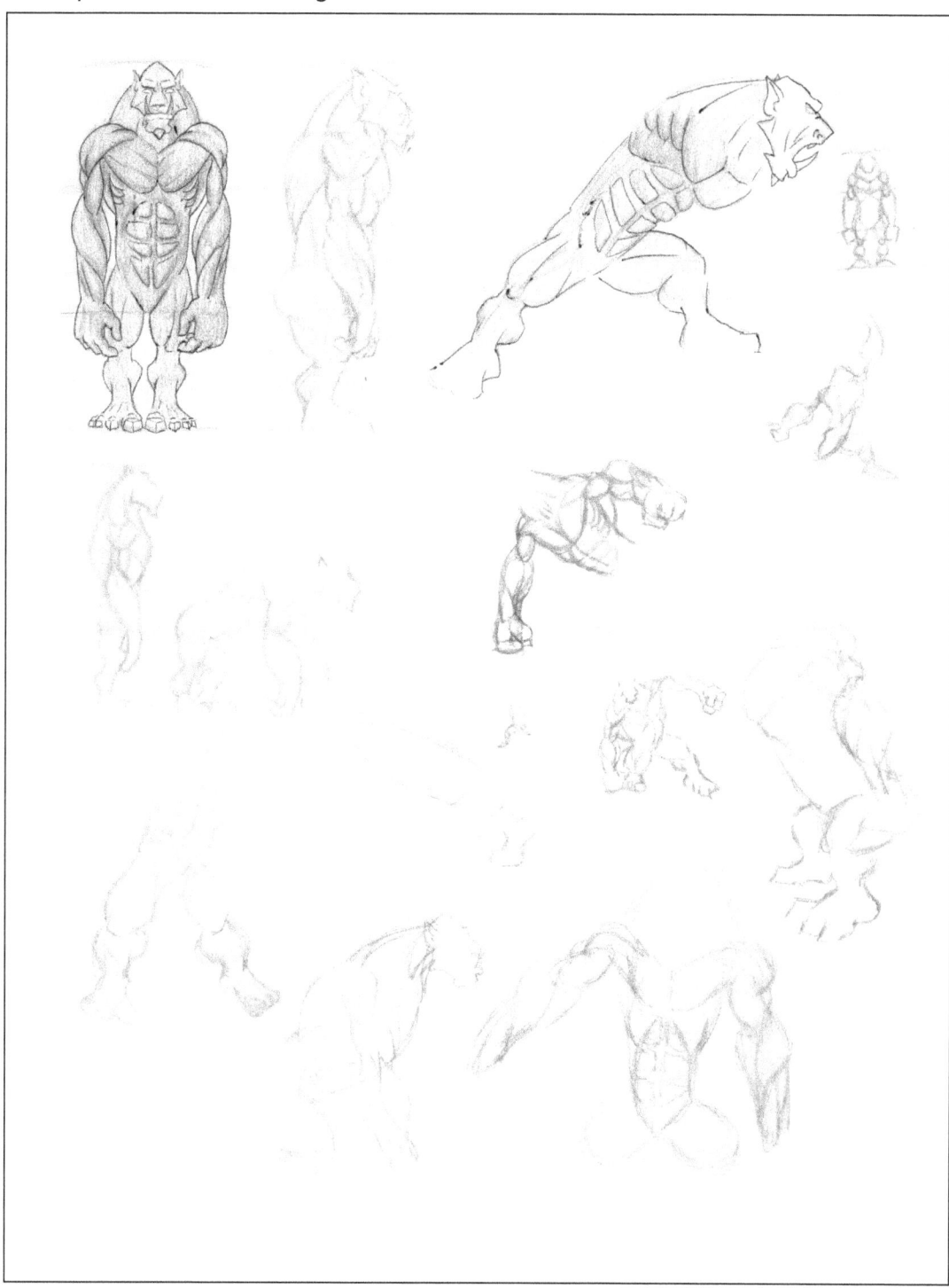

Figure 16-24. Ogre movement/position sketches I

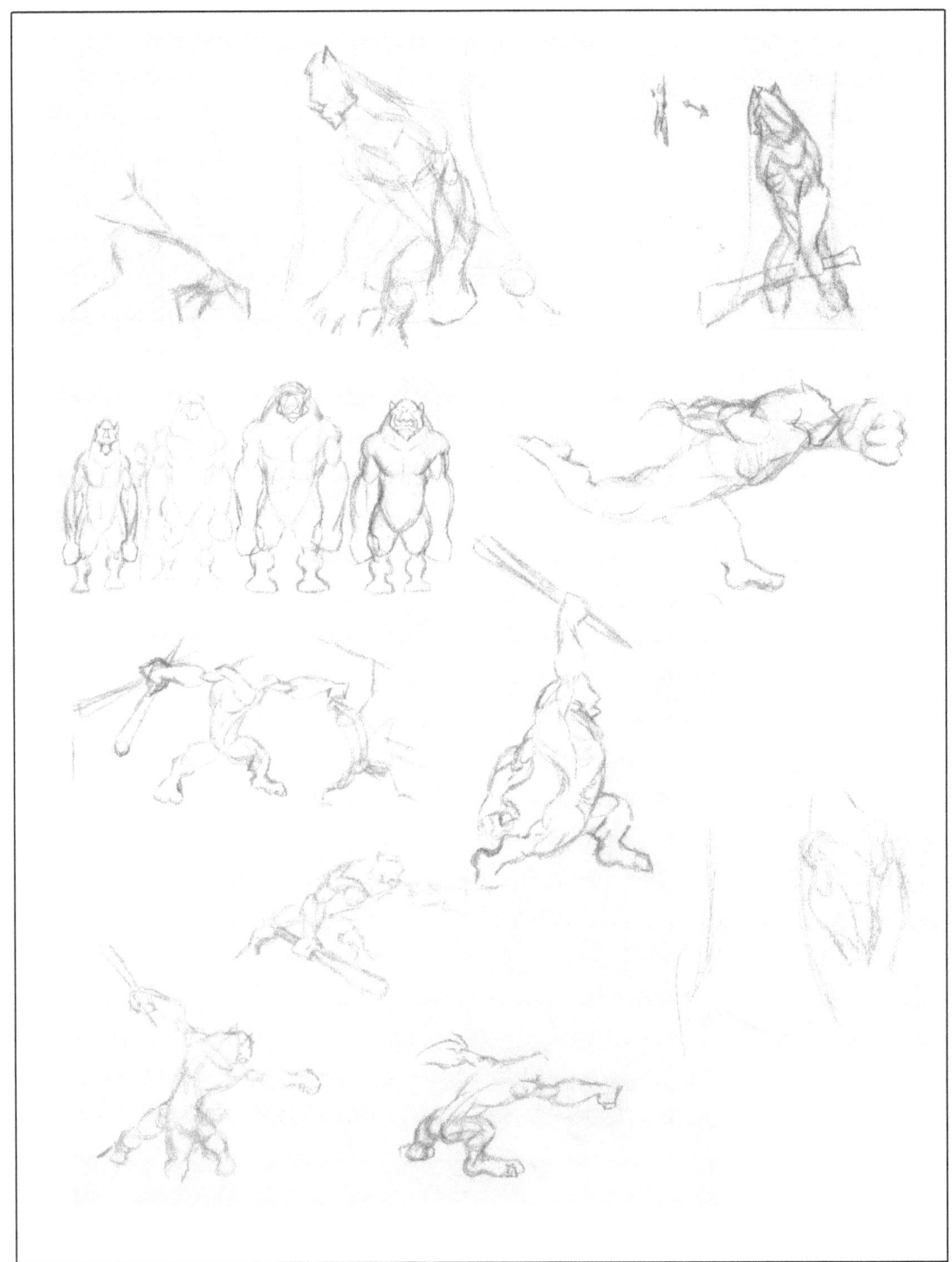

Figure 16-25. Ogre movement/position sketches II

With the basic body shape for the ogre complete you can begin sketching details such as clothes, weapons, armor, and faces. These sketches will be used to create the final appearance of the ogre in this drawing.

In this scenario, I'm going to assume this ogre is an ogre champion, therefore he's going to have the finest armor and weapons that ogres can make. Ogres are not regarded as great craftsmen but I can make some assumptions before I start which will help direct my sketches. First I'm going to assume that ogres live in at least some sort of society in which they can help each other and work together. Next, I'm assuming they have a basic ability to forge metal and can use simple rivets to secure pieces of metal together. Lastly, I'm assuming they can sew clothes from leather with heavy cordage. These assumptions will shape the way I develop the ogre's gear. Your personal assumptions about ogres may change the gear you decide to give them. For example, if you assume this ogre is solitary and just slightly more intelligent than a chimpanzee, its gear would be significantly different. It would probably be very basic and rudimentary, or wouldn't fit well because it's stolen from other creatures. The assumptions you make will greatly influence the final design of your characters.

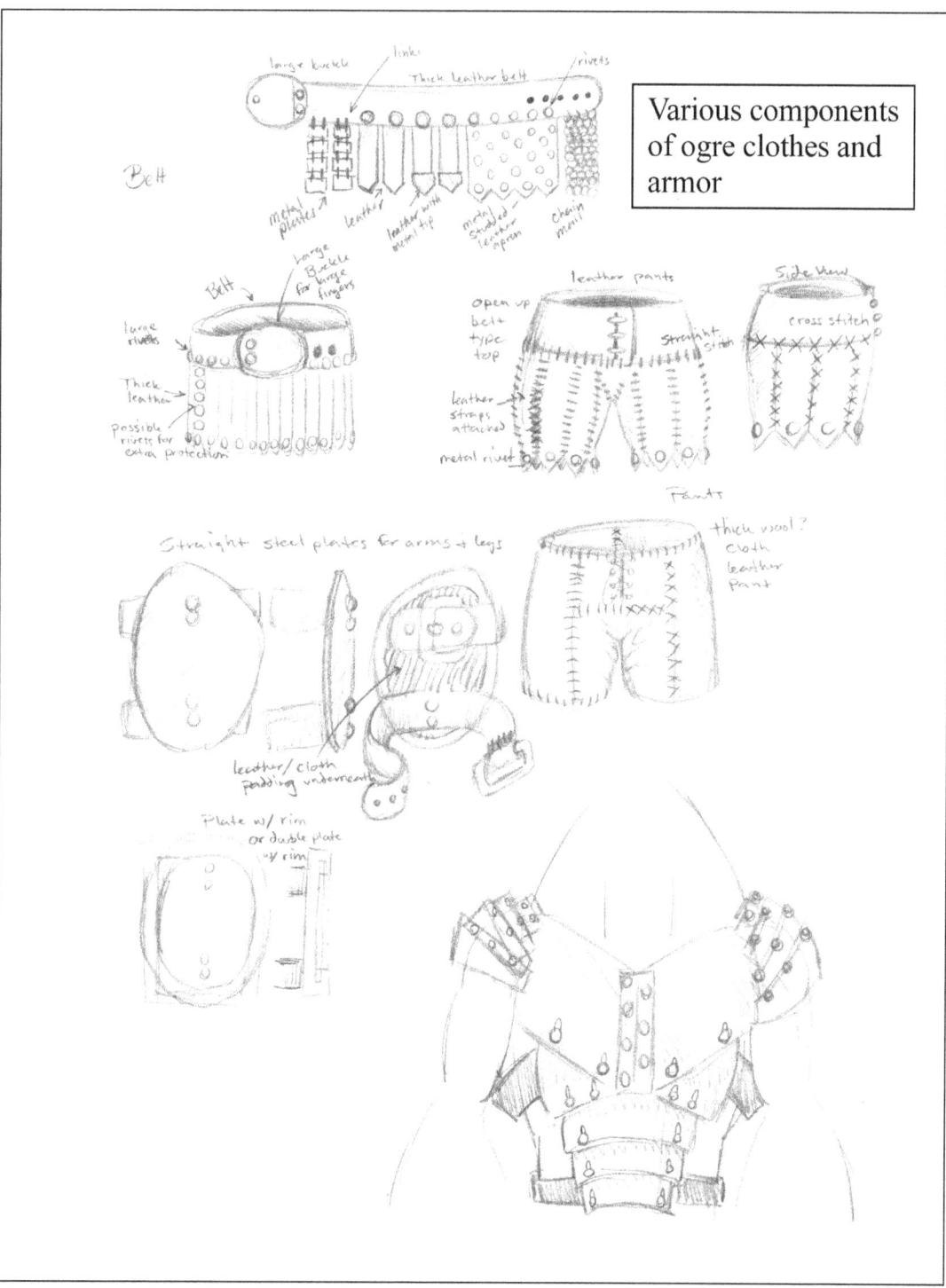

Figure 16-26. Ogre clothes and armor sketches

95

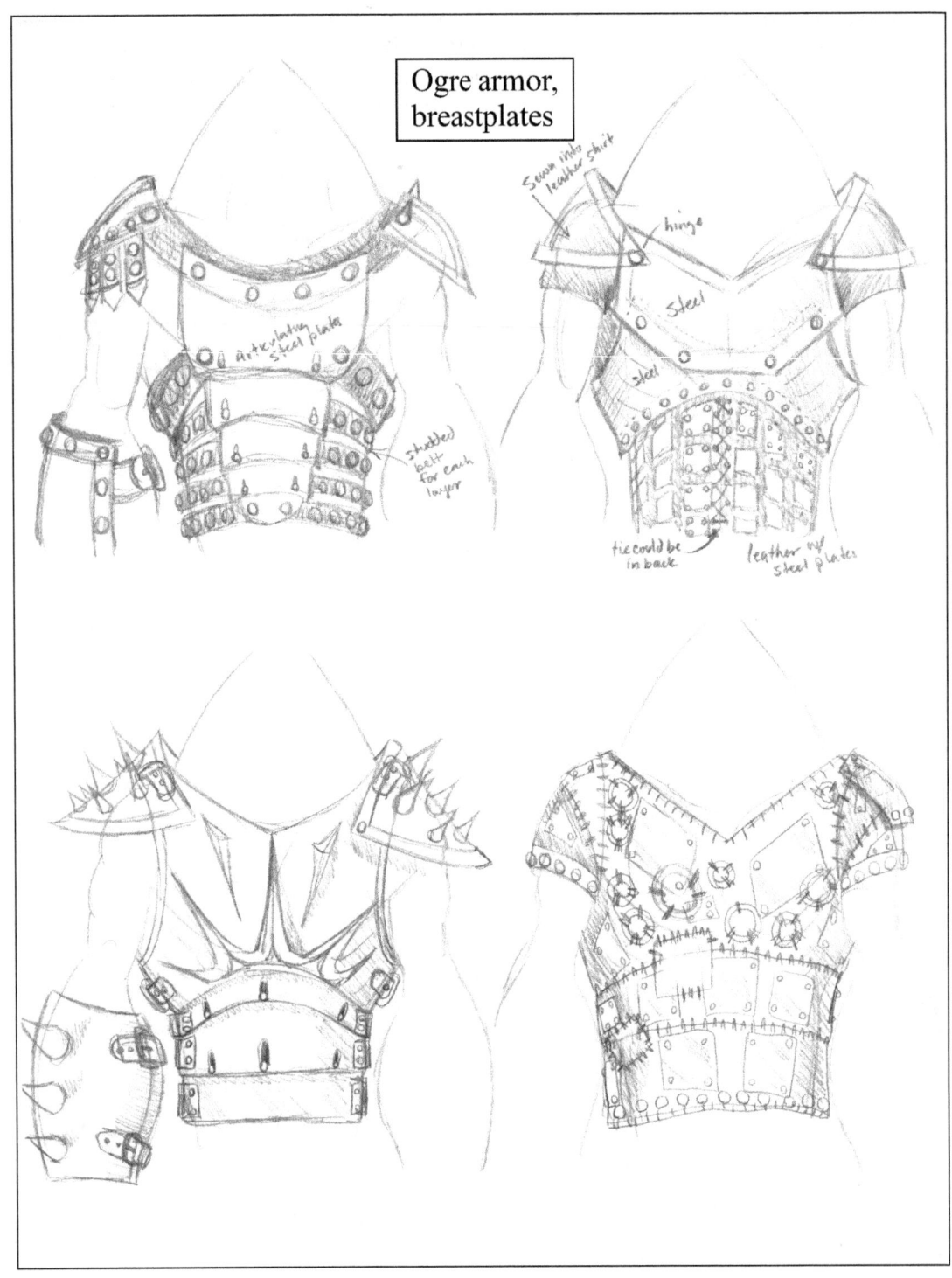

Figure 16-27. Ogre breastplate sketches

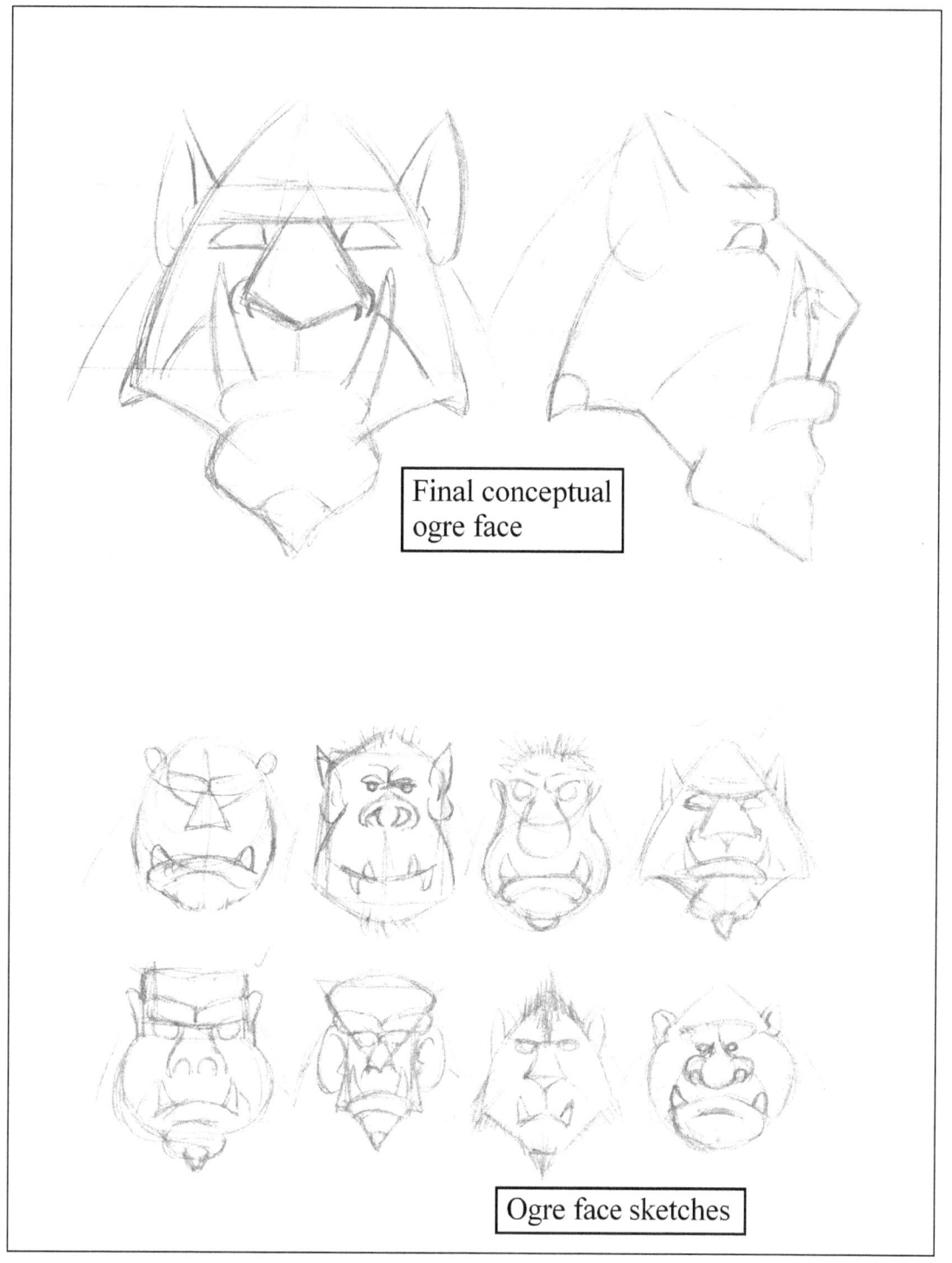

Figure 16-28. Ogre face sketches

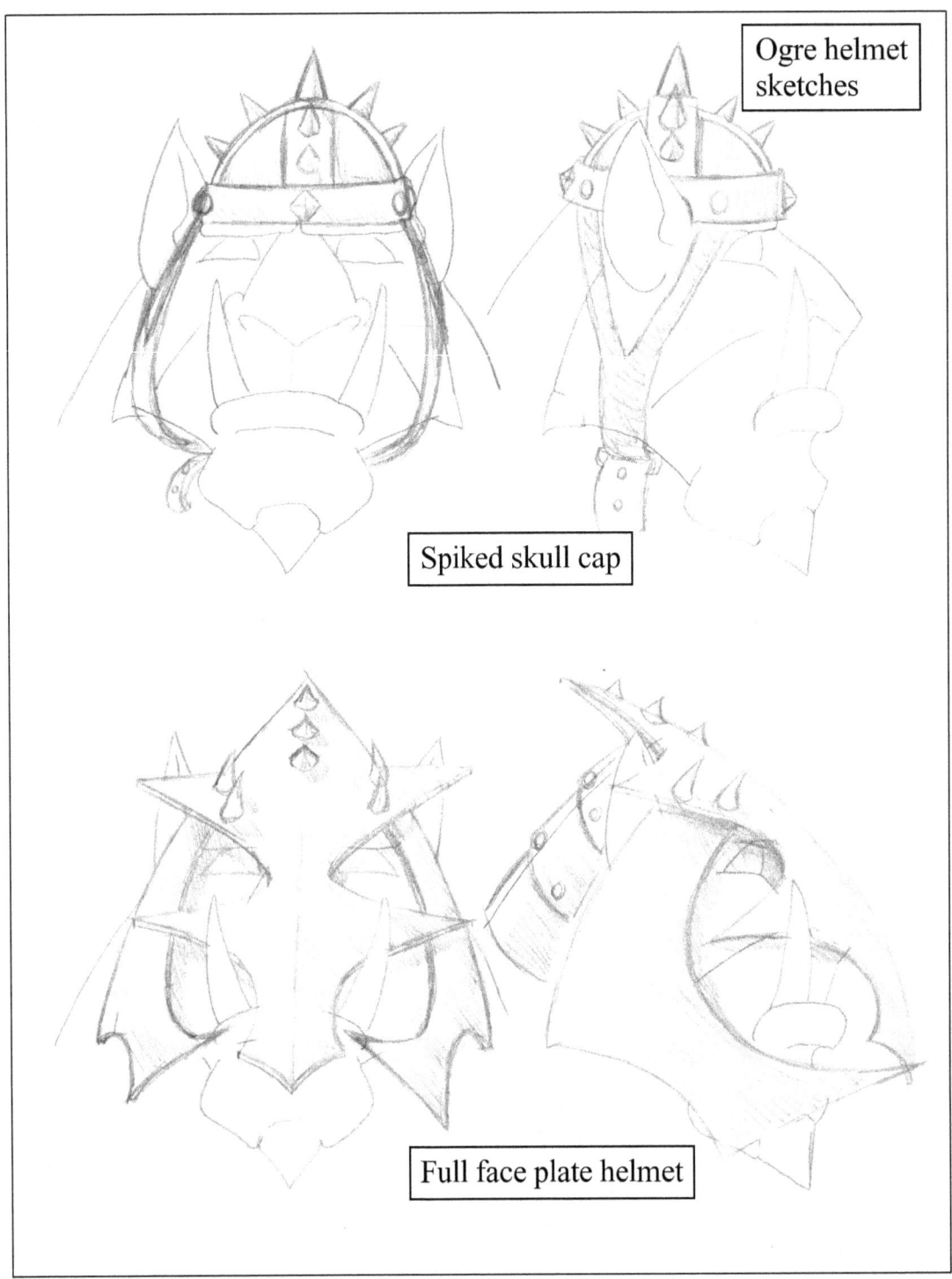

Figure 16-29. Ogre helmet sketches I

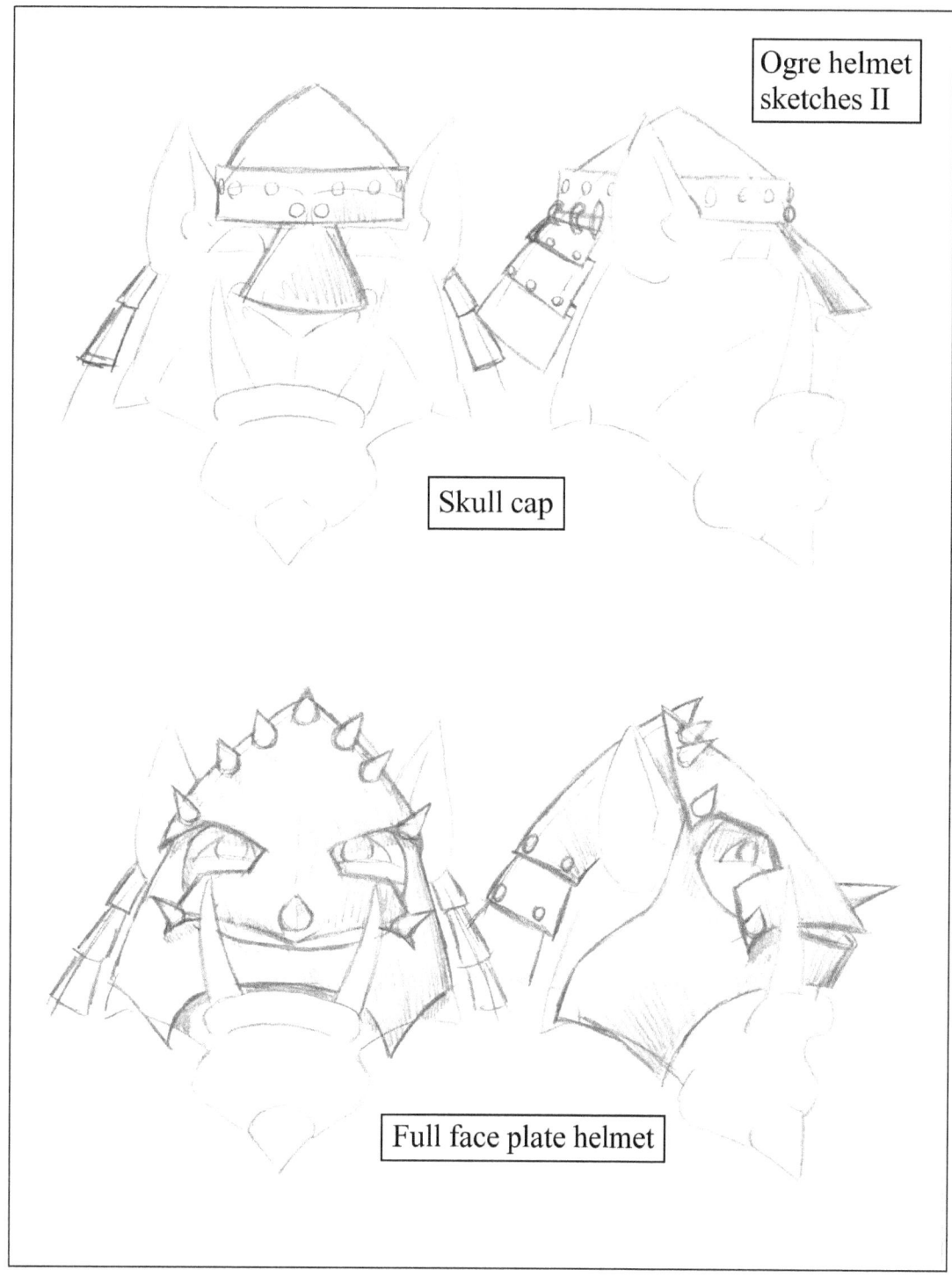

Figure 16-30. Ogre helmet sketches II

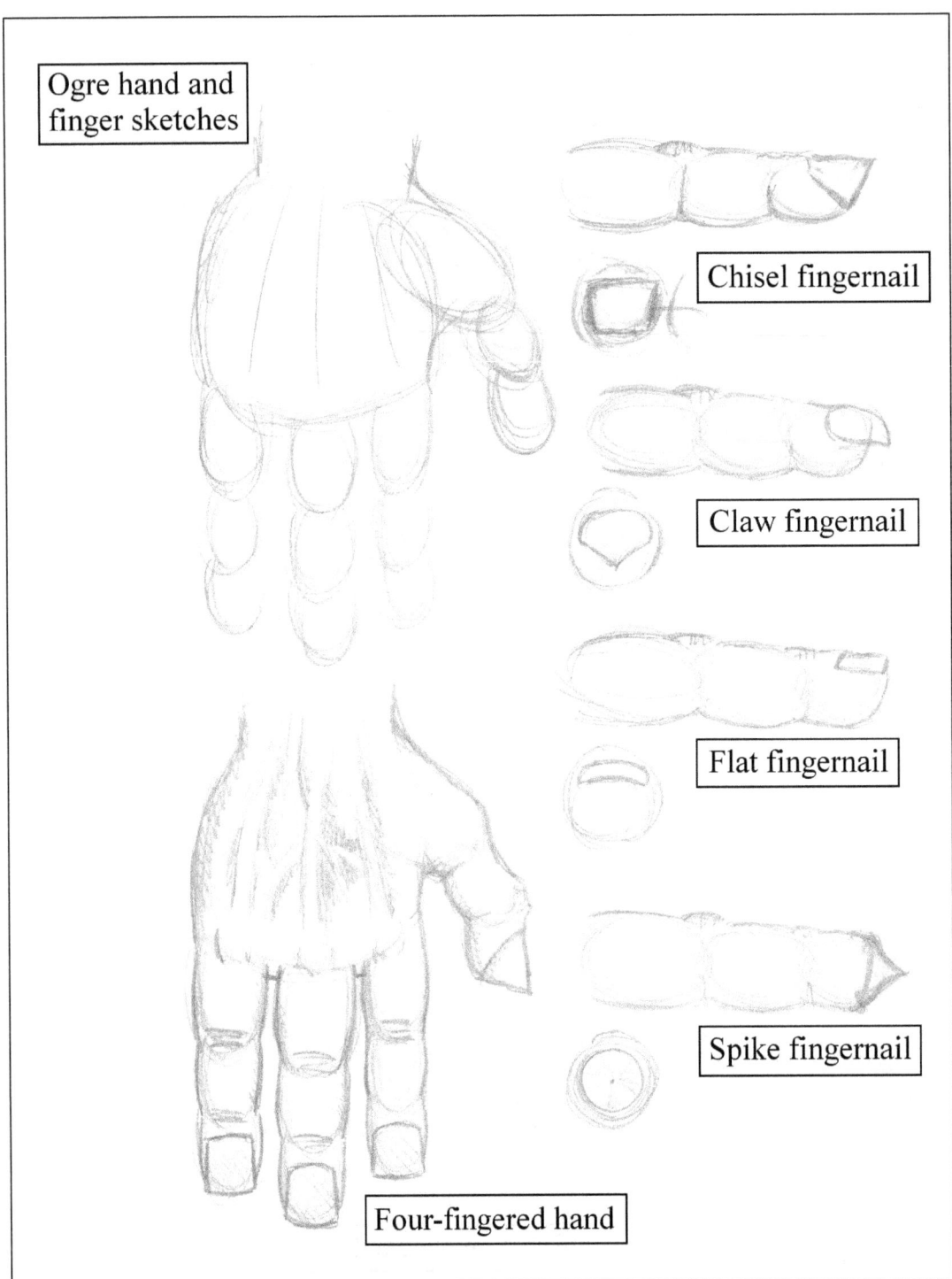

Figure 16-31. Ogre hand and finger sketches

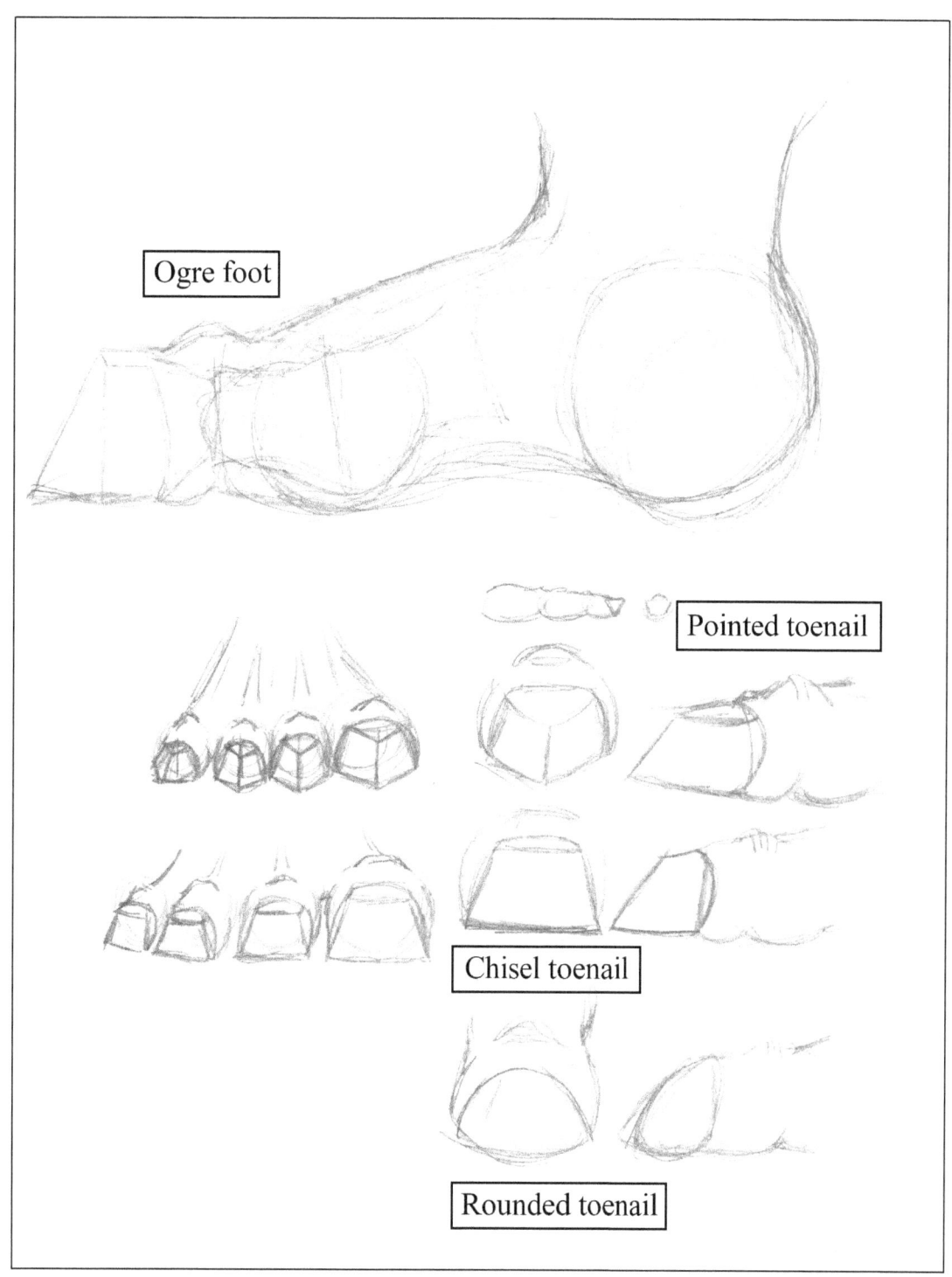

Figure 16-32. Ogre foot and toe sketches

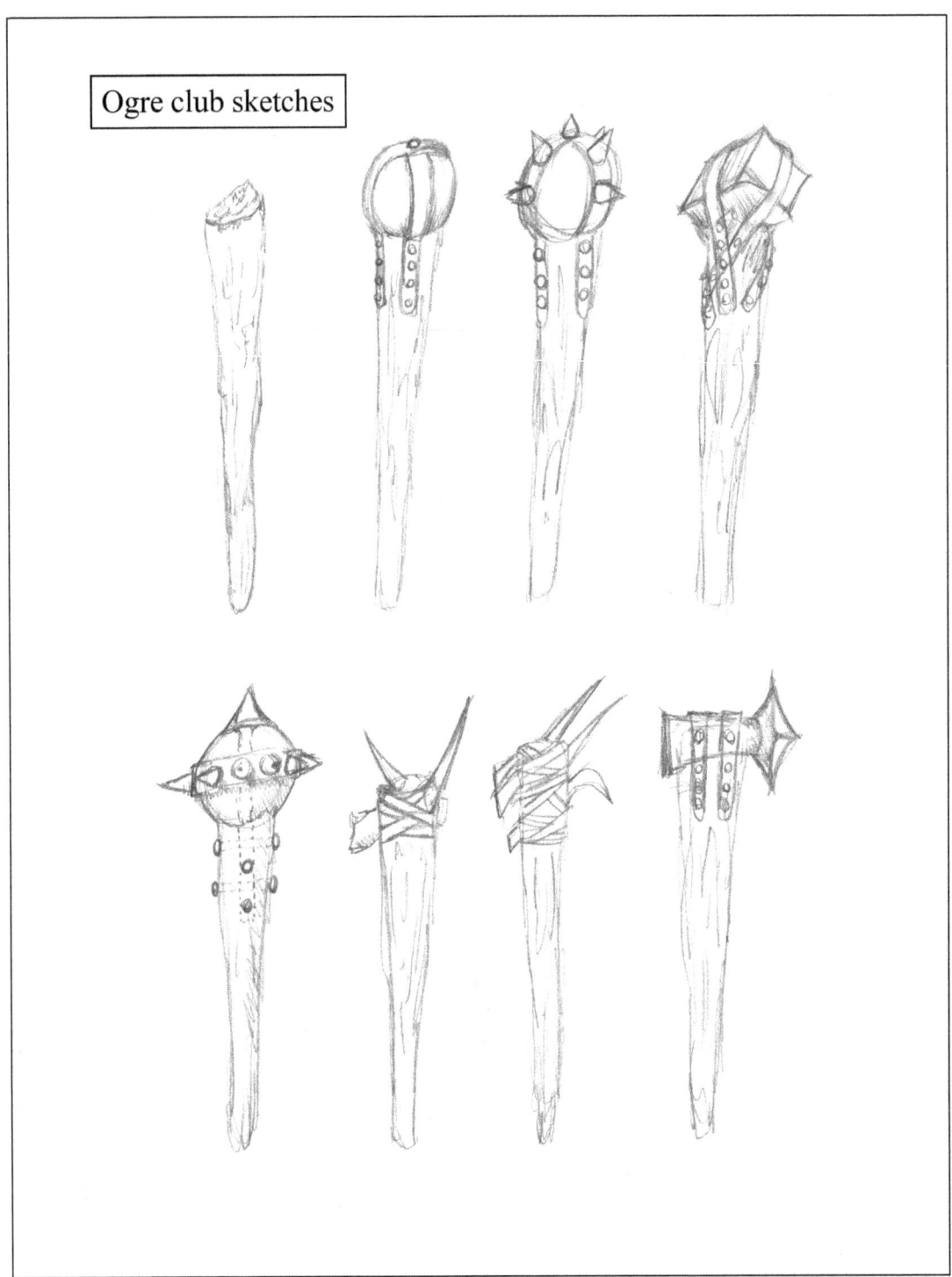

Figure 16-33. Ogre weapon sketches

With many sketches of clothes, armor, weapons and facial features done, go back to the ogre body sketch and start adding the components you like best. As stated before, this is an ogre champion so it's assumed to have the best gear an ogre can have. The outfit developed below is based on several of the sketches done previously but the final outcome is unique. The armor is somewhat fantastic but also relatively basic due to our assumption that ogres are not great craftsmen.

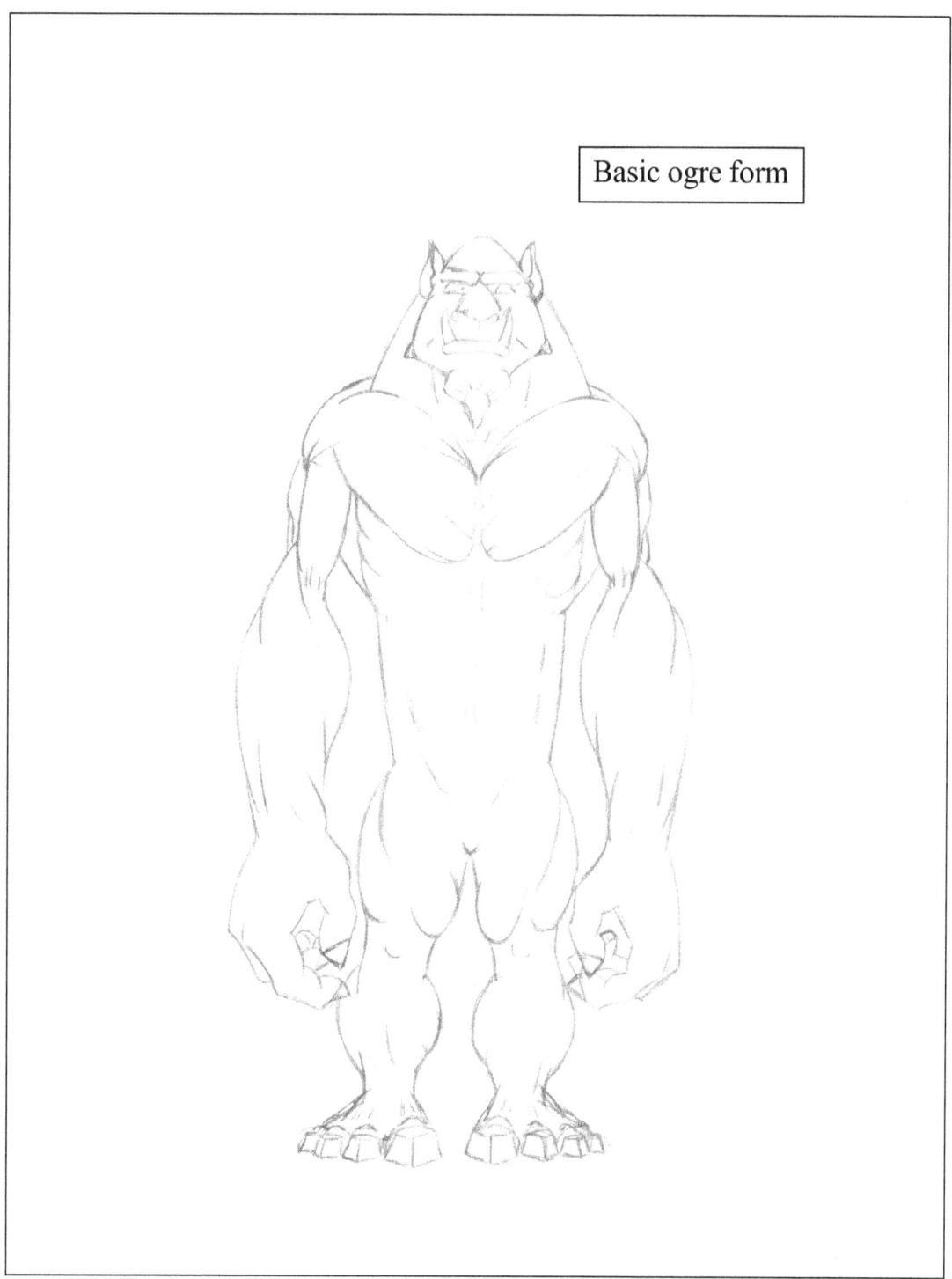

Figure 16-34. Final ogre sketch

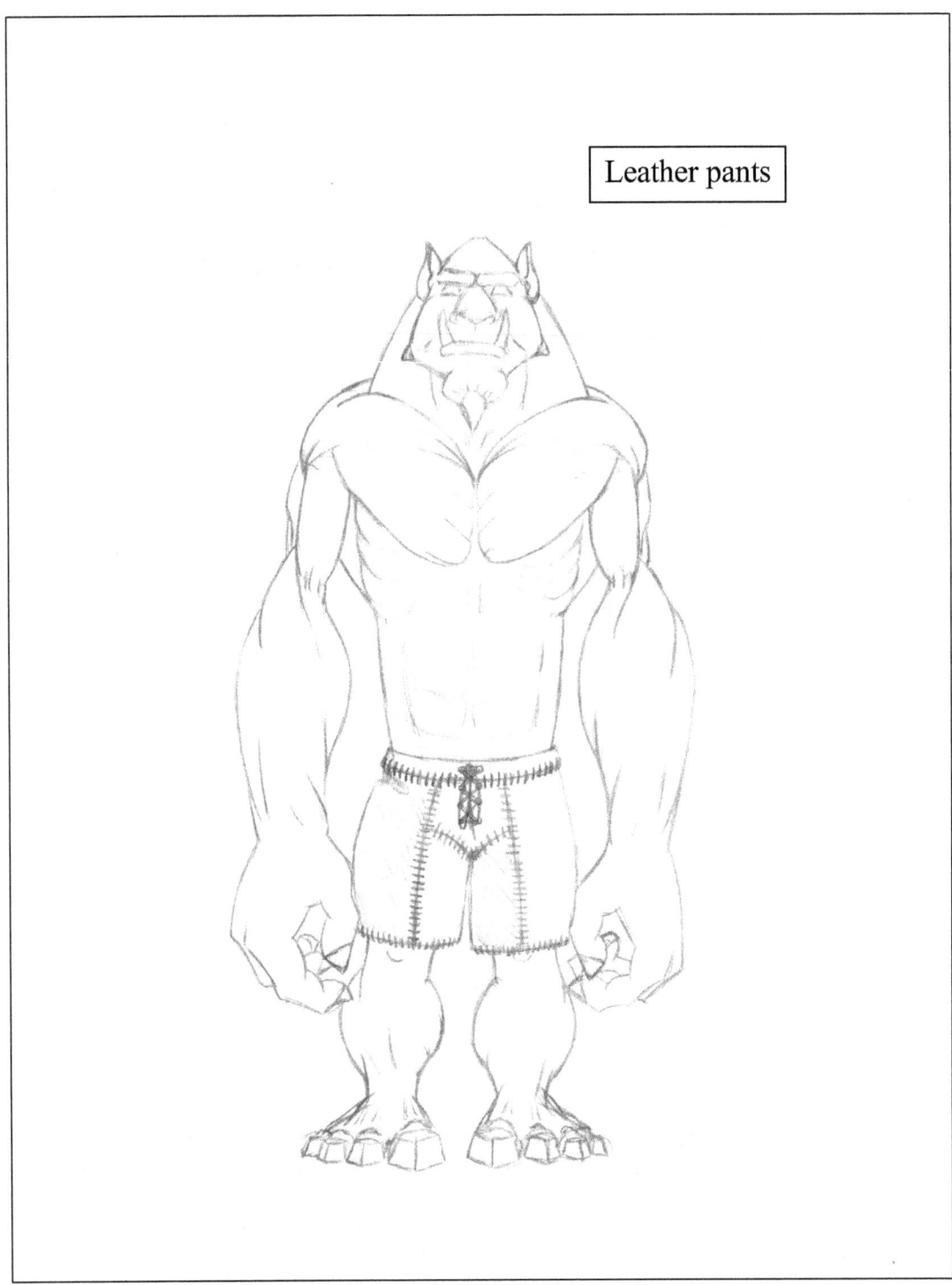

Figure 16-35. Final ogre sketch, add crude leather pants

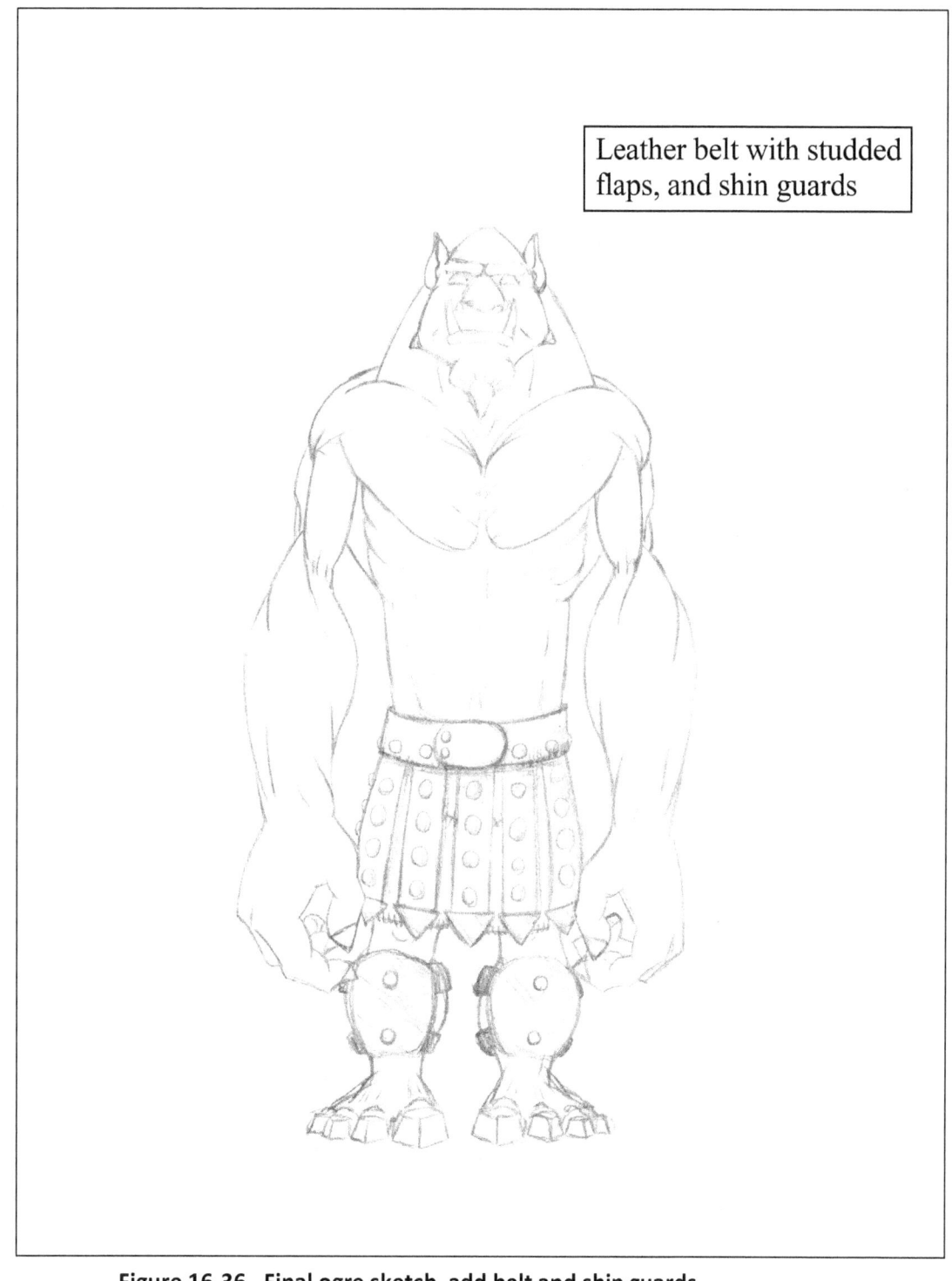

Figure 16-36. Final ogre sketch, add belt and shin guards

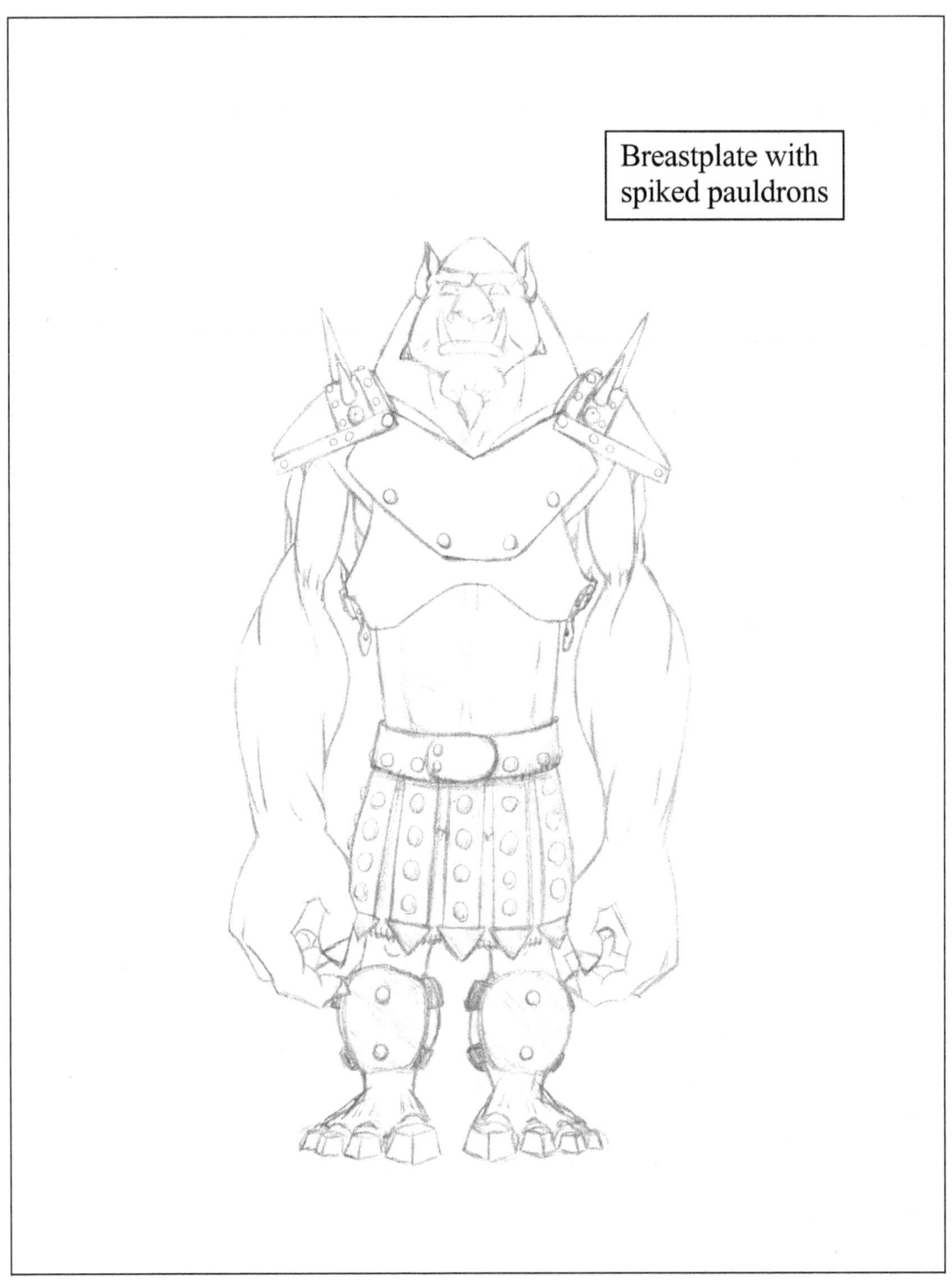

Figure 16-37. Final ogre sketch, add breastplate and spiked pauldrons

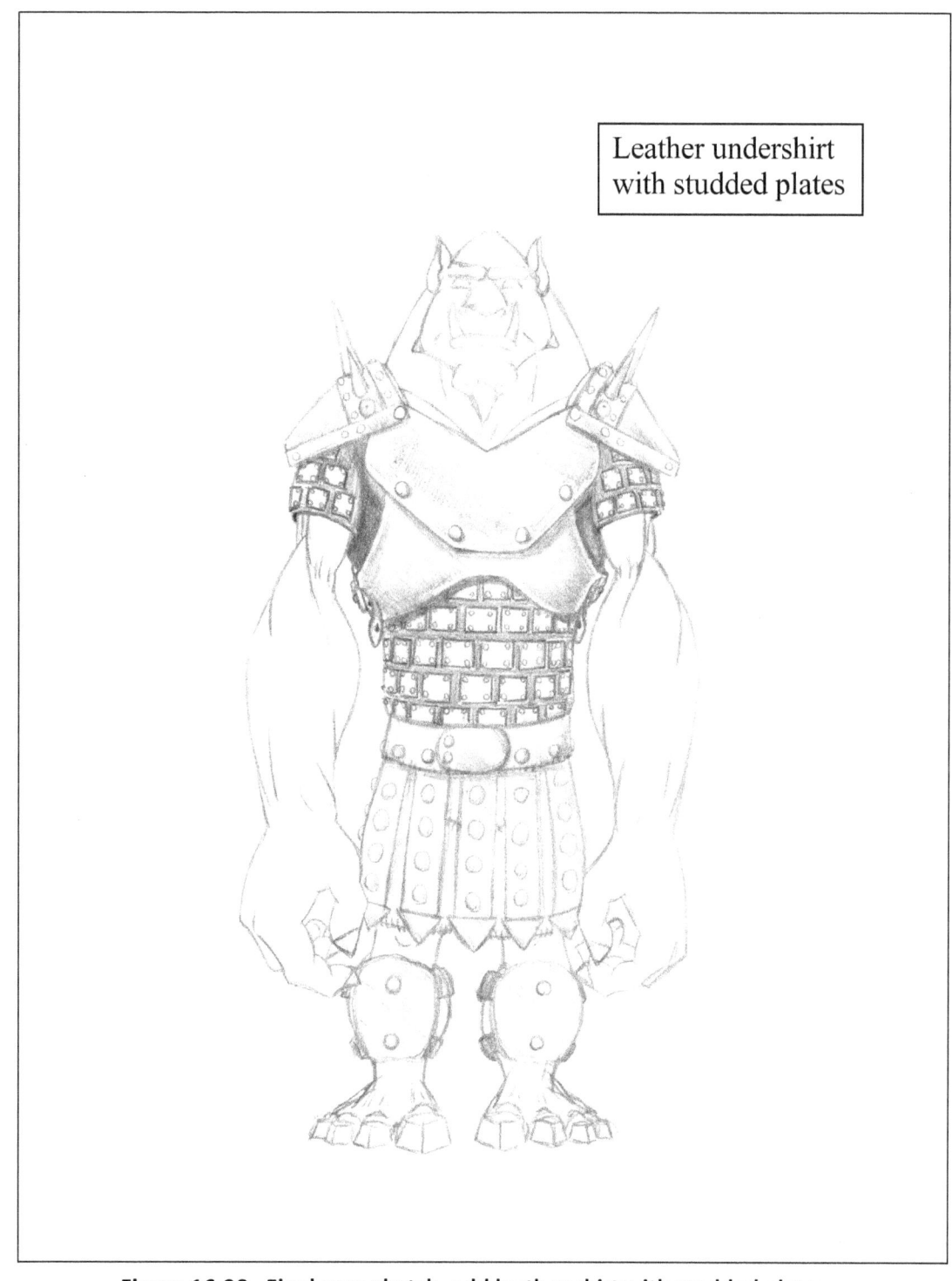

Figure 16-38. Final ogre sketch, add leather shirt with studded plates

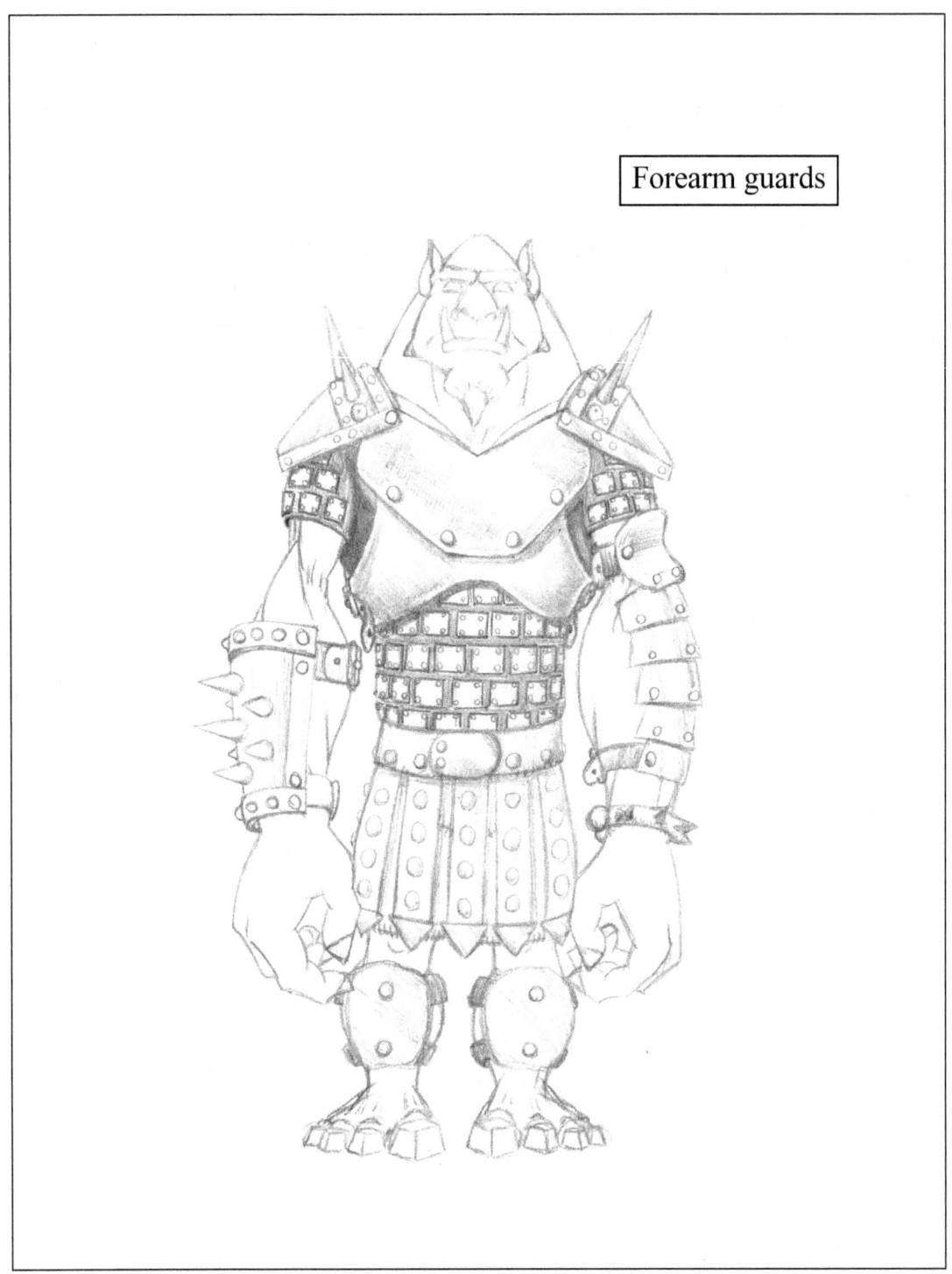

Figure 16-39. Final ogre sketch, add forearm guards

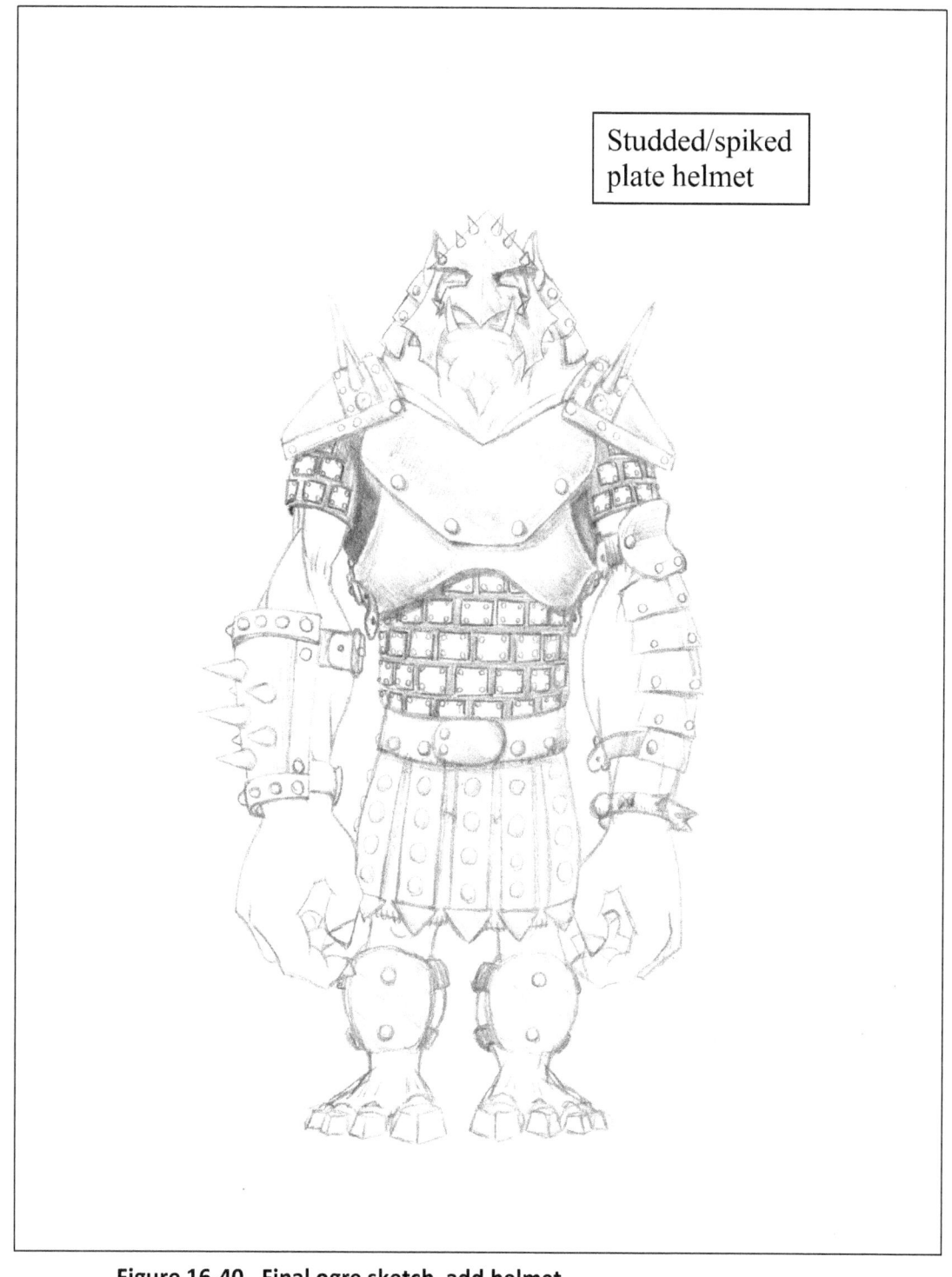

Figure 16-40. Final ogre sketch, add helmet

With the dwarf and ogre sketches complete, do one final sketch and place them side by side to create a sense of size and scale. You're free to make some assumptions about the size of each character however, ogres are typically very large and dwarfs are generally considered small; viewers will understand your drawing easier if you stick to this convention. The problem with scaling a dwarf up or down too much is that it could easily be confused with other humanoids. Too big, and it will look like a human, too small and it will look like a leprechaun or fairy. The ogre doesn't have quite the same problem because its body and facial features are different enough from a human, but if it's too small people may mistake it for something other than an ogre. The reason for you to establish a relative scale is more for your own convenience than anything else; it will help you during the lay out of your final drawing.

An easy way to scale the dwarf and ogre is to divide a paper into even intervals and draw area-bubble sketches of each, side by side. For this drawing I'm assuming ogres are between 8 and 9 feet tall, and dwarfs are between 3-1/2 and 4 feet tall.

Figure 16-41. Relative size sketch, ogre vs. dwarf

Inking

The drawing project in this lesson will be finished in ink which is a new medium to the Drawing Mentor series. Ink is a very different medium than pencil though it's by no means new; in fact, ink has literally been used centuries longer than pencils. The Chinese were known to use ink at least as far back as 2250 B.C. and ancient Egyptians used reed pens to write and draw with ink as well.

There are many different ways to apply ink; the oldest is to use a brush to "paint" the ink onto the paper, similar to water colors. India ink is a water soluble ink and can be diluted with water to make different shades of gray. These can be built up in layers to create gradients. Aside from brushes, ancient methods of applying ink include reed and quill pens. Traditional ink pens

Figure 16-42. Pen shading techniques

Figure 16-43. Pen shading techniques on shapes; crosshatching, random hatching, and dots

are composed of a shaft with interchangeable nibs. The different nibs can be used to create lines of different thicknesses and shapes. They're designed to hold a small quantity of ink that slowly flows out as you draw or write. Ink nibs should be used mainly with a pulling stroke as pushing the nib can cause the ink to splatter, and they should always be cleaned when you're finished using them. Modern pens of course include various felt tip

pens and markers that can be used in any direction and also come in several sizes, tip shapes, and colors. The most common tool for applying ink is the standard ballpoint pen. Ballpoint pens, though common and not generally considered an artistic tool, can be very versatile if used correctly, but like any tool, practice is required to become proficient.

Figure 16-44. Pen shading an arm with hatching

Figure 16-45. Pen shading an arm with dots/stippling

Ink, unlike pencil, is very permanent which can be intimidating to beginners. Ink-only drawings can be challenging and unforgiving as it's impossible to erase mistakes; however, embracing the likelihood of mistakes and continuing on regardless will yield drawings that reveal a rawness and spontaneity that you rarely find in pencil drawings. A more common way to use ink in drawings is to start with pencil to lay out the drawing and then to ink over it. This technique can create vibrant pieces full of contrast and life. Either way, ink is an exciting medium to work in. One of the great things about ink drawing that makes mastering it worth the effort is the clean vibrant and often detailed appearance of finished pieces of work.

Many inking techniques are similar to the ones used with pencils, with the exception of smudging and erasing which are nearly impossible to use with any great effect. Creating tones with pens usually depends on the density or closeness of the lines, the closer the lines the darker the tone. The four most common techniques that utilize this concept are: hatching, crosshatching, random hatching, and stippling (using dots). You will notice that these are some of the same techniques used in pencil drawings as discussed in Volume 3. Figures 16-42 and 16-43 show examples of these techniques used to create gradients in tone. Though they are similar to pencil techniques you should still practice them with a pen before you try them on a finished drawing.

Another shading technique using ink, which is done best with a ballpoint pen, is gradient shading. This technique involves drawing extremely light lines side by side and on top of each other, relying mainly on the roughness of the paper's surface to take just a very small amount of ink per stroke. Doing this, one can closely approximate the effect of smudging, or gradually increasing the pressure of a pencil. The goal is to add just a small amount of tone while trying to avoid drawing solid lines. This technique can be challenging and it takes practice to become proficient at using the correct amount of pressure. A helpful tip when attempting this type of shading is to only touch the pen to the paper on the downward stroke. Figures 16-44 through 16-47 show a forearm and hand shaded using various techniques. Figure 16-46 illustrates the results of gradient shading.

You may not like using ink as much as pencil but hopefully, as you use it in this lesson you will at least come to appreciate it and what it can add to your work. Here are some helpful tips to keep in mind as you work in ink:

Do your best to keep your pen tip clean as you work. When using a ballpoint pen some of the unused ink from each stroke can build up on the tip. If you don't regularly clean it off on a scrap piece of paper, globs of ink may roll off onto the paper and possibly smear.

Be careful of smudging. Although it's difficult to smudge ink to produce the same effect as pencil, ink will smudge unless it's totally dry. Do your best to not touch the ink until it's dry, and be aware of any loose clothing that may wipe across it too. It's almost impossible to cover up or fix an ink smudge.

Figure 16-46. Pen shading an arm with gradients

Learn how to use various marks. Lines, hatching, circles, squiggly lines, etc., will all create different effects. Practice as many different strokes as you can think of to learn the textures they produce.

Be careful about using too much tone. Ink tone is very powerful and it's possible to get carried away adding

Figure 16-47. Pen shading an arm, two-tone

tone to the point where a drawing becomes unbalanced. Stop often to assess the progress of tones in your drawing.

Embrace spontaneity. Ink is more or less permanent so be willing to just go with it. If you think you've made a mistake, continue anyway and see what happens. You may surprise yourself.

Experiment with different tools. Don't confine yourself to just using ballpoint pens, try drawing with nibs, brushes and markers too. Each tool has its place and value, and enjoyment can be found in using each one.

Step by Step Exercise

After researching the subject extensively it's time to begin the final drawing. Feel free to copy the example in this lesson or just follow the steps as you develop your own drawing.

Brainstorming

A significant amount of time was spent developing characters for this drawing and now it's time to bring them together. Sketching was used to create the characters and now it's used again to brainstorm their layout, and positions.

The ogre is big enough and strong enough to pose a threat to several dwarfs at once. This drawing will feature the one ogre champion battling many dwarf soldiers.

The physiology of the ogre is the more complicated of the two so more time was put into exploring its body position. The ogre should look powerful and dynamic; a mid-swing stance will accomplish this. Many of the sketches explore wide foot placement and extreme hip and shoulder rotations to convey power in the swing of its club. The

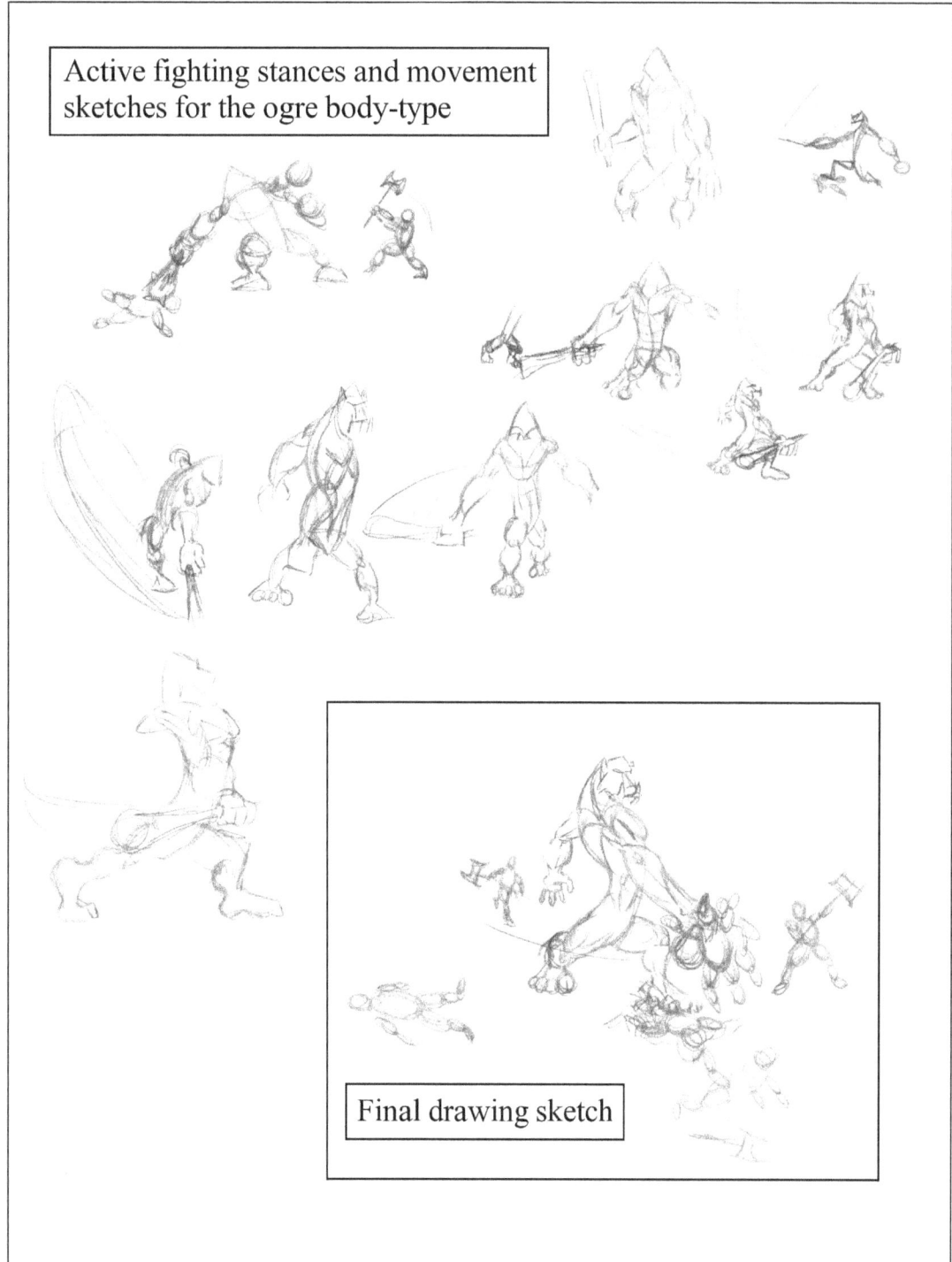

Figure 16-48. Final drawing sketches

dwarfs were simpler as their form is similar to a human and they're basically just cannon fodder for the more powerful ogre. Their stances should still be dynamic and intense; after all this is a life or death situation they're in.

Figure 16-48 is a collage of several sketches done while brainstorming the arrangement of characters in this drawing, it also shows the configuration used as the inspiration and guide for the final layout.

At this point the background is not important but as dwarfs are typically mountain dwellers the terrain will likely be rocky and mountainous.

The final drawing will utilize a pencil to lay out the characters and background, and then a ballpoint pen will be used to trace over the lines and apply tone. Most of the tone will be applied using the gradient method; however, examples of other forms of shading will also be shown.

Step 1.

The focus of this drawing is the ogre so it will be large and more or less centered in the paper.

Sketch the wireframe of the ogre. Refer to the sketches of the ogre body and the final drawing layout for references. To create the appearance of power and movement the ogre has a wide stance, a substantial twist through the spine, and the shoulders are heavily angled toward the swing. The position of the head is integral to the balance of the body. If the upper body is leaning back, the head should be forward and down, if the body is leaning forward, the head can be used to counterbalance by angling it back.

After the wireframe has been completed, sketch area-bubbles over each limb, the torso, chest and head.

Use relatively light pressure to lay out the drawing. This will go a long way to making cleanup easier later on and it'll reduce the chance of an eraser damaging the surface of your paper.

Figure 16-49. Wireframe and area-bubbles of the ogre

Step 2.

The same method used to outline the ogre is now used to populate the drawing with dwarfs. Refer to the preliminary sketches of the dwarf and the preliminary layout sketch as needed.

Sketch dwarf wireframes and overlay with area-bubbles to approximate muscle volume

Within the layout of this drawing, it was possible to clearly situate about seven dwarfs around the ogre; two are being hit by the ogre's club, one is under his forward foot, one is preparing for an attack, another has been downed in the bottom corner, and two more are running toward the ogre. More dwarfs may be able to fit but this is enough for our purposes. Draw each wireframe as if there was nothing else around it; it's okay if the wireframes and area-bubbles overlap, they'll be cleaned up later. Again, these wireframes should show intensity and movement by incorporating wide stances, and large angles between the hips and shoulders.

Figure 16-50. Wireframe and area-bubbles for dwarfs

Step 3.

Now that character layout is done, refine the ogre's area-bubbles into more defined muscles. This shouldn't be difficult if your preliminary sketches include some sketches of basic musculature.

The neck and back are composed mainly of the lats and traps which are large and wide. The shoulders are divided into several long sections that originate at the base of the neck and extend to the outside of the top central portion of the upper arm. The arms are similar to humans', divided into biceps, triceps, and the several forearm muscles. The abdominals are large and wide but not fully visible because the torso is twisting away from the viewer. The quadriceps muscles are basically the same as a human's.

Finish refining the ogre by sketching the face; add the large nose, heavy set eyebrows, pointed ears, large bottom lip and tusks.

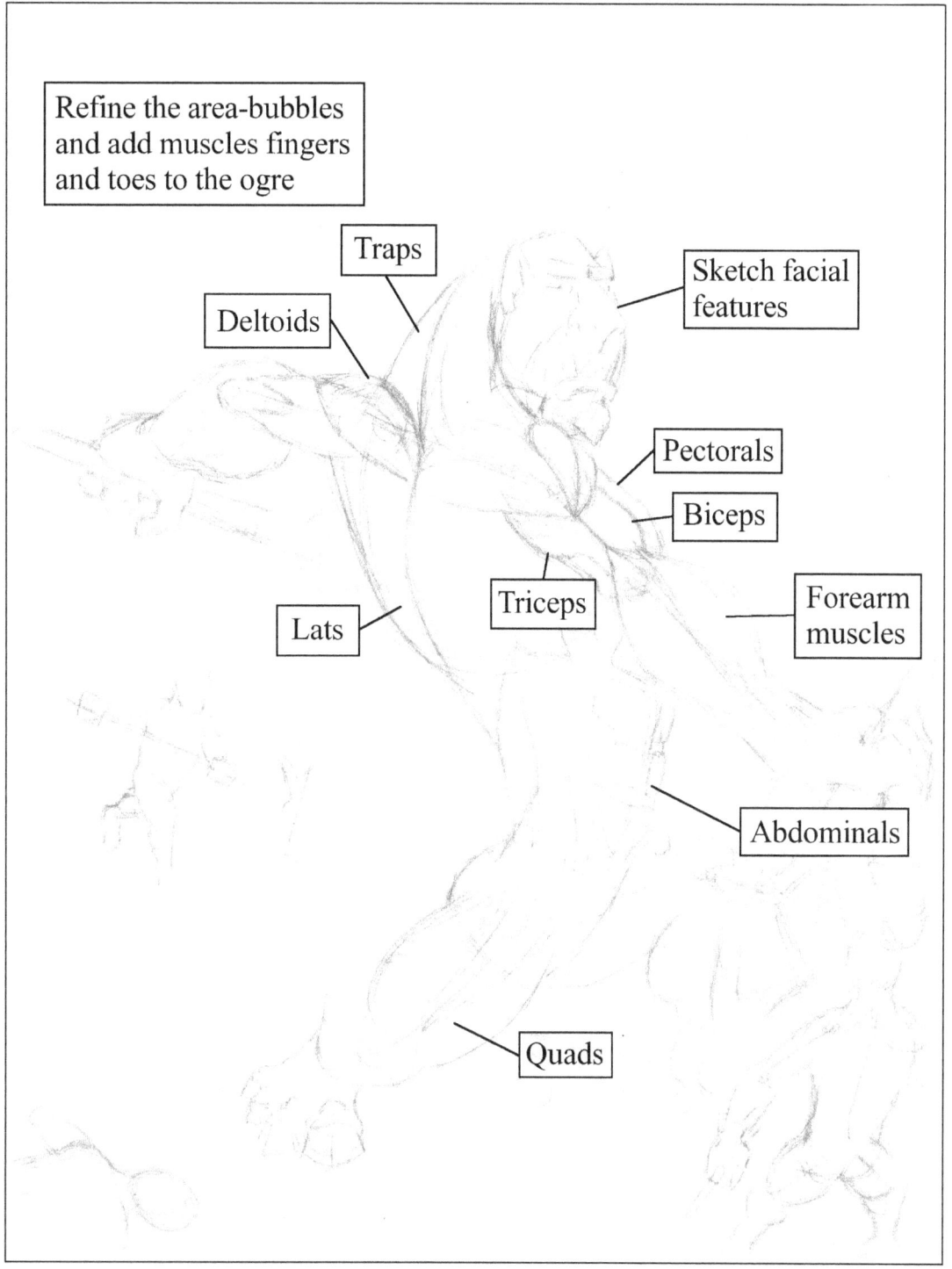

Figure 16-51. Divide area-bubbles into muscles and add facial features to ogre

Step 4.

Refine the area-bubbles for each dwarf. The dwarfs are obviously smaller than the ogre and don't need to be as detailed but the end result should be relatively well defined outlines of their bodies.

Defining the musculature of the dwarfs isn't as important as it was for the ogre because they'll be completely covered in armor. The main idea here is to make sure the proportions of each dwarf are good and that they're all roughly the same size.

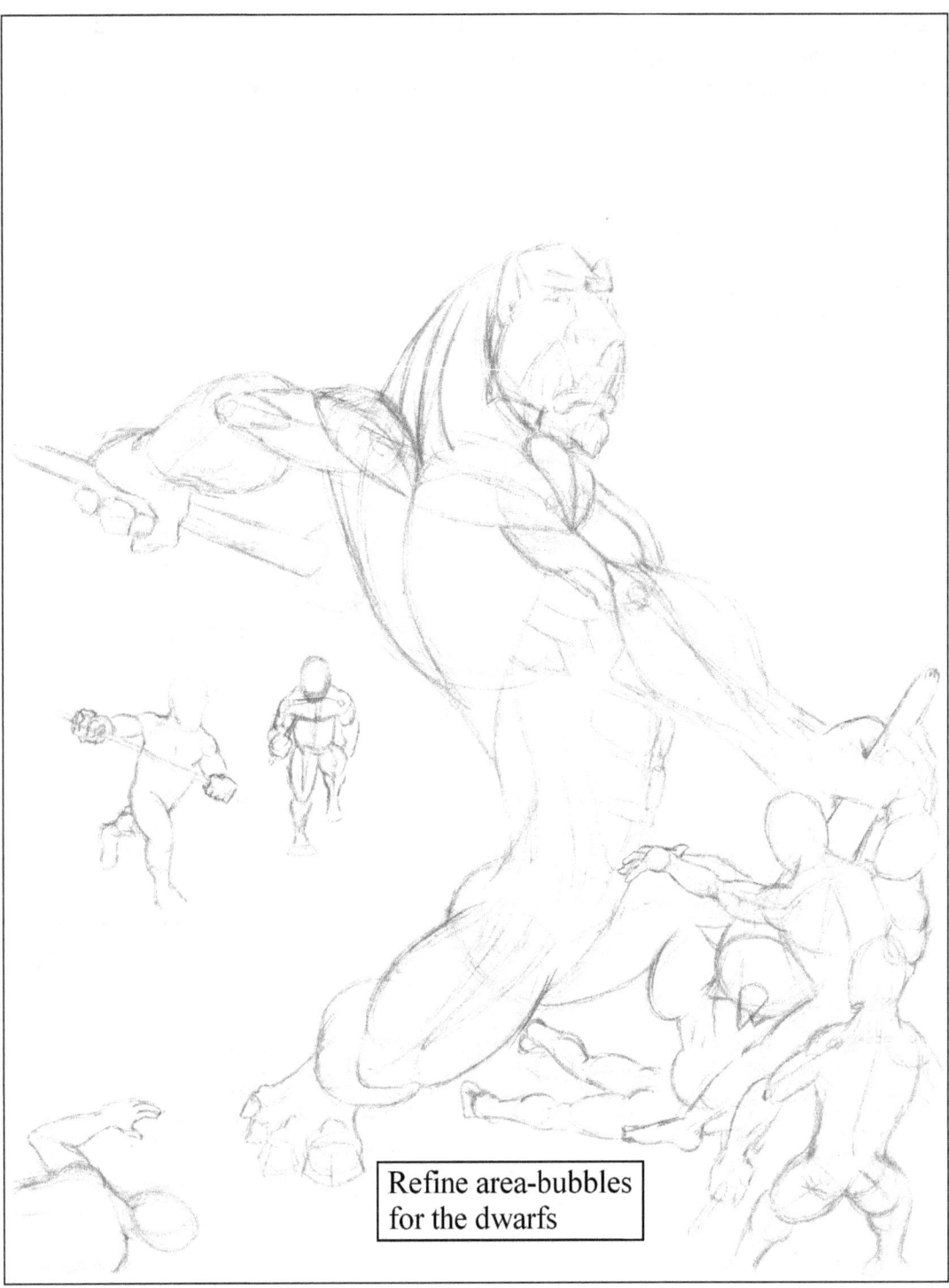

Refine area-bubbles for the dwarfs

Figure 16-52. Refine area-bubbles for dwarfs

Step 5.

Now that character outlines are finished, lightly erase the wireframes and area-bubbles and touch up the outline of each character.

It's not completely necessary to erase the wireframe at this point. Once the drawing is inked all pencil lines will be erased anyway but eliminating some layout lines now will make it easier to add armor and ink the drawing without cluttering the paper.

Make sure the outline of each character looks proportional and appropriate. Just because the character layout is basically done doesn't mean you can't make changes. In this revision, the running dwarf on the right was altered to change the energy of the stance. By increasing the slope of the shoulders and hips it puts the dwarf in a position with more potential energy built up in its body.

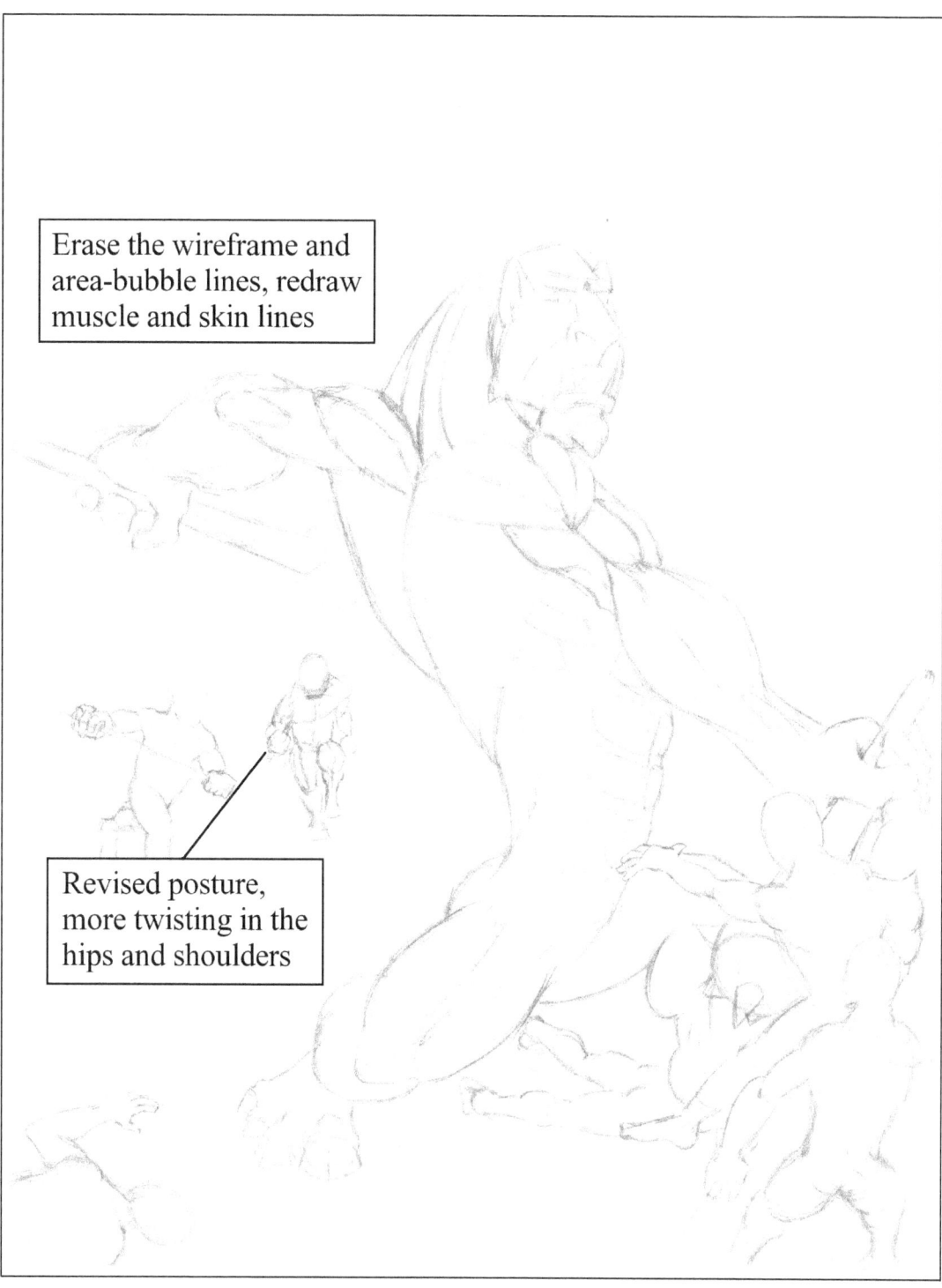

Figure 16-53. Erase wireframe and area-bubble lines

Step 6.

Lightly sketch the armor onto the ogre. Adding armor is arguably the most difficult step in this drawing but referring to the armor sketches done previously will help. Unlike the generic ogre body used to sketch and develop the armor, the ogre in this drawing is in a twisted profile view. This adds complexity to the armor placement and will require some three dimensional thinking to place each piece. As you sketch the armor onto the ogre you must do your best to visualize how the armor wraps around the body.

The breastplate is similar to a tube that wraps around the chest, and the pauldrons are similar to a quarter sphere sitting on top of each shoulder. The plated shirt can have some tension lines in it due to the torso twisting; this will also move some of the rows of plates closer together. The left forearm guard and right shin guard are heavily influenced by the position of the limbs to the point where large portions of them aren't visible. The studded belt tassels are drawn in a state of movement, having been affected by the large powerful

- Add armor components from preliminary sketches
- Studded/spiked plate helmet
- Breastplate with spiked pauldrons
- Leather undershirt with studded plates
- Leather belt with studded flaps
- Forearm guards

Figure 16-54. Sketch ogre armor

step which has just taken place.

Step 7.

Sketch armor onto the dwarfs; again, this step can be difficult and time consuming and you should refer to your sketches for guidance.

The dwarfs in this drawing are relatively small compared to the dwarf form used previously to make the armor sketches. The large dwarf form used for sketching allowed the armor sketches to include several details that may be difficult to include on these smaller dwarf counterparts. The armor added to the dwarfs in this drawing doesn't have to perfectly match the sketches, but the sketches should be used as a guide. Again, as with the ogre, some three dimensional thinking will be required to transfer the armor developed in the sketches, onto the dwarfs in this drawing.

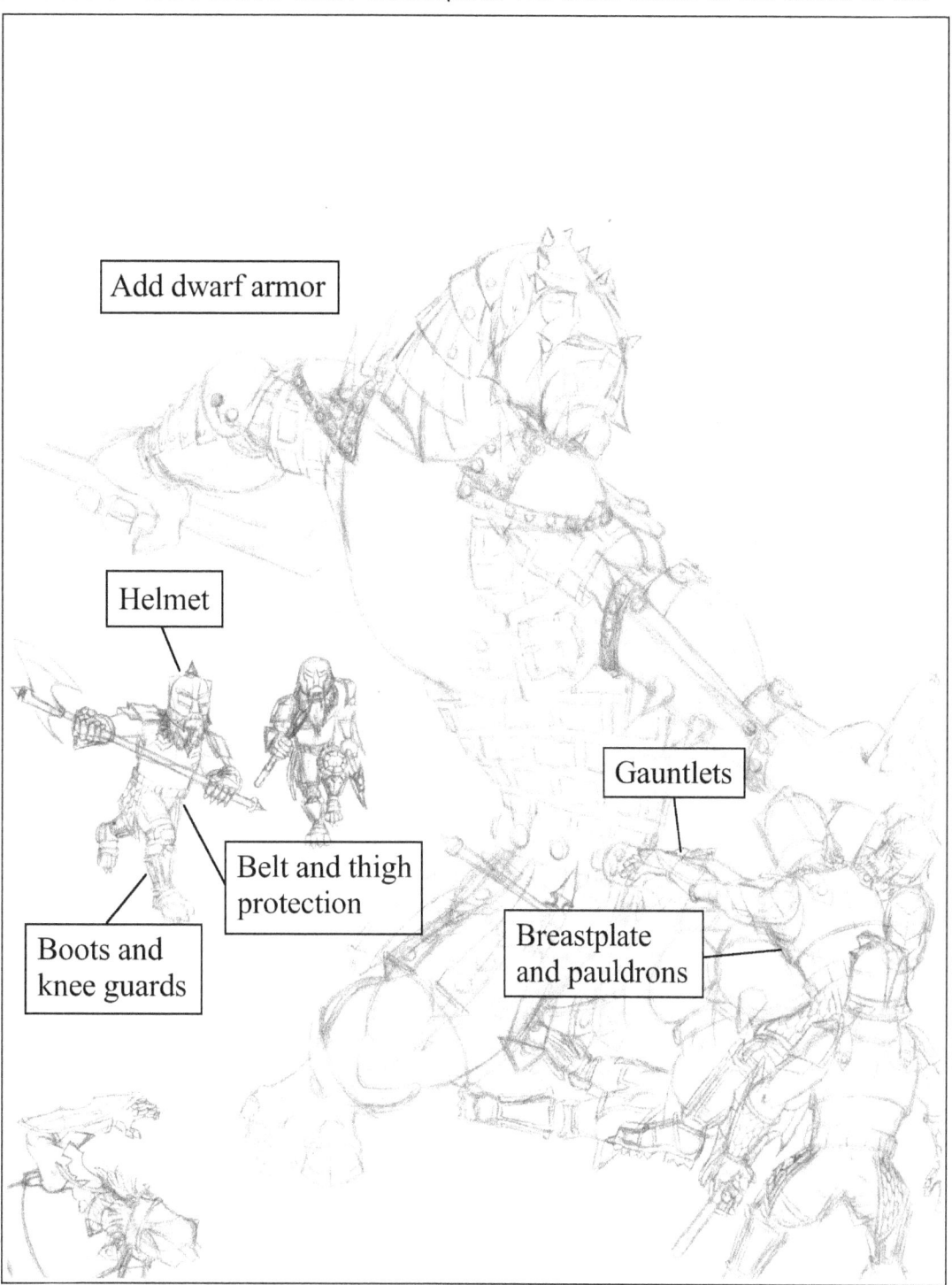

Figure 16-55. Sketch dwarf armor

Step 8.

Now that the ogre and dwarfs are fully armored take a moment to remove overlapping lines.

Most of the cleanup will take place along the perimeter of each body where armor and skin overlap. However, there may also be areas where pieces of armor overlap that also need to be cleaned. Erase the extra lines and redraw any that should remain.

Remember to be careful while erasing to keep the surface of the paper from being damaged.

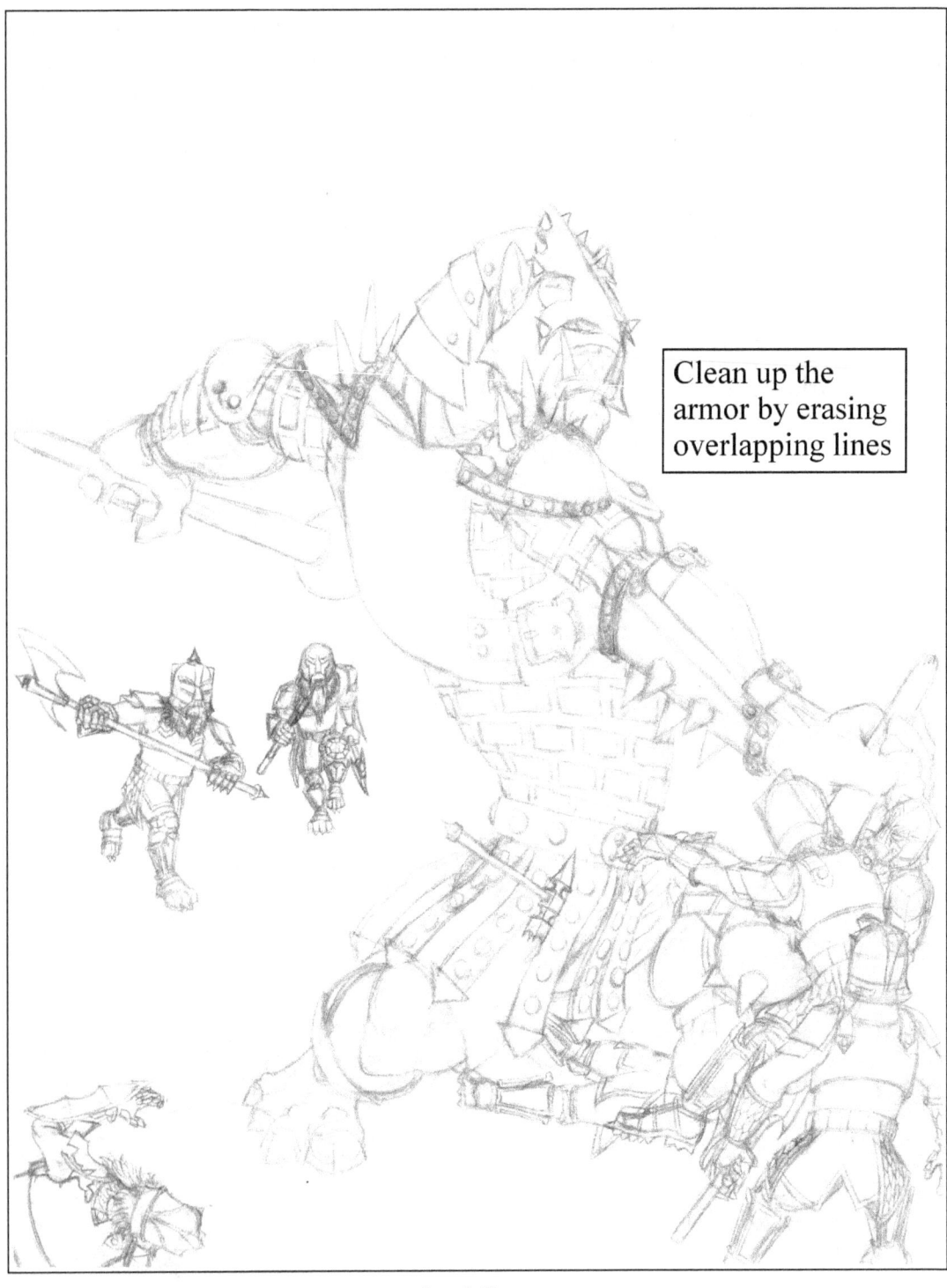

Clean up the armor by erasing overlapping lines

Figure 16-56. Remove excess sketch lines

Step 9.

The point at which you add a background depends on your desired outcome. Sometimes it's easier to draw terrain before adding characters, sometimes it's easier to draw the background around the characters, and sometimes you don't need a background at all. A background for this drawing is optional but in this step we'll add one.

The far background is made by sketching tall, jagged mountains. The placement is not extremely important but aesthetically it looks better to have two or three prominent peaks. In front of those mountains a low rolling hill or two can also be added.

Draw a horizon line to divide the near background from the far background mountains. This line should mimic the terrain of the area; in this case it should be relatively jagged because the terrain is rocky.

Prominent ground features such as large rocks, trees, cracks, and large patches of vegetation and grass should be added to the near background and foreground.

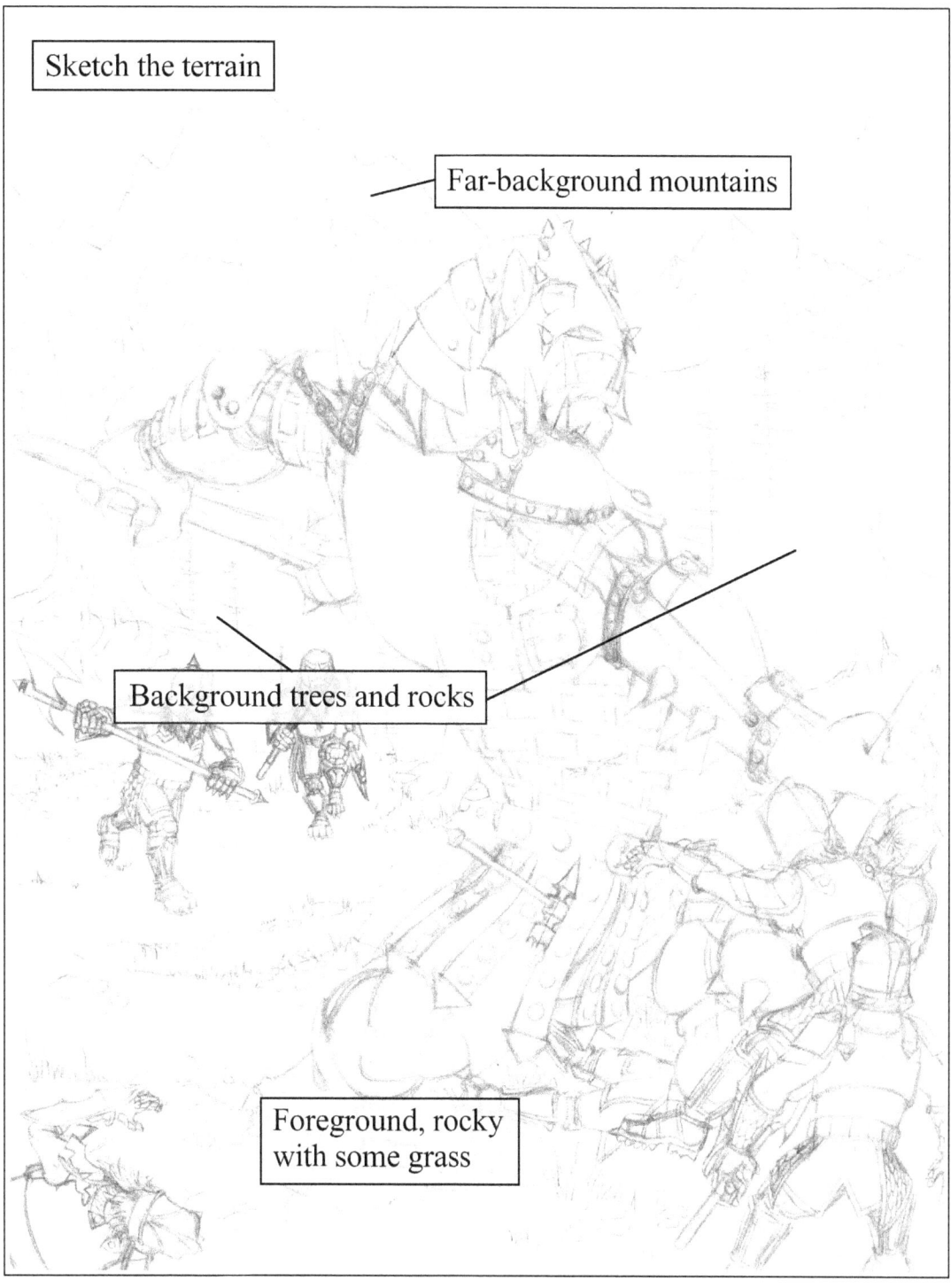

Figure 16-57. Add mountain background and rocky foreground

Step 10.

With the drawing fully sketched in pencil the next step is to start inking. As mentioned before there are several methods which can be used including a brush or inking pen, but this drawing will be done using a standard fine tip ballpoint pen. Depending on the technique you intend to use you can either begin shading immediately, or just trace over the pencil lines.

To help avoid the chance of smudging, start at the top of the paper in the corner opposite your drawing hand. Trace over the lines, working toward the bottom on the same side as your drawing hand. Also, make sure to periodically clean the tip of your pen. Some ballpoint pens have a tendency to build up excess ink on the tip; this can come off the pen all at once and leave an ink spot if you aren't careful.

> Trace over lines with a pen

> Move from top left to bottom right if right-handed, top right to bottom left if left-handed

Figure 16-58. Begin inking over pencil lines

Step 11.

Continue tracing over pencil lines until they've all been inked.

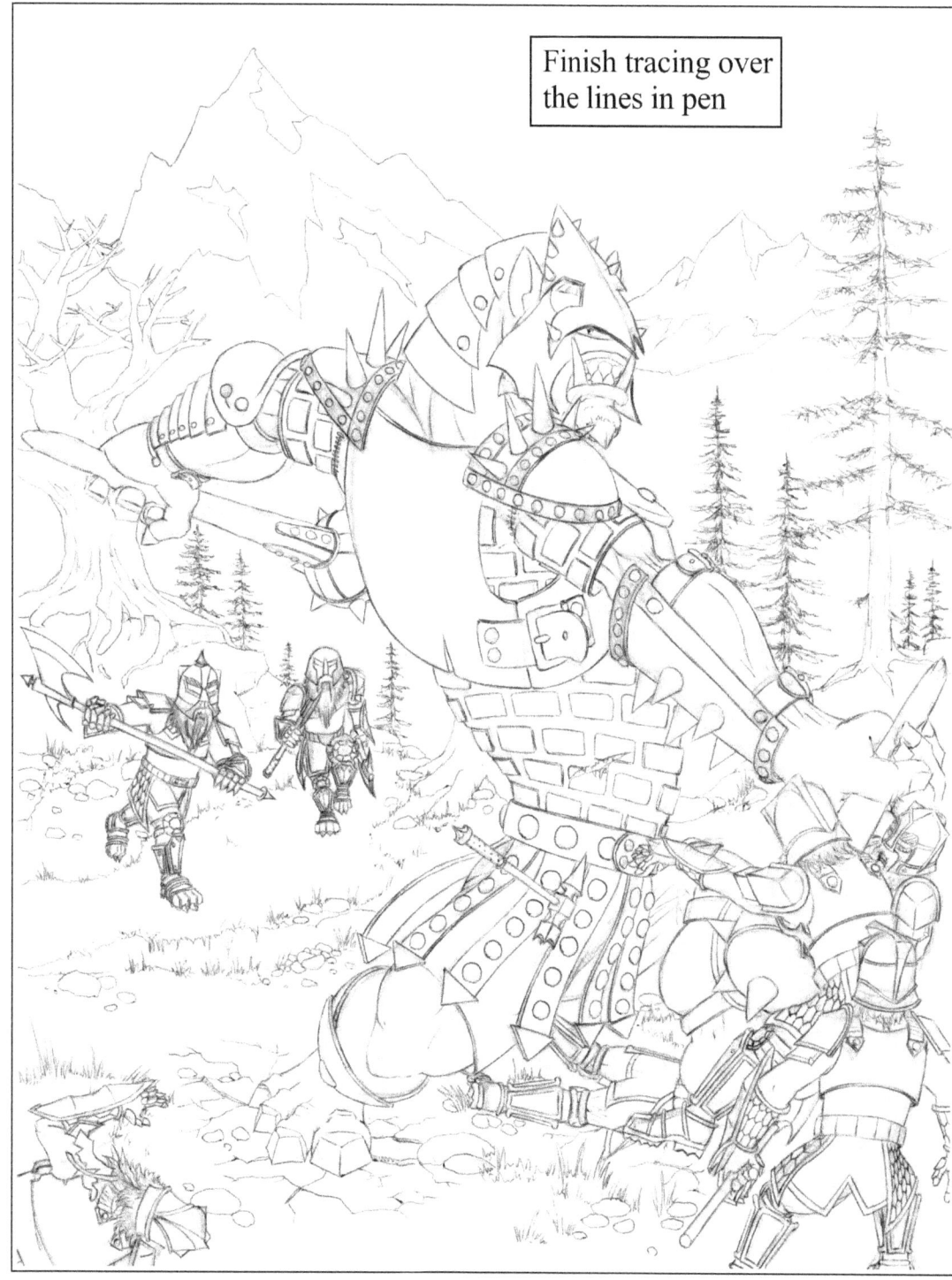

Figure 16-59. Finish inking the pencil lines

Step 12.

When all the pencil lines have been inked, let the drawing rest long enough to allow the ink to fully dry. If during the tracing process you accidentally got an ink-buildup spot on the paper, allow for extra drying time. It's sometimes surprising how long ink spots can remain liquid enough to smudge.

Once the ink has fully dried, use an eraser to gently erase the pencil lines. Look over the drawing to make sure you didn't erase any lines you needed but forgot to ink, and redraw any you may have missed.

Allow the ink to fully dry

Erase all pencil lines

Figure 16-60. Erase all pencil lines

Step 13.

With all lines inked, it's time to begin shading, but before you begin applying ink a couple choices must be made. First, determine at least a rough location for the light sources so you can highlight and shade consistently. Second, pick a shading method.

If you haven't decided which shading technique you want to use, you can make photocopies of your line drawing to experiment on. If you can't make copies of your drawing, there's a progression you can use to see which method of shading you like best. Begin by using regular hatching and cross-hatching. If you don't like the look of the hatching you can draw over it to create either a two-toned drawing or a two-toned drawing combined with hatching.

Another option is to shade using gradients as shown in Figure 16-61a. Shading with gradients can take a significant amount of time but the effect can be stunning and vibrant. When using this technique the pen strokes must be extremely light, especially in highlighted areas. If this technique is unfamiliar to you, you should practice on a different piece of paper before using it on your final drawing. Be careful to only apply light

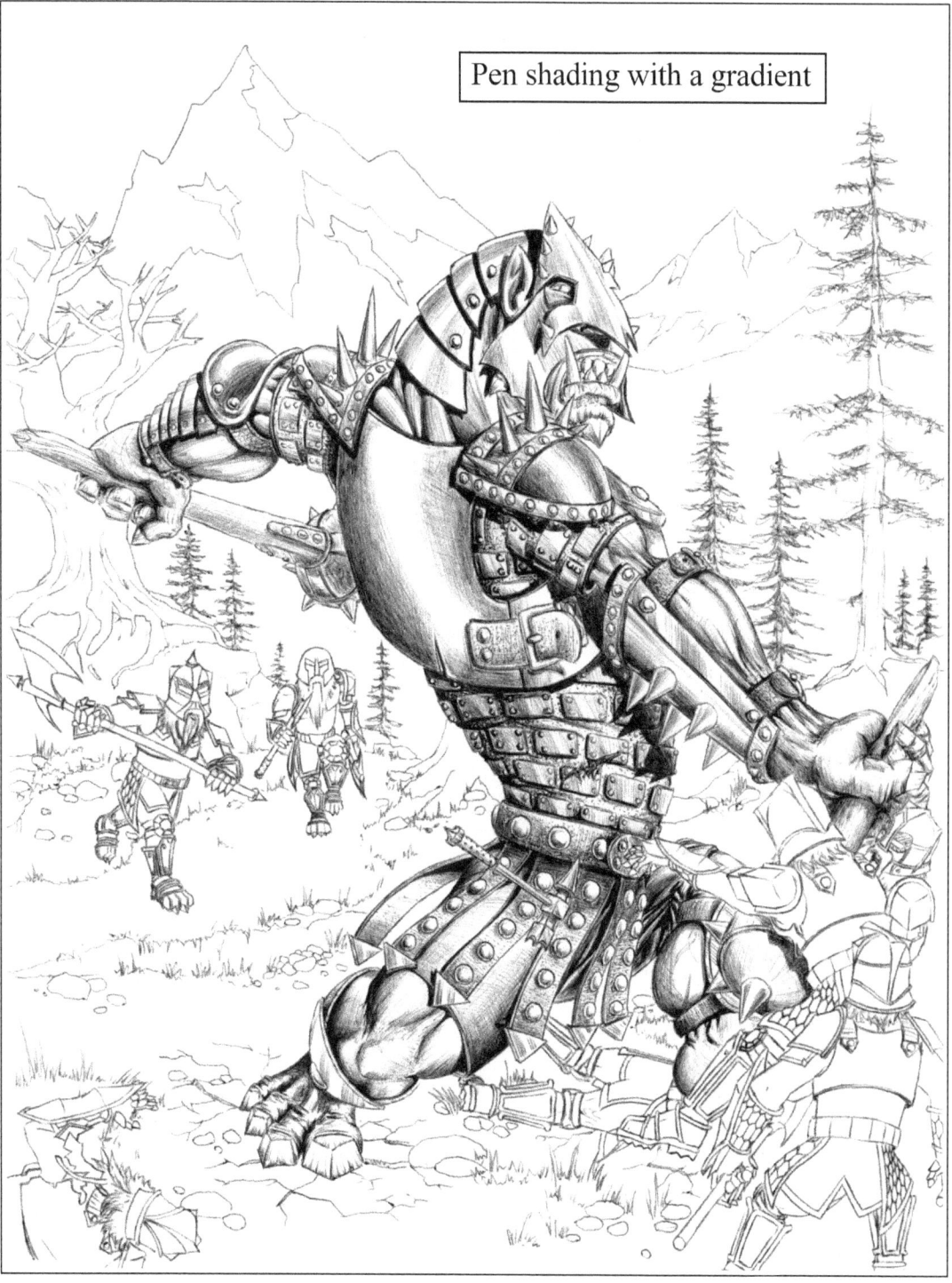

Figure 16-61a. Shading with gradients

129

layers of ink on each down-stroke. As you get more comfortable with the technique and your pen you can begin to apply ink on both the up and down strokes.

Figures 16-61a – 16-61d illustrate various shading techniques applied to the ogre. Each technique offers its own unique look.

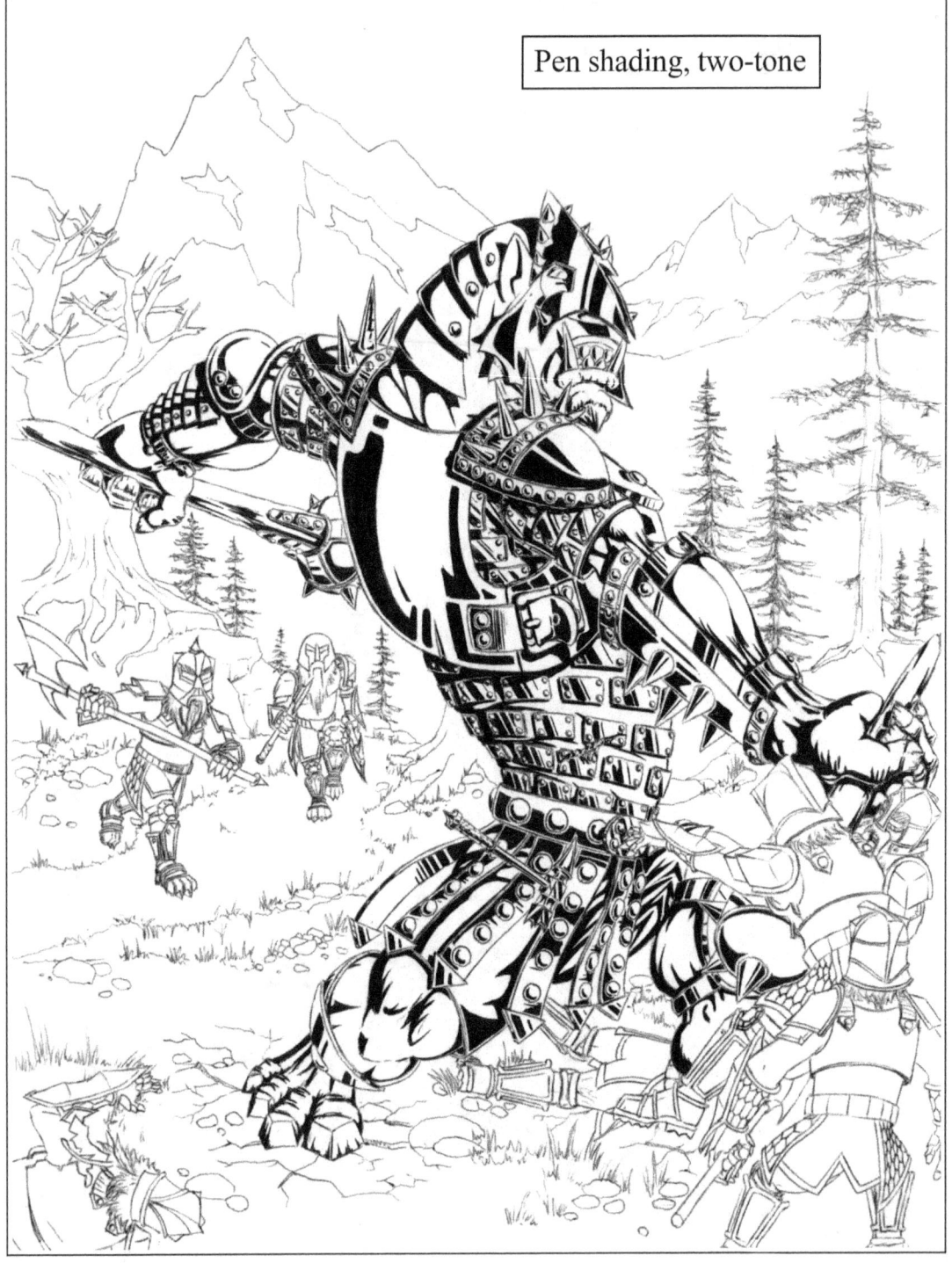

Figure 16-61b. Shading with two-tone

When shading, just like when tracing over pencil lines, you need to be careful of the order you add ink to avoid smudging fresh areas. Work more or less diagonally from top to bottom and take your time.

The majority of the surfaces on the ogre are relatively smooth, especially the metal armor. Metal can have very bright, reflective highlights in contrast to potentially deep crisp shadows at seams and overlapping edges, however, the majority of the metal should be a moderate gray tone. Leather straps are much less reflective and will usually have a lot more texture as well; this can be added with stippling or very small hatching. The skin of this ogre is smooth and the gradients describing the skin indicate that. Striations in the muscles are shown with lines and very tight hatching. Additional texture to the skin, and/or hair could also be added with hatching and crosshatching.

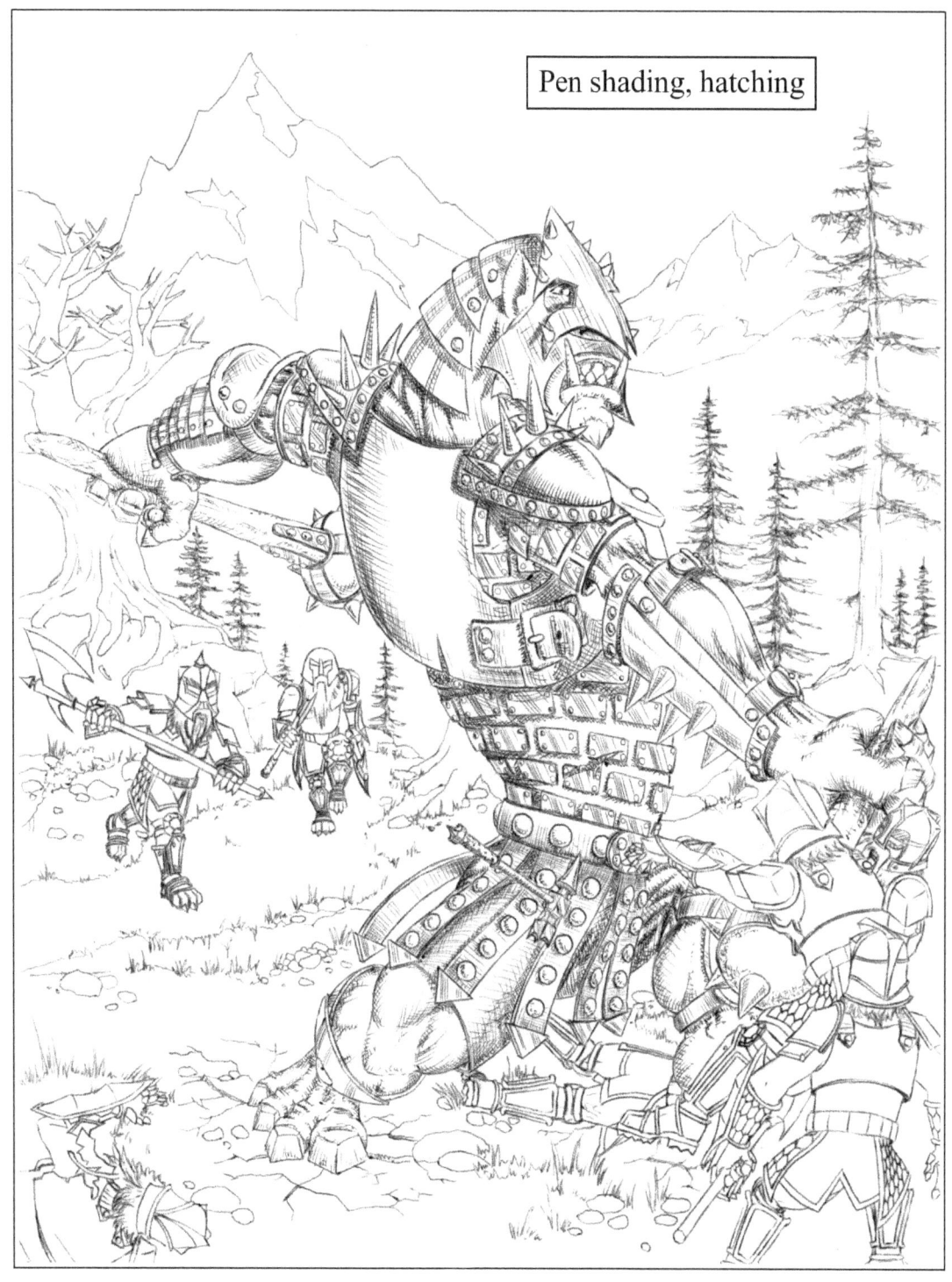

Figure 16-61c. Shading with hatching/crosshatching

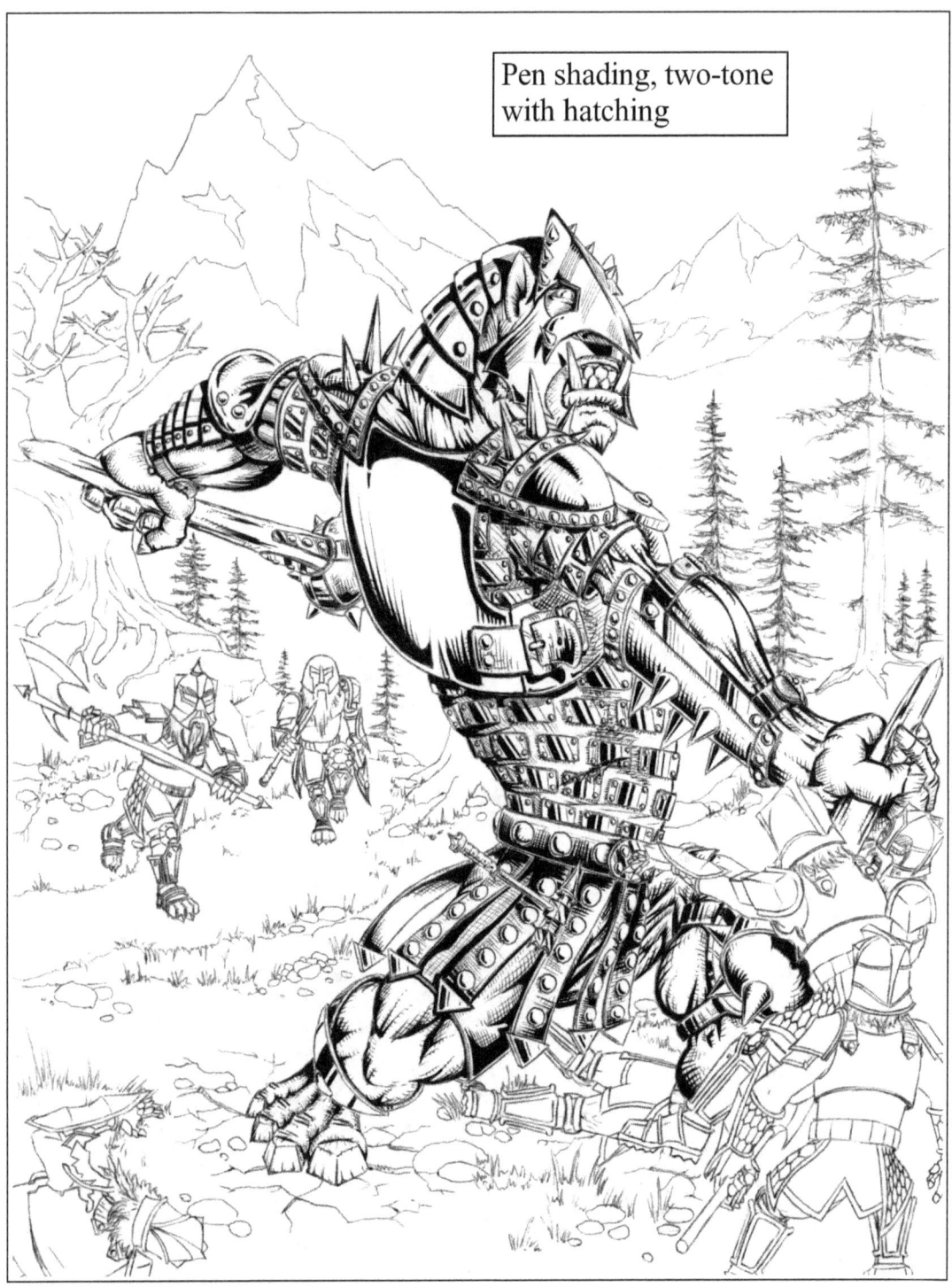

Figure 16-61d. Shading combining two-tone and hatching

Step 14.

The far background mountains can be deeply shaded in many areas indicating either, rocks, dense forests, or shaded ravines. The snowy peaks should be lightly shaded mainly to show various contours and to provide some depth.

The nearest background mountain can be detailed with a forest by using many small upside-down "V"s to create a textured appearance. The areas without trees can be shaded to various depths of tone to show ravines and cliffs.

The two large, near background trees, were detailed before starting the last, far background hill. The bark of both trees was done using a technique similar to continuous line and movement sketching (Drawing Mentor Volume 5), using an intentional side to side wobble while working up and down the trunks. The evergreen boughs were detailed using tight squiggly lines for each bunch of needles.

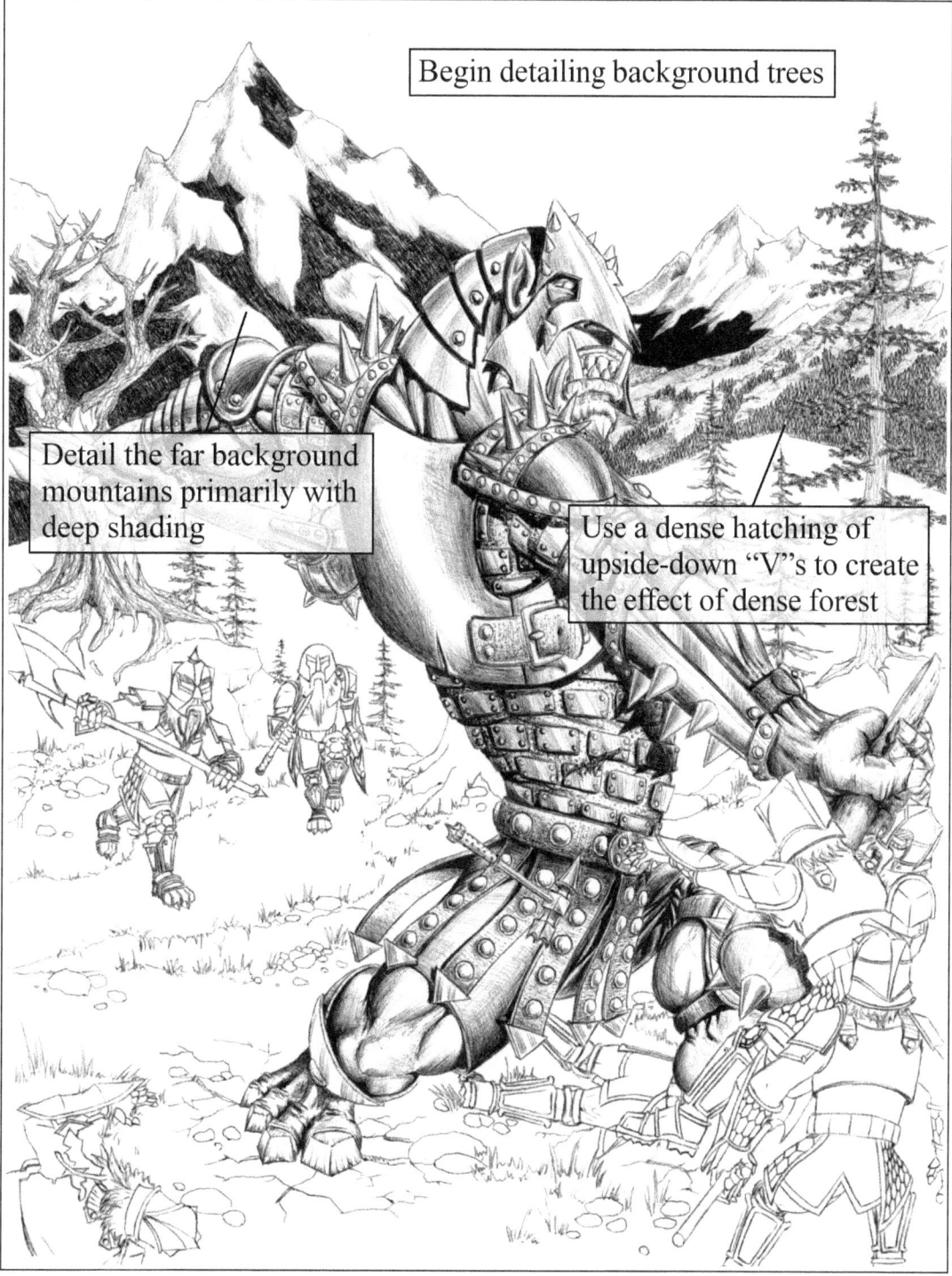

Figure 16-62. Begin detailing background

Step 15.

The last far background hill was detailed beginning with a relatively even covering of tone. Some areas were made to appear slightly darker in order to show minor contours. The hillside was then forested with trees. Create the look of an evergreen forest by using many tiny squiggly lines side by side. The forest can be as sparse or dense as you like but including at least some variability will create a more visually appealing result.

Use small simple squiggly lines to approximate evergreen trees

Overlap the squiggly lines to create a dense forest

Figure 16-63. Finish detailing background features

Step 16.

The next area of focus is the foreground. A general layer of light tone, or a light hatch, can be drawn to represent the natural gray and brown color of the rocky ground. Rock faces and surface cracks angled away from the light can be shaded much deeper. The hard edges of rocks typically create very clean contrasts between shadows and highlights.

There's not a lot of vegetation on the small rocky plateau but there are patches and tufts of grass. Tufts of grass can be made with a technique similar to hatching. Start the pen at the base of the blade of grass and stroke up to the tip. To create a clump of grass, repeat this motion several times from a similar starting point but at different angles. This technique can also be used for large areas of grass.

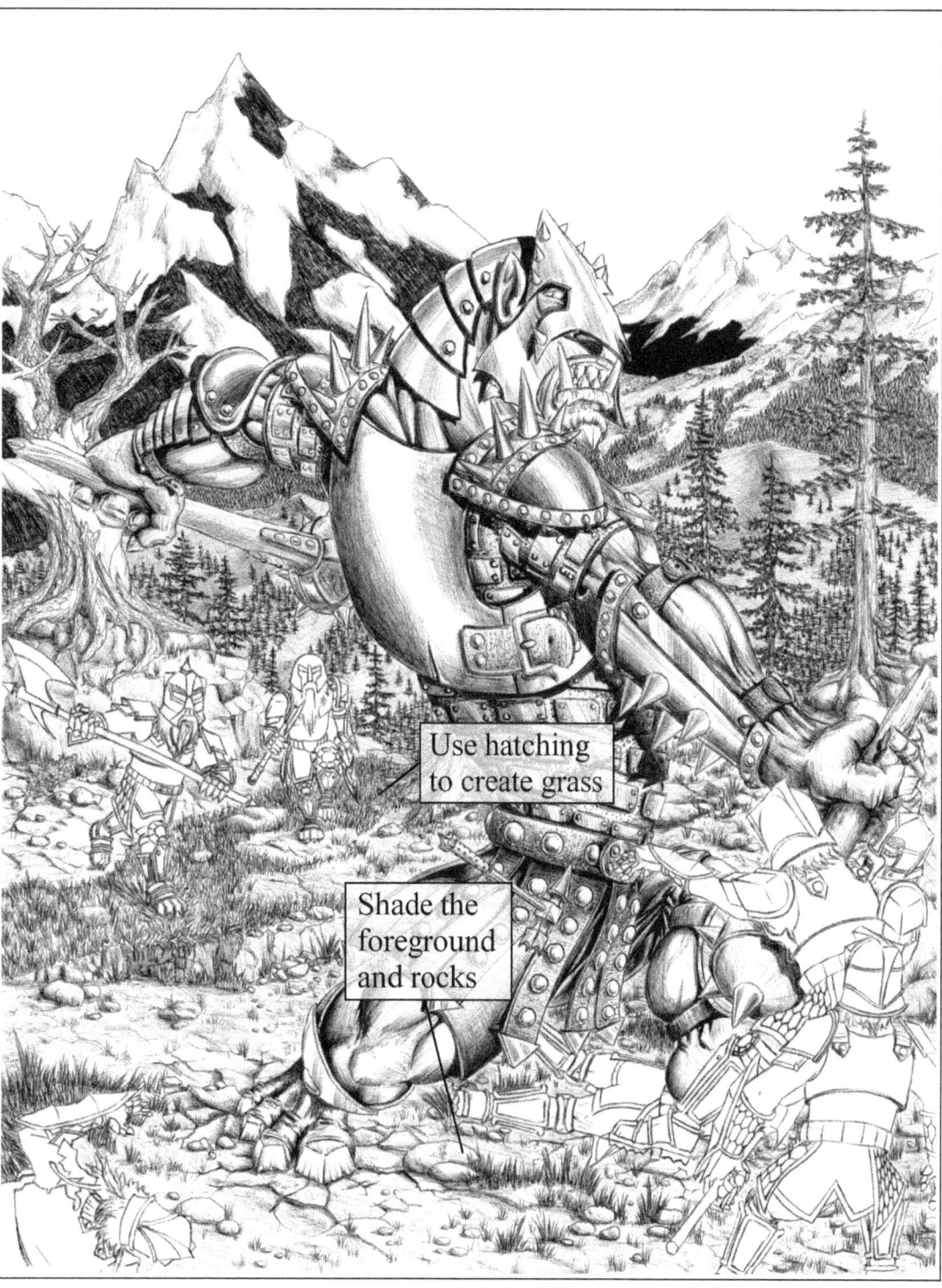

Figure 16-64. Begin detailing foreground features

135

Step 17.

The dwarfs are all fully armored and their armor should be shaded similar to the ogre's.

The dwarf armor has two elements that the ogre's doesn't, chainmail, and linked plates. Chainmail with rings this small can literally be detailed by simply drawing tiny circles. If you want to be slightly more accurate you can transition the circles into ellipses as the chainmail reaches the edges curving away from the viewer. In areas that are shaded, draw two, slightly offset, overlapping circles, in areas that are highlighted draw thinner lines with less overlap.

The linked plates are intricate but the main task is to simply define the shade between each plate and add a small shade and highlight to each rivet.

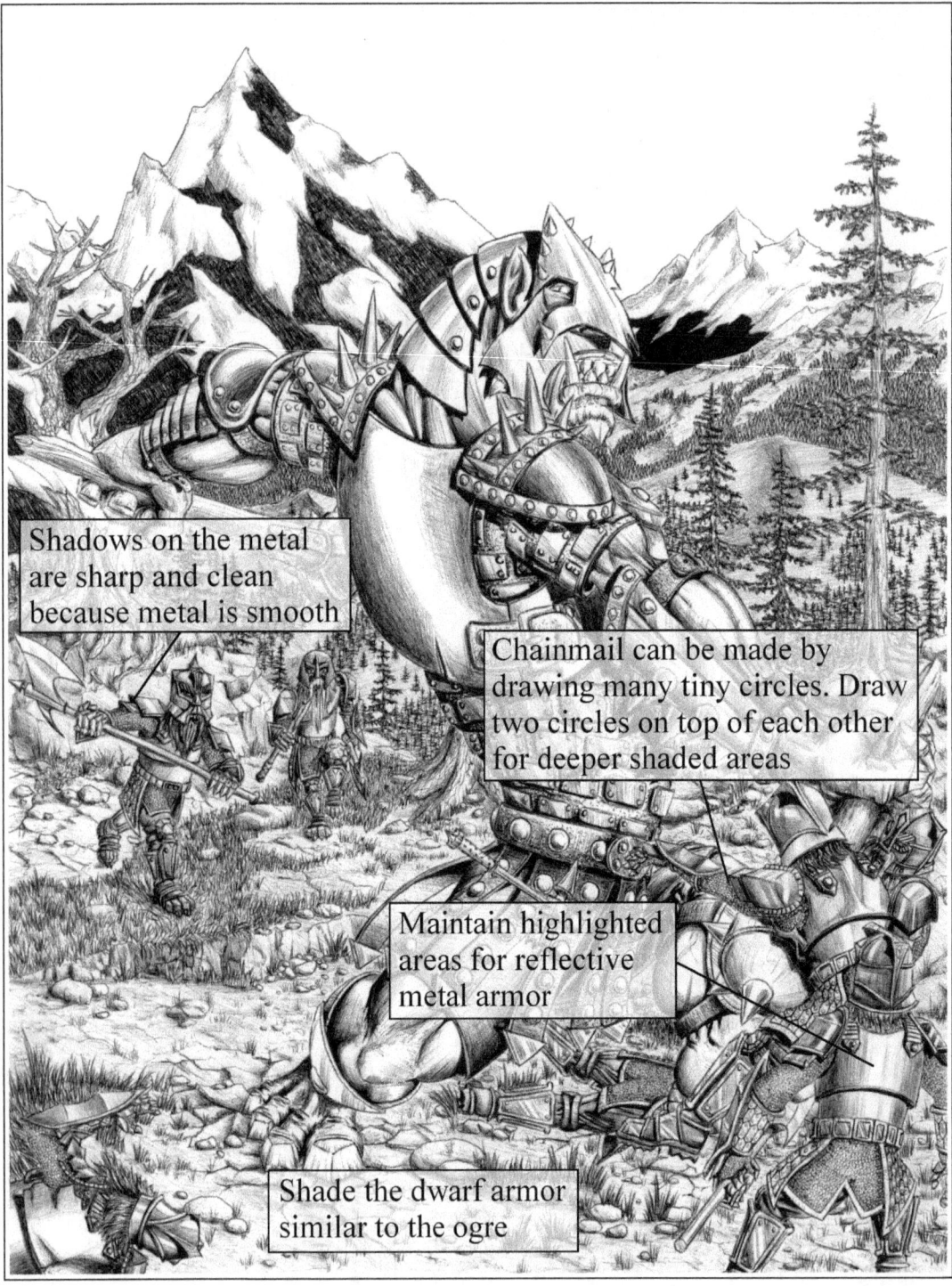

Figure 16-65. Detailing dwarf armor

Step 18.

Finally, add the major shadows associated with the characters and trees; then go over each area to do touchups.

A dark shadow should be added below and to the left of the ogre and each dwarf. Adding shadows can be somewhat tricky as they don't usually mimic the object creating them, especially when they project onto varying terrain. Simply do your best to project shadows more or less at the same angle, making sure to account for each limb that may project a shadow onto the ground.

Review the objects of the foreground and near background. Finish shading each one and project shadows over the terrain if necessary.

Finishing details on a drawing like this may take some time depending on how satisfied you are with the depth of tone you achieved at each step. Take time to slowly build up all shadows until you are satisfied with the results.

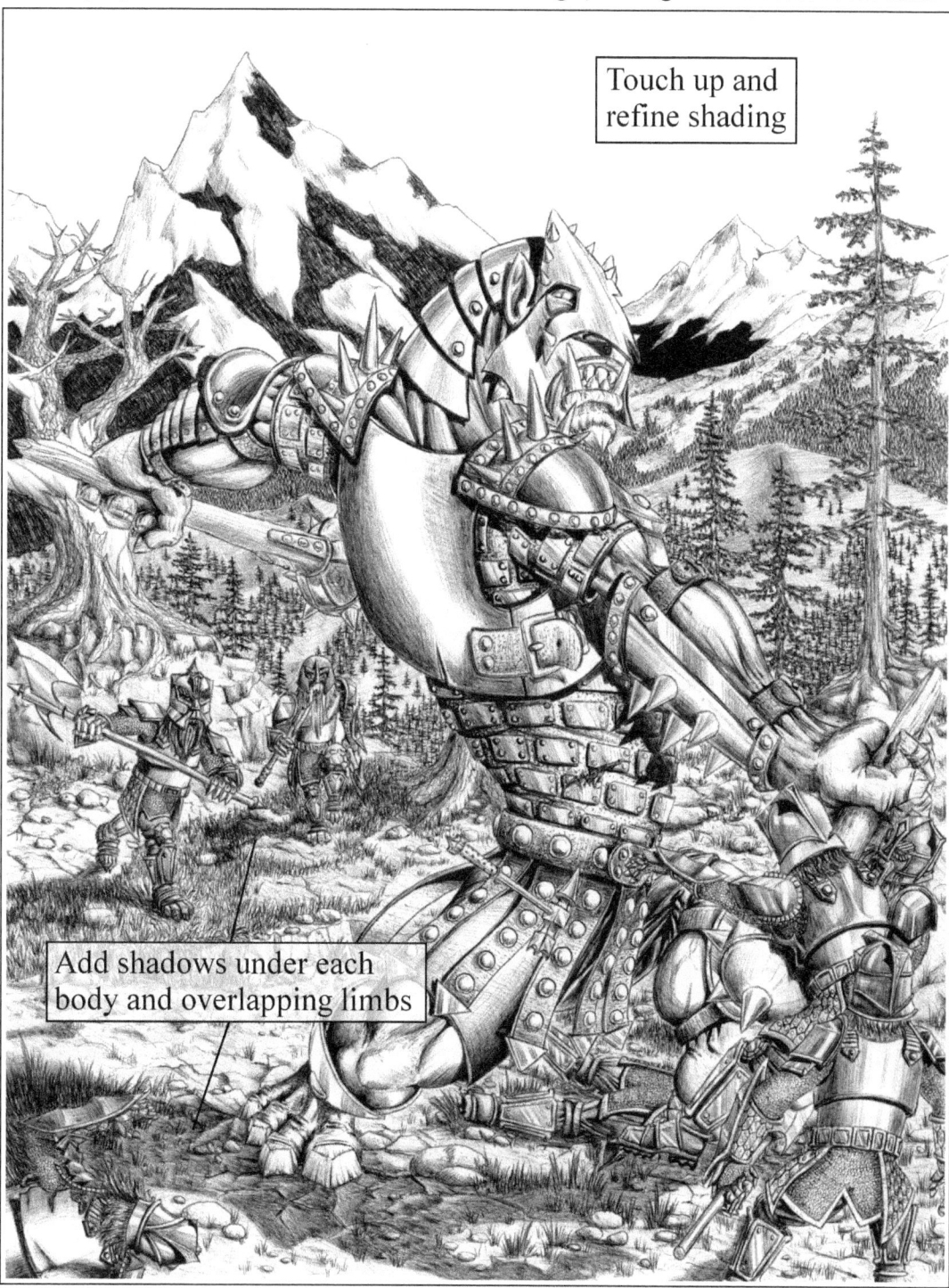

Figure 16-66. Final shading and touchups

Figure 16-67 shows the completed drawing of a battle between an ogre and dwarfs. As there is nothing to compare it to, you will either be satisfied or dissatisfied with the results. If you like the results of your drawing count it as a win, if you don't like it, consider it a detailed sketch, learn from it, and try again. Remember, each time you draw a fantasy drawing you'll get better at it, it'll become easier, and your personal style as an artist will start to show. There's no right or wrong in fantasy, just different.

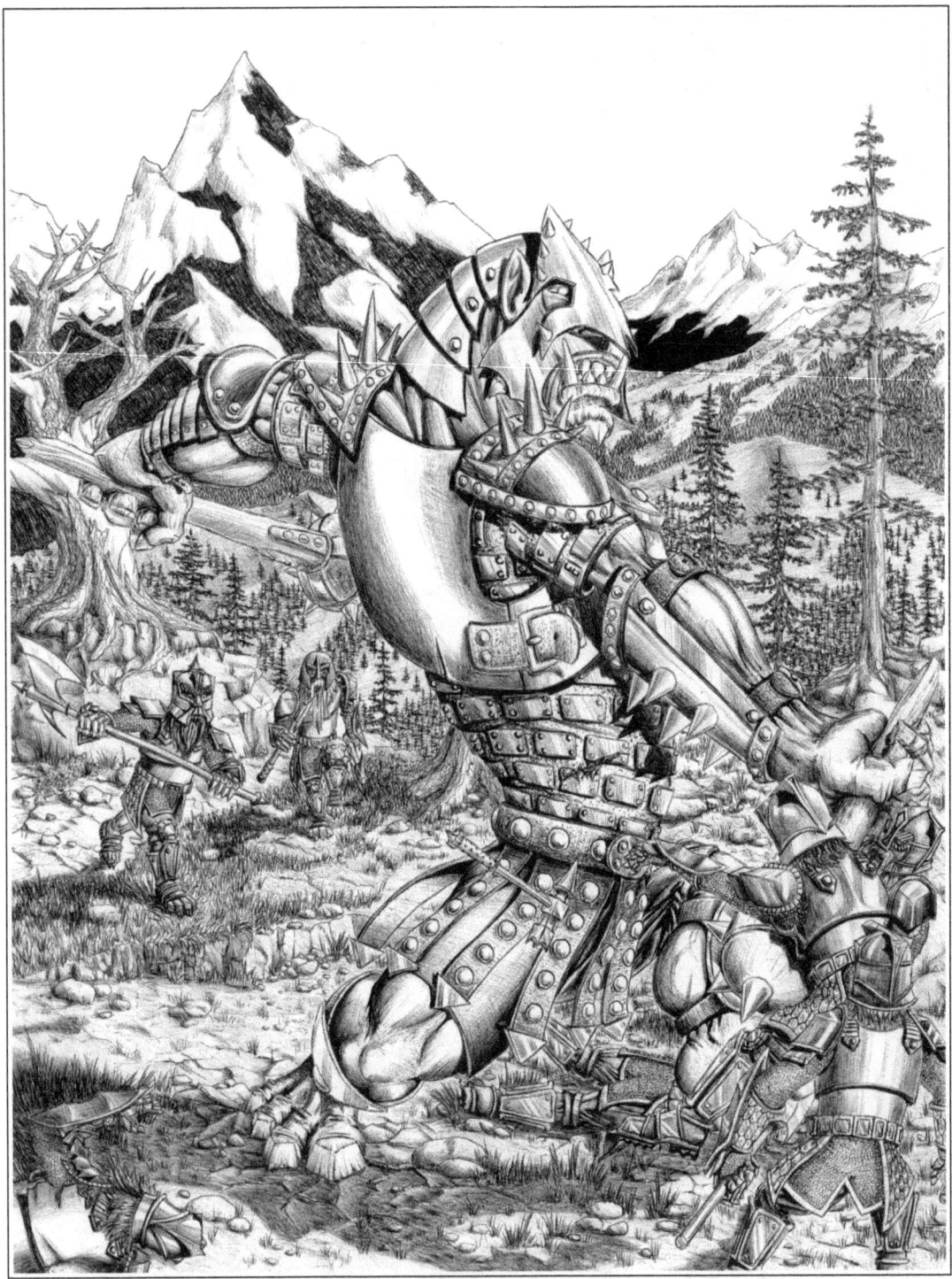

Figure 16-67. Finished drawing, ogre vs. dwarfs, in ink

Conclusion

You've now completed Volume 16 which is a continuation of the fantasy genre. This subject is vast and there is always more to explore but hopefully you enjoyed this lesson and learned or discovered something new. Don't forget that the key to success in drawing is simply to practice. The more you work on your skills the easier drawing anything becomes. No matter what level you're at, continually observing and sketching can only improve your skills and help you enjoy drawing even more.

www.ingramcontent.com/pod-product-compliance
Lightning Source LLC
Chambersburg PA
CBHW080658190526
45169CB00006B/2171